IMAGES
of America

AROUND
WISCASSET
ALNA, DRESDEN, WESTPORT ISLAND,
WISCASSET, AND WOOLWICH

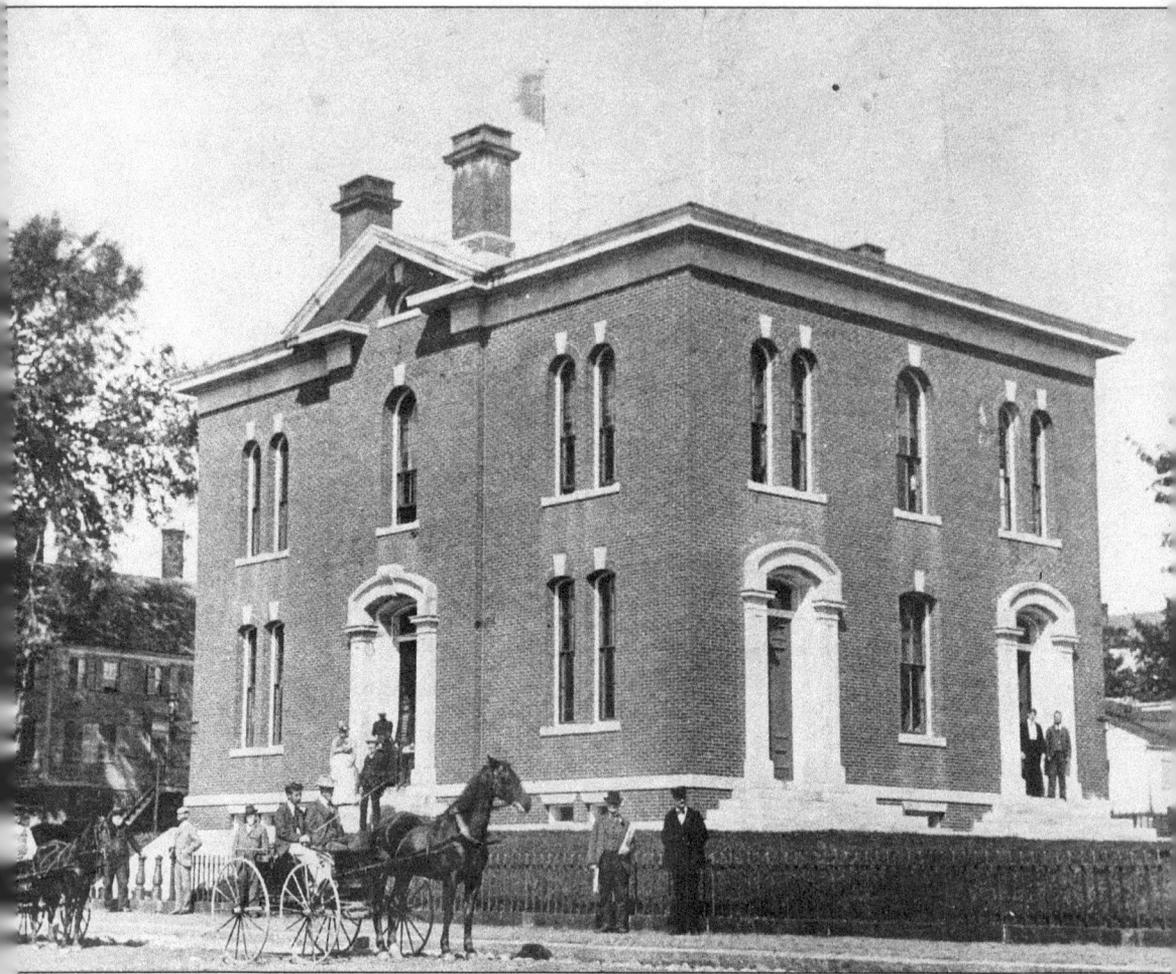

IMAGES
of America

AROUND
WISCASSET
ALNA, DRESDEN, WESTPORT ISLAND,
WISCASSET, AND WOOLWICH

Jim Harnedy

ARCADIA
PUBLISHING

Copyright © 1996 by Jim Harnedy
ISBN 978-1-5316-4242-6

Published by Arcadia Publishing
Charleston, South Carolina

Library of Congress Catalog Card Number: 2009921952

For all general information contact Arcadia Publishing at:
Telephone 843-853-2070
Fax 843-853-0044
E-mail sales@arcadiapublishing.com
For customer service and orders:
Toll-Free 1-888-313-2665

Visit us on the Internet at www.arcadiapublishing.com

OTHER PUBLICATIONS BY JIM HARNEDY

Images of America: The Boothbay Harbor Region (1995)

Contents

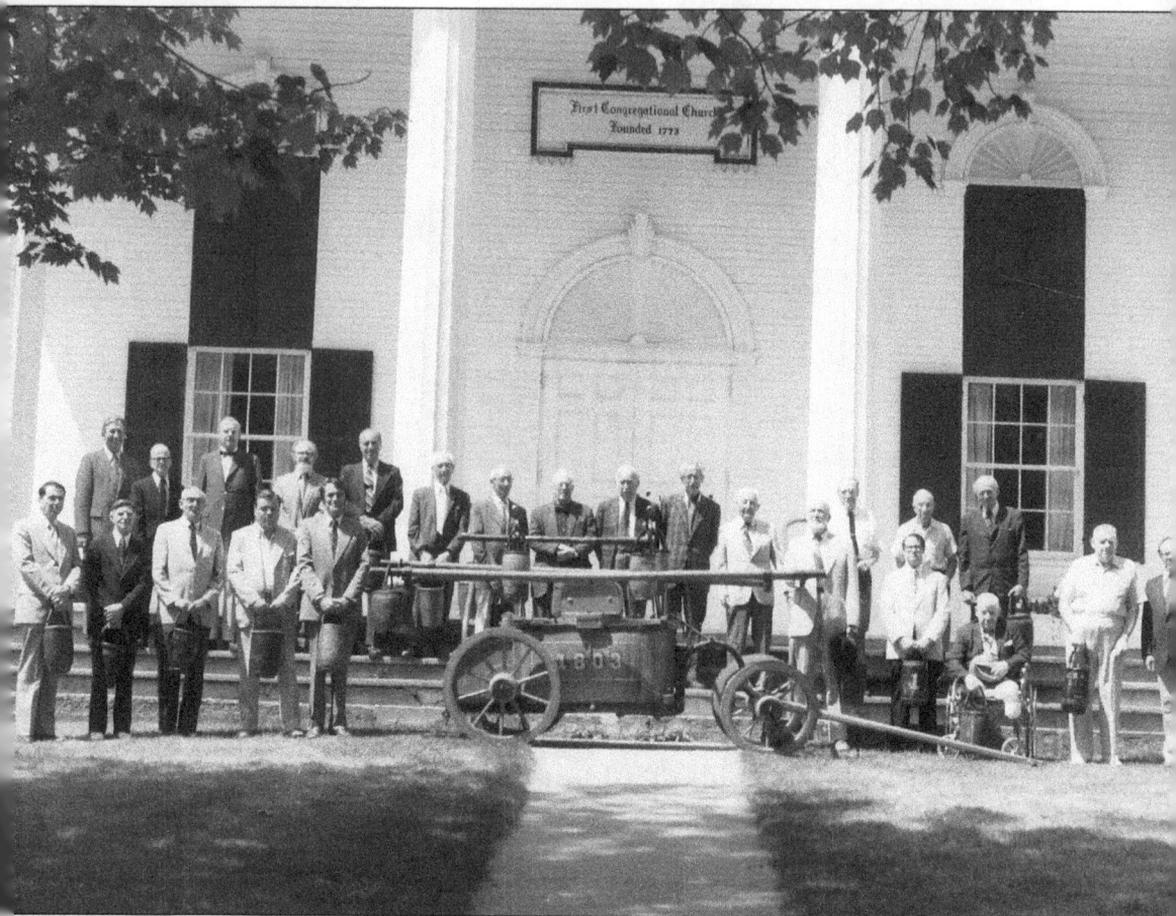

The Wiscasset Fire Society was founded in 1801 and is among the oldest volunteer fire departments in the country. From left to right in this 1960s photograph are: (front row) Roy Farmer, Frederick Pendleton, David Soule, Gardinier Flood, Conrad Peters, John Rafter, Walter Sherman, Robert McQuestion, Leslie Sullivan, and Gerald Sherman; (back row) Harry Haggett, George Cowan, Brewster Doggett, William Whitefield, Rufus Stetson, John Jackson, Lawrence Haggett, Leon Flood, Harold Campbell, Stuart Chaplan, Dr. Milton Stevenson, William Kierstead, Charles Plumstead, and Boylston Hutchins.

Introduction

The towns of Alna, Dresden, Westport Island, Wiscasset, and Woolwich are bounded by the Kennebec River on the west and the Sheepscot River on the east. It is alleged that in 1524, the explorer Giovanni da Verrazzano explored the area near the mouth of the Kennebec River. In 1603, the French made a claim to the region, which they considered to be part of Acadia. Samuel de Champlain recorded an exploration to the area in 1605, as did an English explorer, Captain George Waymouth. In 1606, the region became the possession of the English Plymouth Company, and in 1607, the Popham Colony was established. During the colony's brief one year existence, there were several encounters between the English and Native Americans. While the two were cordial, both sides were cautious to the point of suspicion.

The first inhabitants of the Wiscasset region were the Abnaki. The waterways provided an easy way for Native Americans living further inland to make summer visits to the coast, as well as a means for European explorers, fishermen, missionaries, and traders to navigate and occupy the new areas they discovered. All the lands of the region during this first portion of the seventeenth century were held under Abnaki Chief Mentaurmet, the father of Robinhood. In 1649, the island of Jeremysquam (present-day Westport Island) was conveyed to a settler, John Richards, by Robinhood.

While a legend exists that the present town of Dresden had settlers in 1630, a Native American deed to a Christopher Lawson in 1649 conveyed a tract of land which included the present towns of Dresden, Alna, Wiscasset, and Perkins, along with a much larger territory. The Nequasset territory, which includes present-day Woolwich, was conveyed by Robinhood to Edward Bateman and John Brown of Pemaquid in 1639. A settlement at what was called Sheepscot Farms, a hamlet about 4 miles up the river from Wiscasset, was settled in about 1630 by some fifty families. Where these early settlers came from is still a mystery, but the remains of old foundations and other relics attest to a settlement having once been present.

Wiscasset's written history began with the arrival of George and John Davie in 1660. These men built cabins and started homesteads at a point near the present-day Old Jail and Lincoln County Historical Museum on Federal Street. The tract the Davie brothers settled with two associates from Massachusetts was passed down by inheritance and sale to the Wiscasset or Boston Company, which was formed in 1734 by the heirs of these first settlers and other interested parties.

Local Indians remained friendly toward the settlers until the beginning of King Philip's War in 1675. Those early colonists that weren't killed in the conflict were forced to retreat back to territory which now lies within present-day Massachusetts. The Indian wars raged with but only slight intermissions for more than eighty years, completely depopulating and desolating the region. Complete peace did not return until the fall of Quebec to the English in 1759, and Montreal in 1760.

The earliest resettlement commenced with the arrival of the Robert Hooper family to

Wiscasset in 1729. The rest of the century saw a steady influx of settlers to the region. Local governments developed in the 1750s, through the building of meetinghouses in compliance with acts passed by the Massachusetts General Court. Education was addressed during the 1760s. The development of commerce, trade, and shipbuilding were important elements in the late eighteenth century and the first years of the nineteenth century. The Embargo Act of 1807, followed by the War of 1812, devastated the short-lived "golden era" that the area had enjoyed. Hard times followed and continued for the next half-century.

In the years following the Civil War, the region was discovered as a vacation destination for folks from away to visit during the summer. As in most communities across America, a wave of technological change came to the Wiscasset region during the late nineteenth and twentieth centuries, changing forever our landscape and lifestyle.

The photographs, postcards, and related memorabilia compiled in this volume present a visual history of how much, and yet how little, has changed through the years. The book's themes have been arranged to reflect the evolutionary process which has taken place, as well as to celebrate the contributions of the area's people and identify some of the events that have left a mark on our towns.

Jim Harnedy

One

Our Towns

Alna, Dresden, Wiscasset (formerly called Pownalborough), Westport Island (once known as Jeremysquam), and Woolwich (which began as a part of Georgetown) constitute our towns. A shared sense of unbroken continuity of life and history abounds as well as a diverse set of characteristics and traditions that make each community unique and very special. The town of Woolwich received its name from Woolwich, England, which is situated on a navigable river and has a similar landscape to our town. Waterways border Woolwich; the Sasanoa and Sheepscot Rivers and Montsweag Bay are to the south and east. To the northwest lies Merrymeeting Bay, which results from the confluence of the Abagadasset, Androscoggin, Cathance, Kennebec, and Muddy Rivers. These five rivers were once known as the Sagadahoc River area.

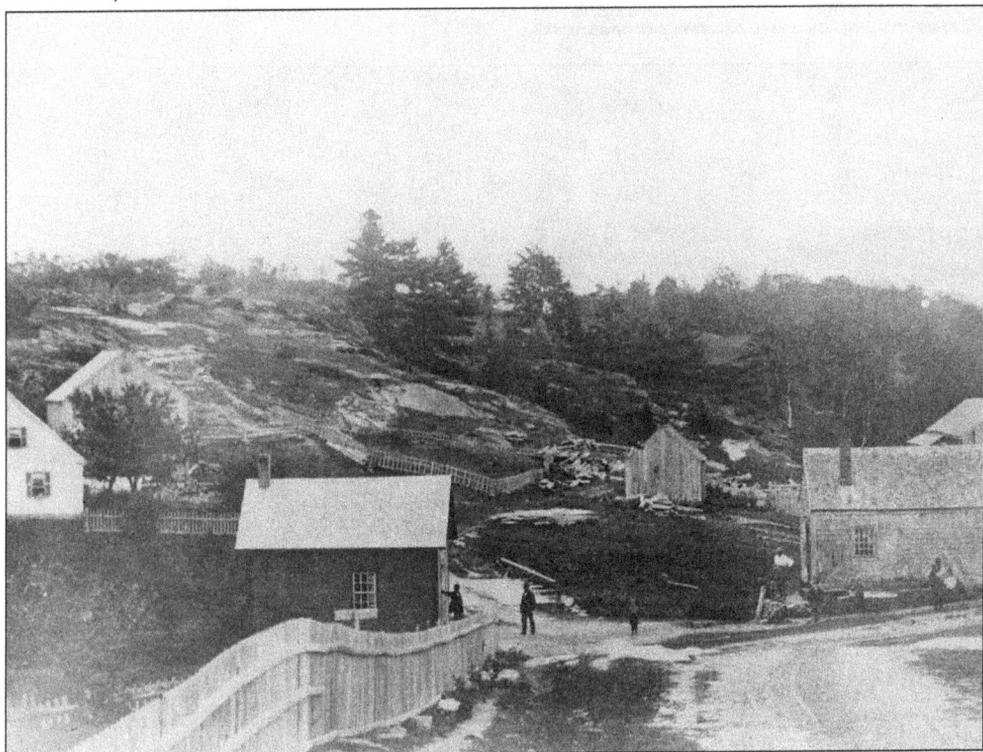

Ryan's Corner, Woolwich, 1873.

A scenic Woolrich postcard. Folks from away often sent postcards like this back home when vacationing in pristine Woolwich during the late eighteenth century.

Well, here I am in
Woolwich, Maine
Enjoying its Sights and Cheer.
I'm feeling first rate, and this Town
is just great;
Now, don't you wish you were here?

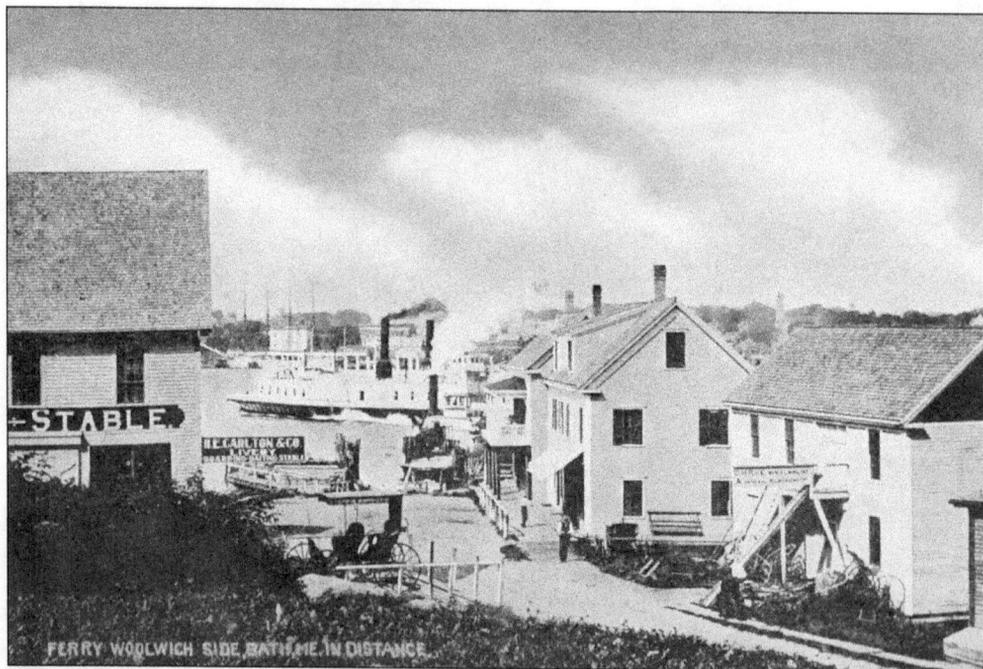

The Woolwich ferry terminal, c. 1900. Until the building of the Carlton Bridge in 1927, people traversed the Kennebec River from Bath to Woolwich by ferry.

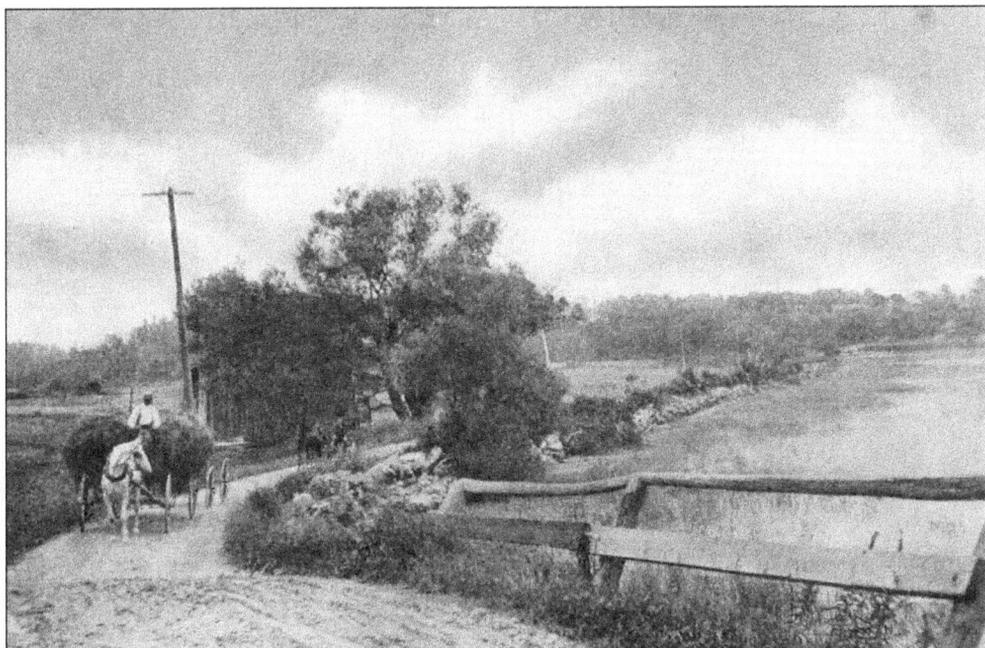

The Dike Road in Woolwich, c. 1900. This photograph was taken from a point behind the present-day Taste of Maine Restaurant on Route 1.

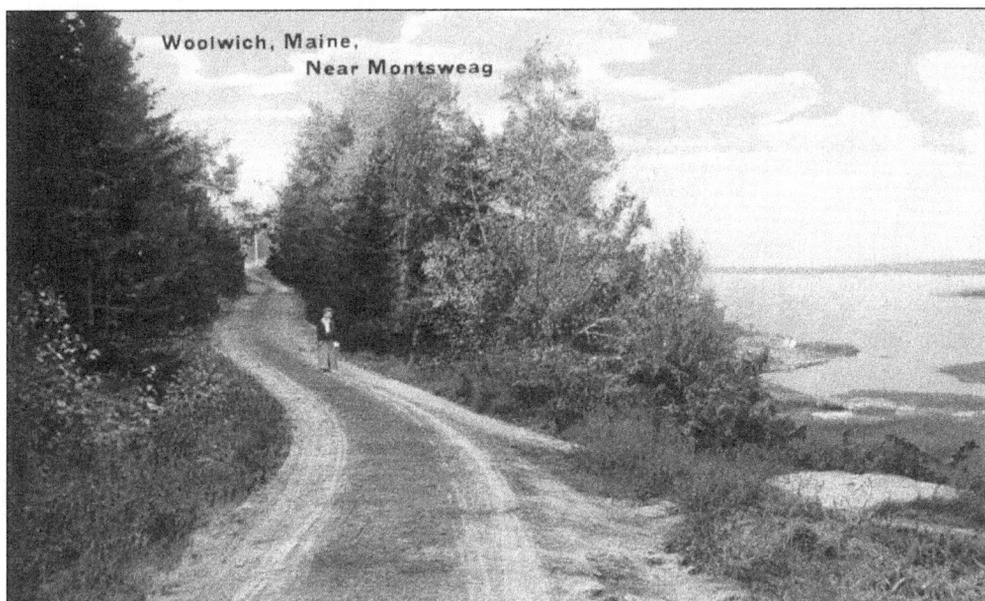

Out for a summer stroll in Montsweag, c. 1900.

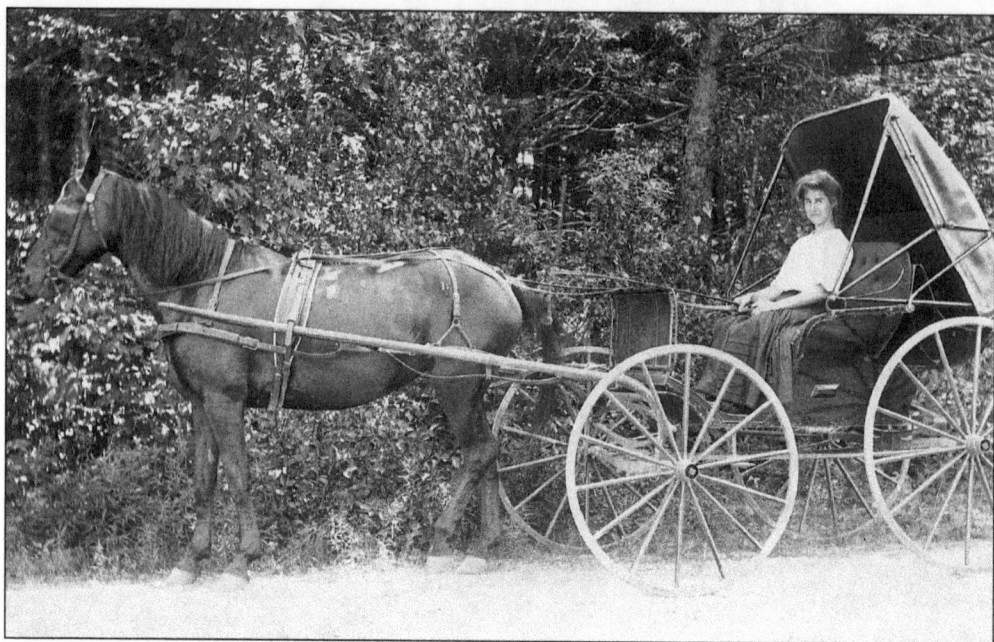

Ms. Effie Fife of Boston enjoying a summer ride. This photograph dates from her 1905 visit with relatives on Phipps Point, Woolwich.

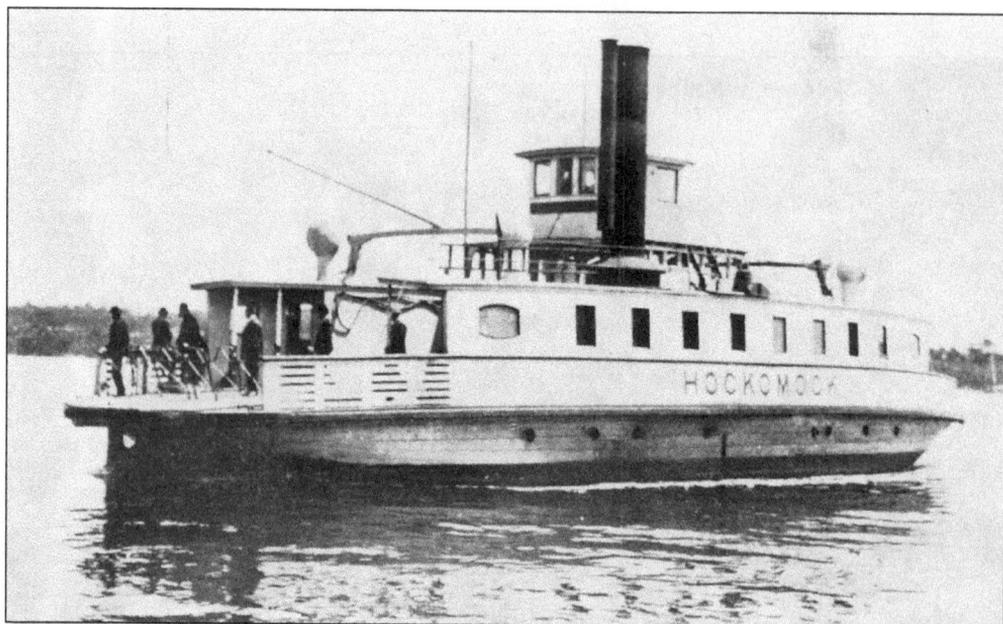

The ferryboat *Hockomock*. This vessel carried passengers and cargo between Bath and Woolwich during the early 1920s.

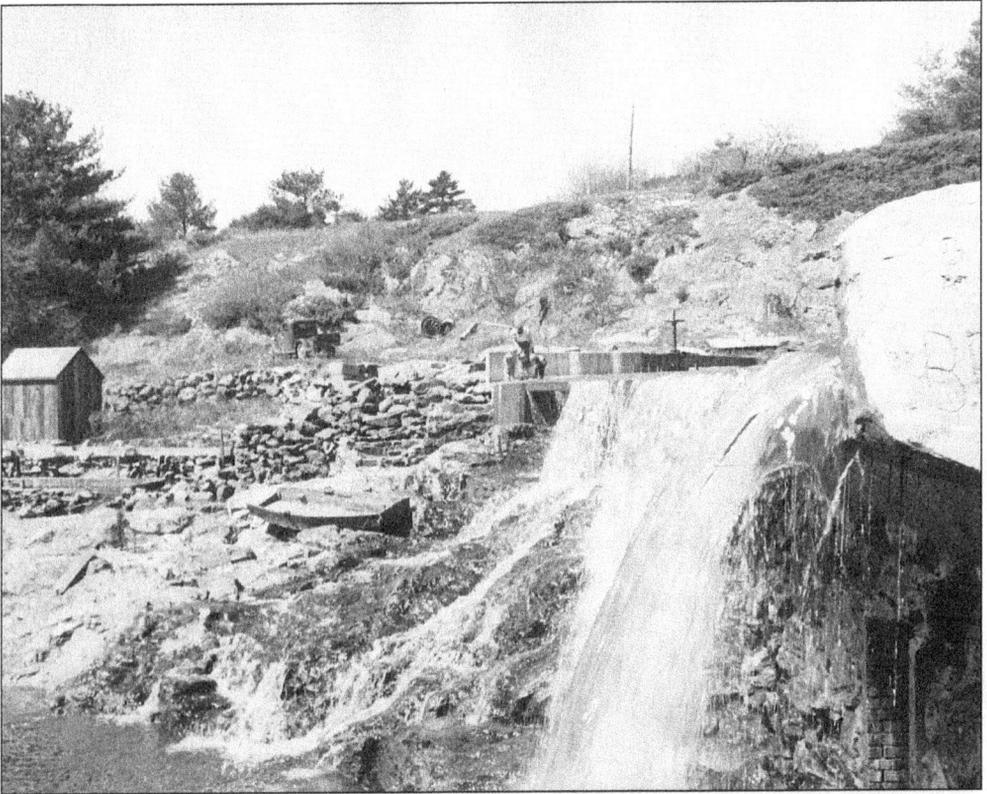

The dam and fish way at the Nequasset Lake outlet, c. 1920. The smokehouse was used for smoking the annual run of alewives.

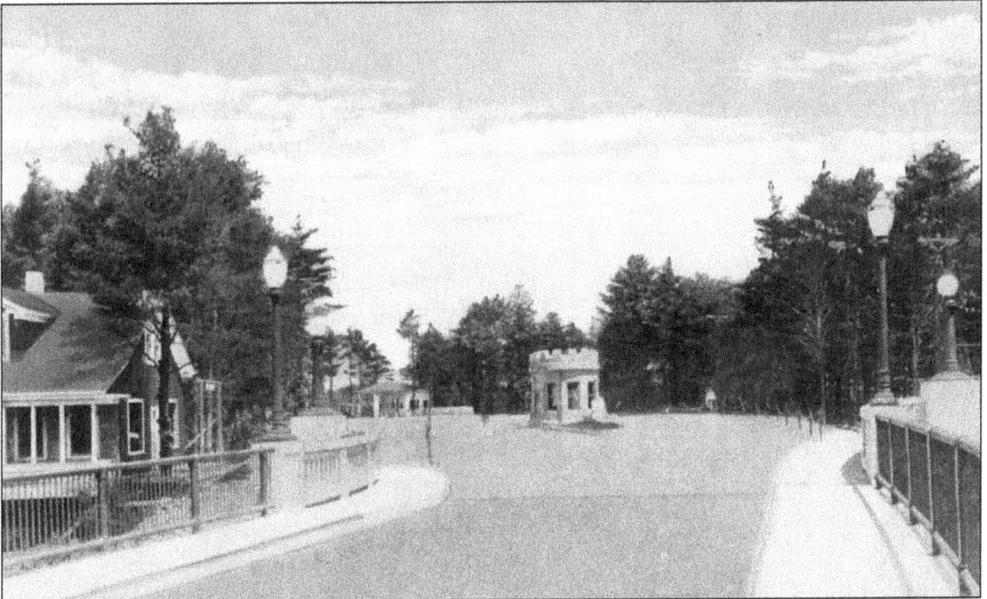

The Carlton Bridge. This span was built as a toll bridge in 1927 to provide faster access for the growing automobile traffic on the mid-coast.

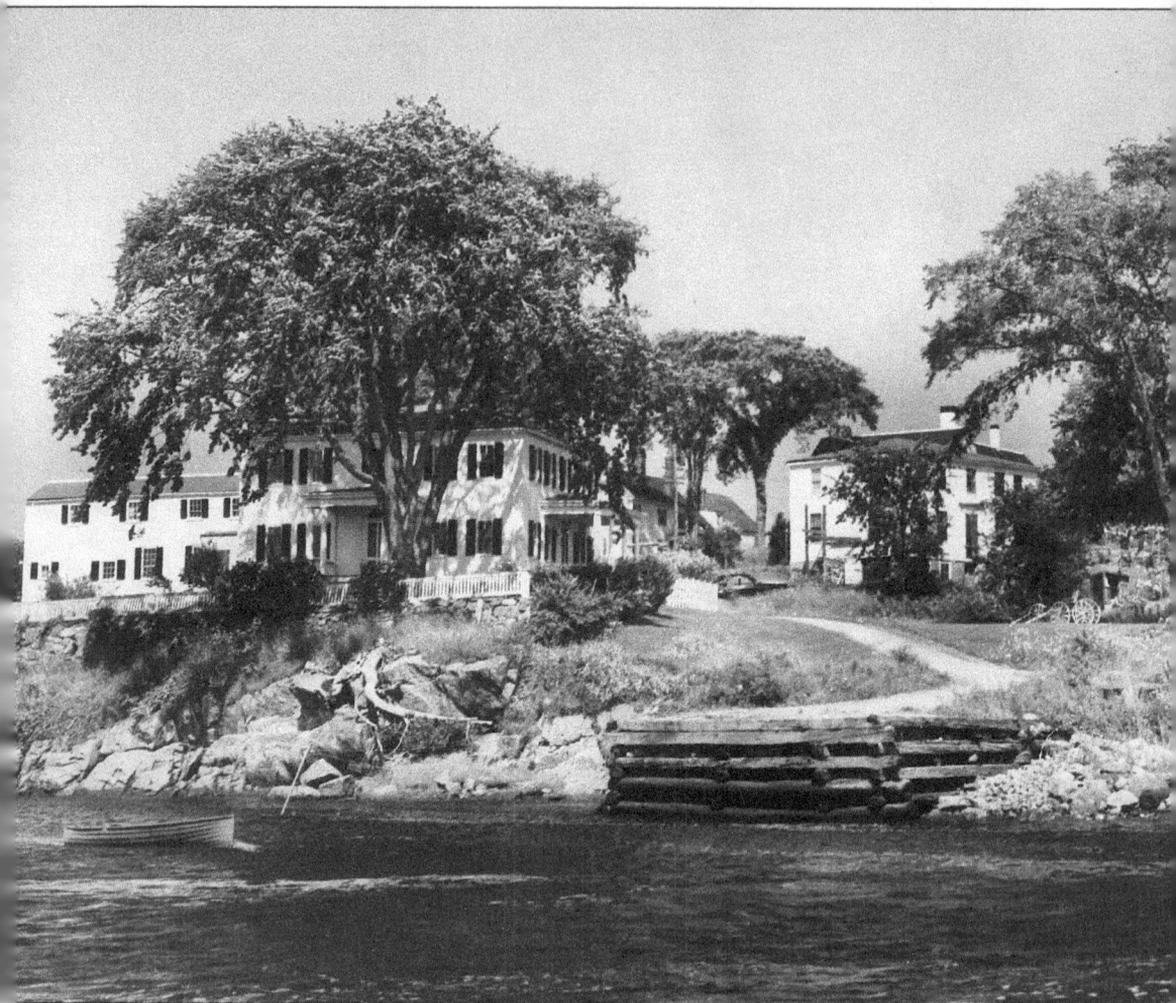

Town Landing Day's Ferry, *c.* 1930.

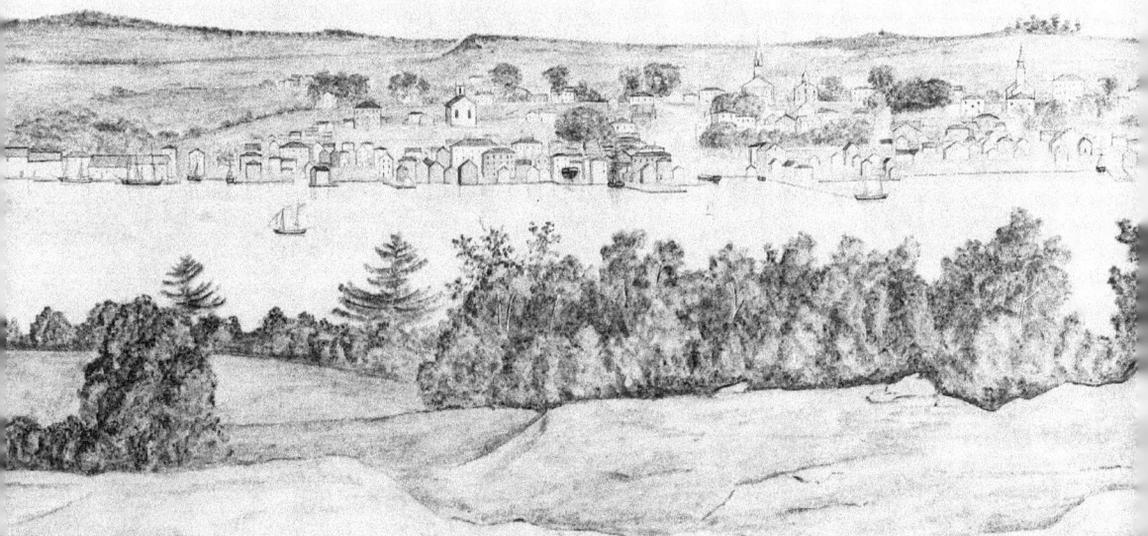

A copy of a drawing of the Wiscasset waterfront as seen from Edgecomb that Joseph Kingsbury Neal completed at age fifteen in 1845. It was made two years prior to the building of the first bridge between Wiscasset and Edgecomb.

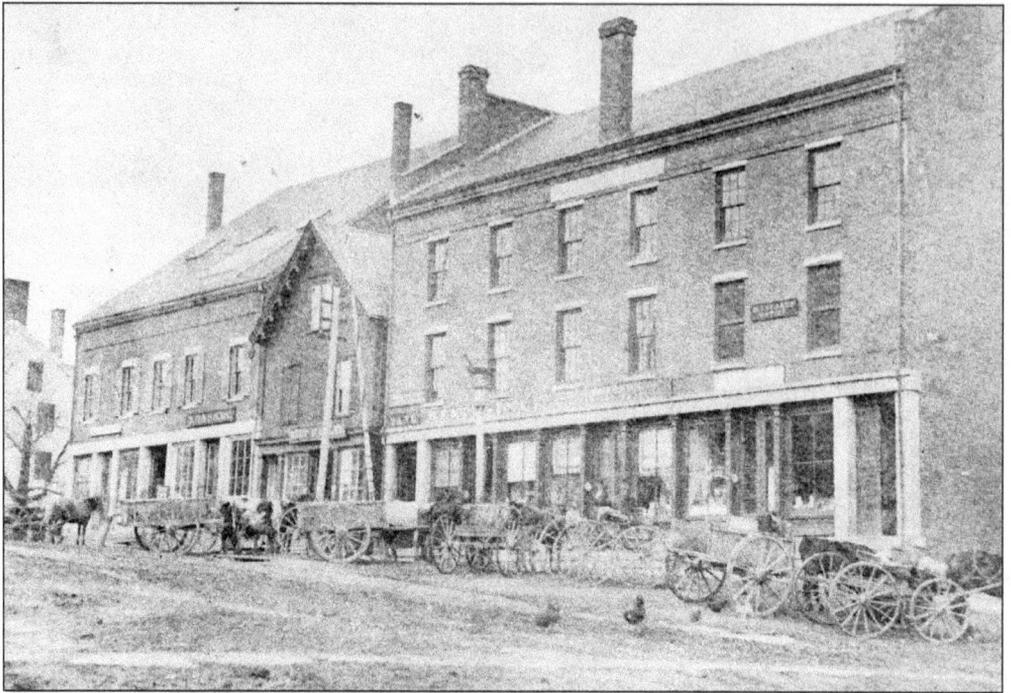

Lower Main Street, Wiscasset, *c.* 1875.

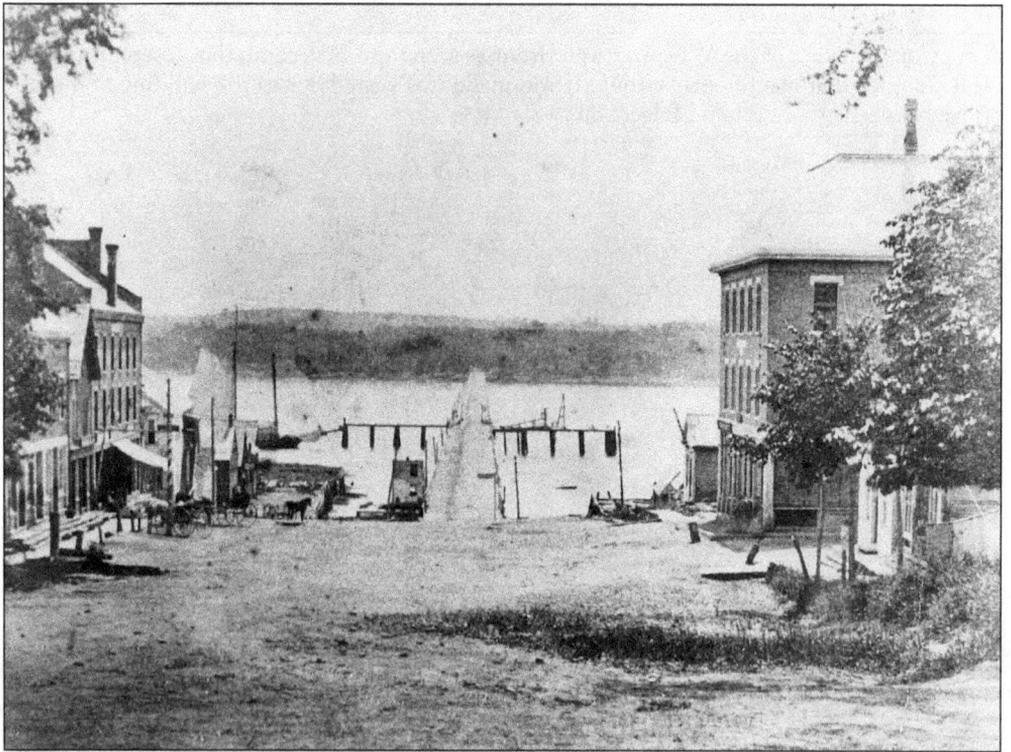

Lower Main Street with the new Rundlett Block, *c.* 1870.

16

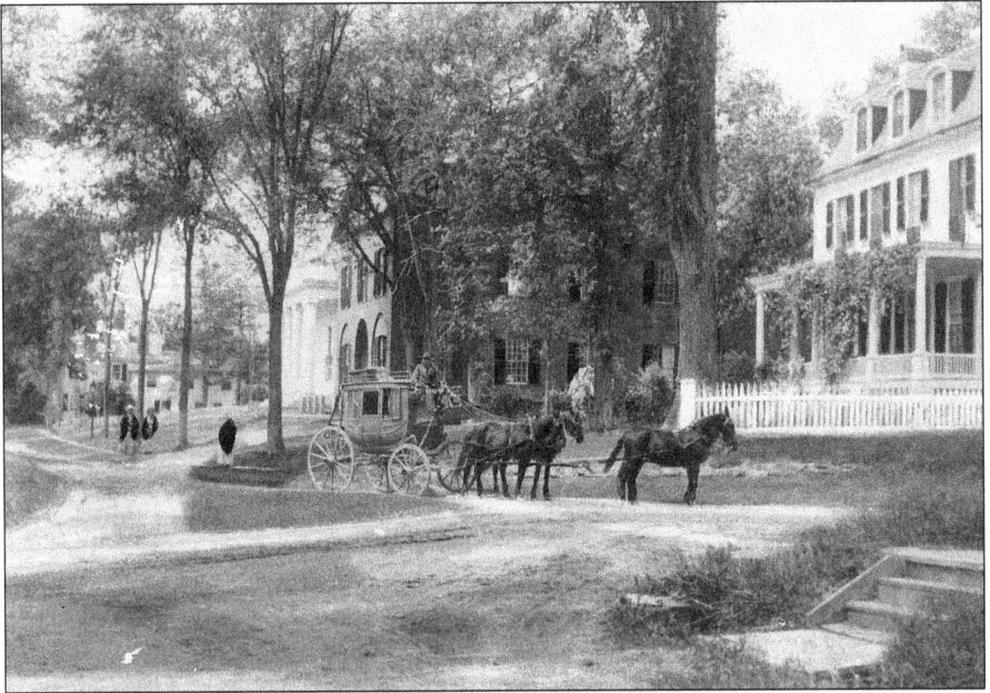
A carriage in front of the Judge Jeremiah Bailey home.

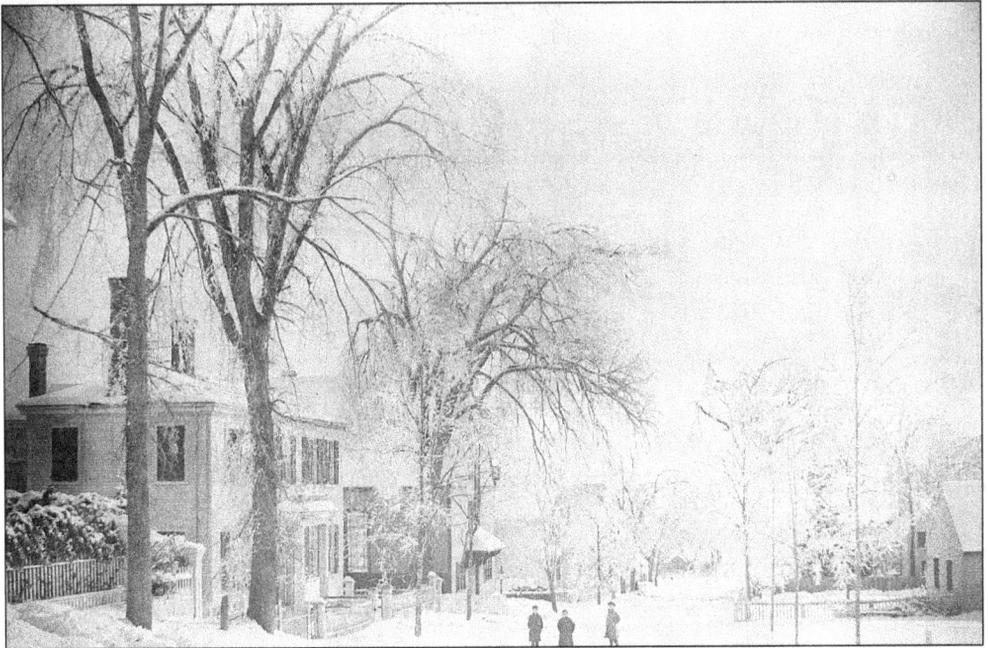
A walk on Washington Street, Wiscasset, during the winter of 1888.

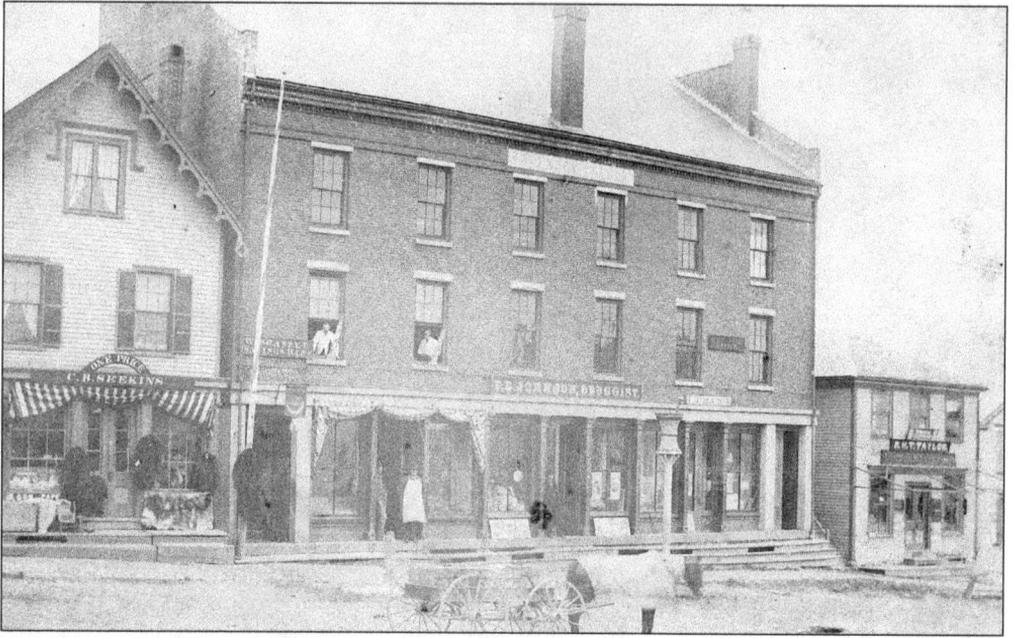

The Wawenock Block, Wiscasset, *c*. 1900.

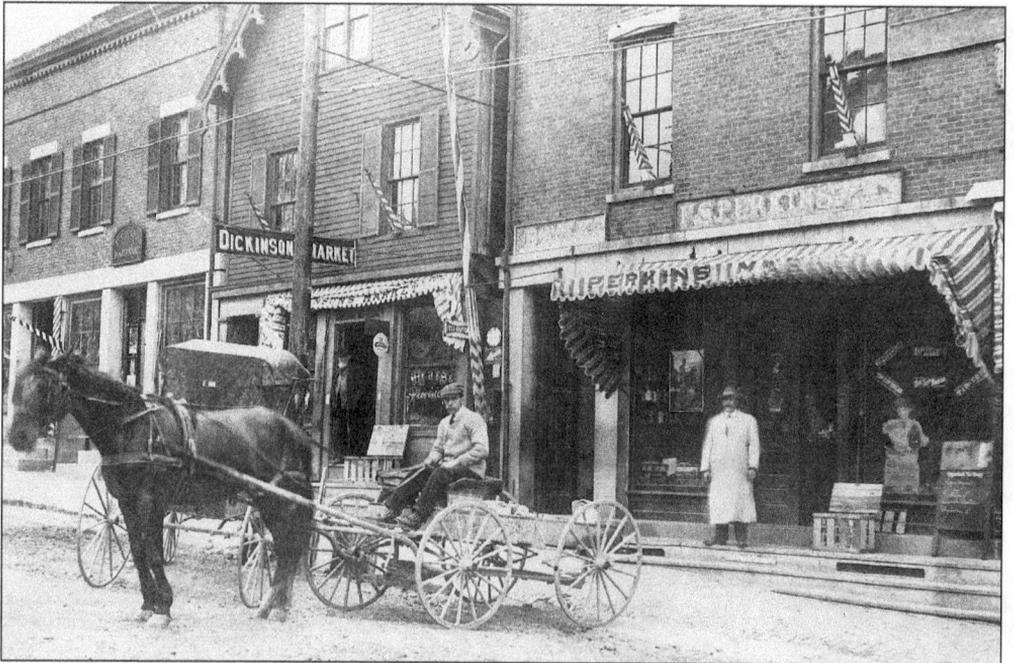

Shopping in Wiscasset at the C.I. Dickinson Market and Perkins Market, *c*. 1900.

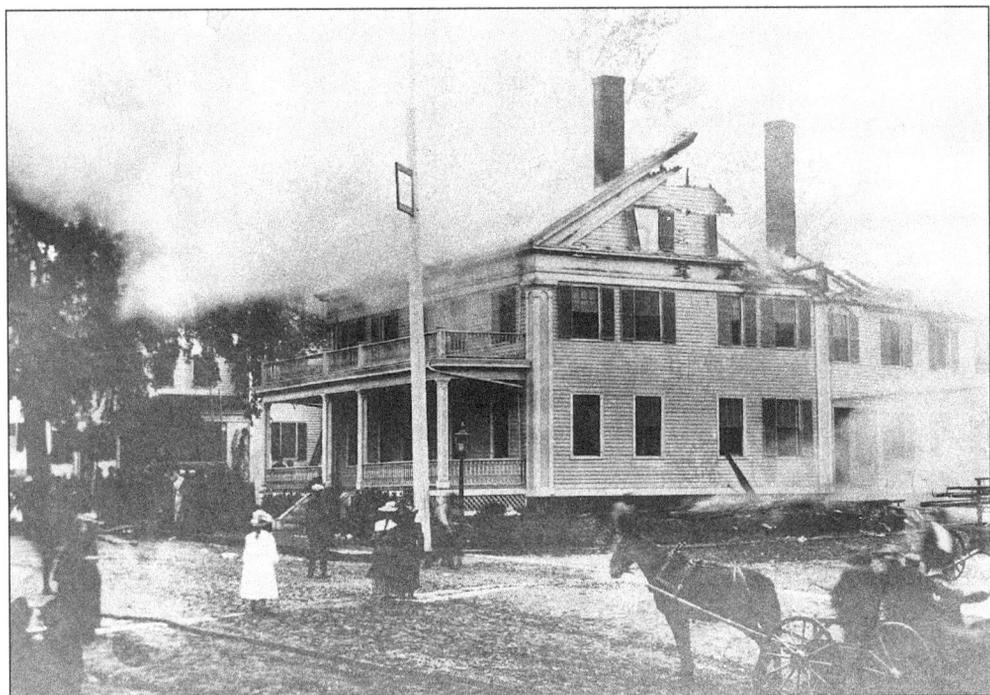

Hilton House and the Sunken Garden. The Hilton House on Main Street in Wiscasset burned to the ground on October 8, 1903. Its foundation has been recycled into the present Sunken Garden for the enjoyment of all.

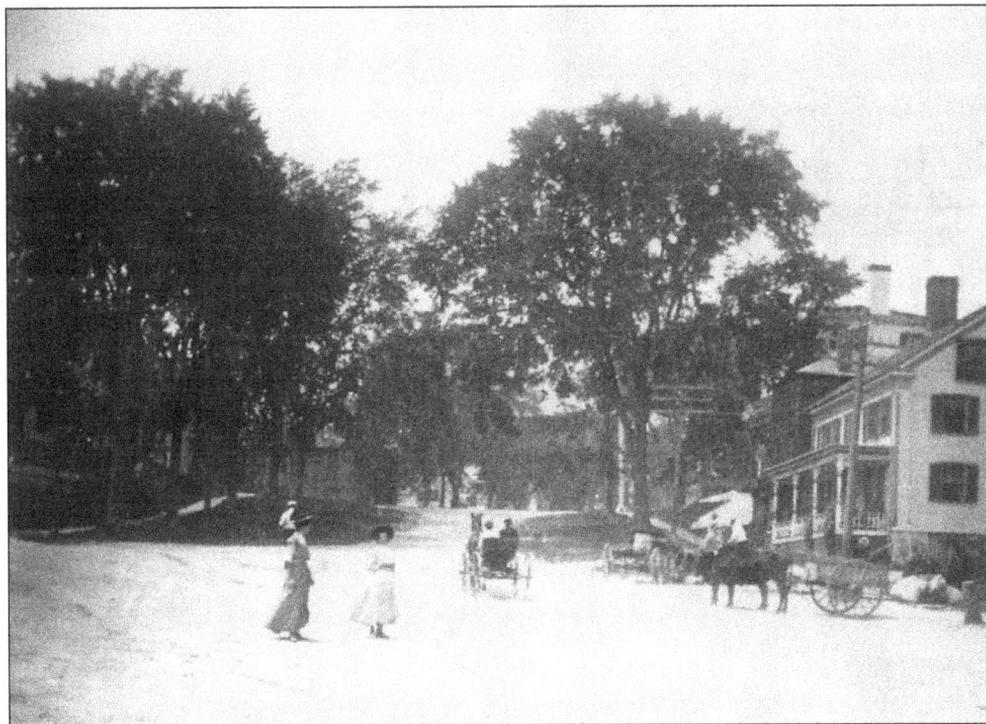

Upper Main Street, Wiscasset, in the summer of 1906.

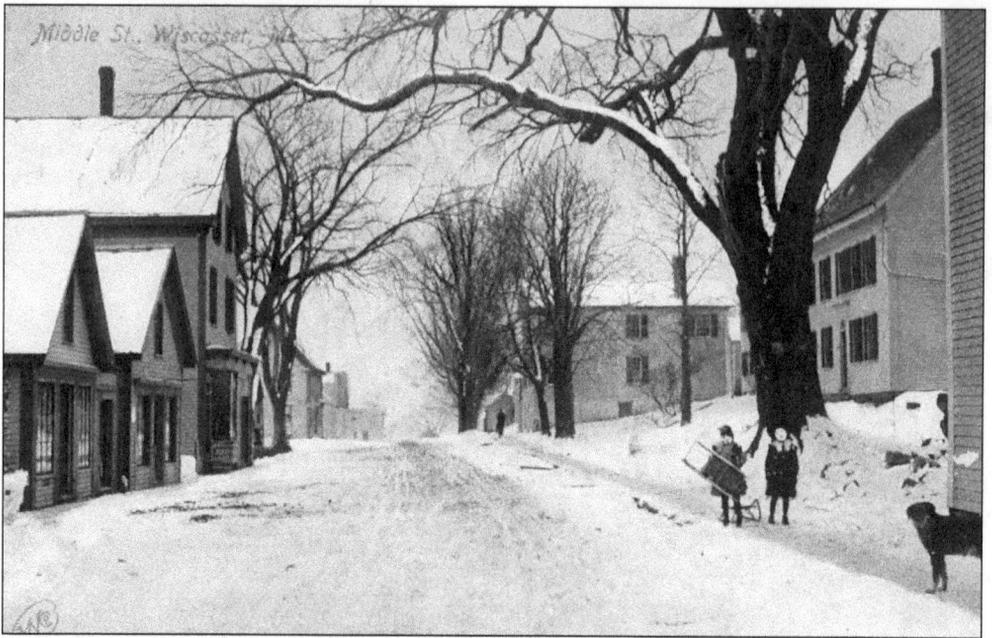

Sledding during the winter of 1905.

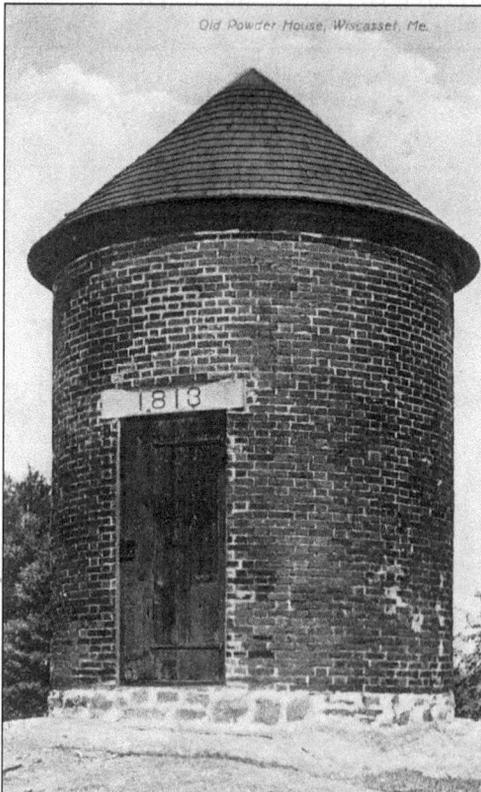

The historic 1813 Powder House in a *c*. 1910 photograph.

The tollhouse on the Wiscasset Bridge, *c*. 1910.

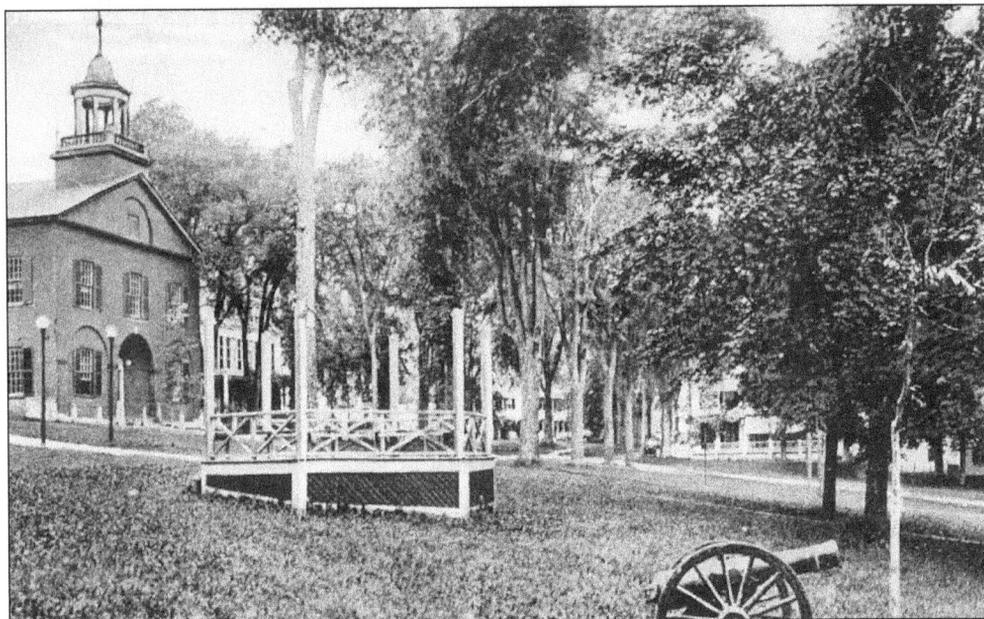

The Wiscasset Common, *c*. 1910. The old town cannon shown in the foreground was purchased at the beginning of the Civil War. It was restored in 1971 by Robert J. Minihan.

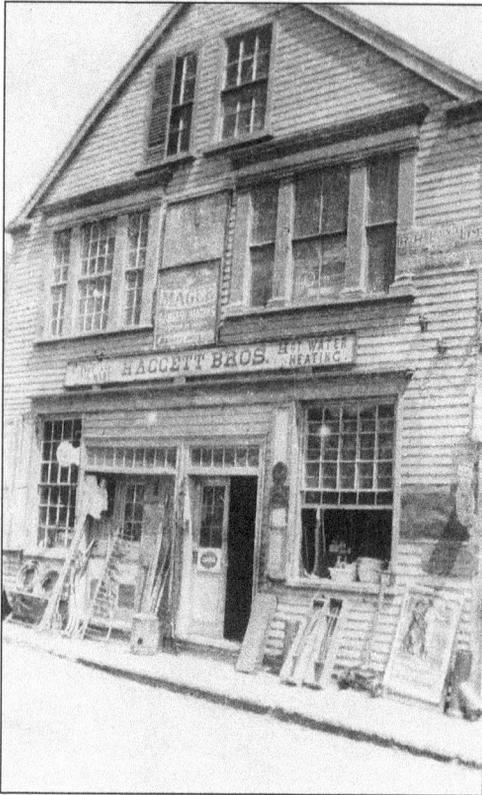

Haggett Brothers Hardware Store on Water Street, Wiscasset, *c.* 1917. Now the Wiscasset Hardware Store, the building serves the same purpose today.

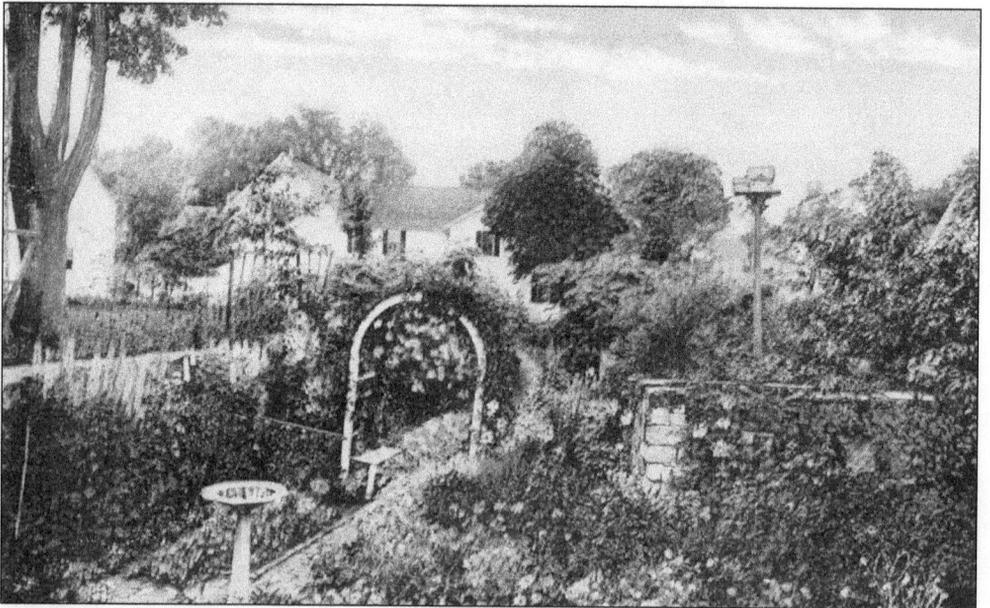

The Sunken Garden, *c.* 1920. This source of beauty is a result of the fire that destroyed the Hilton House in 1903.

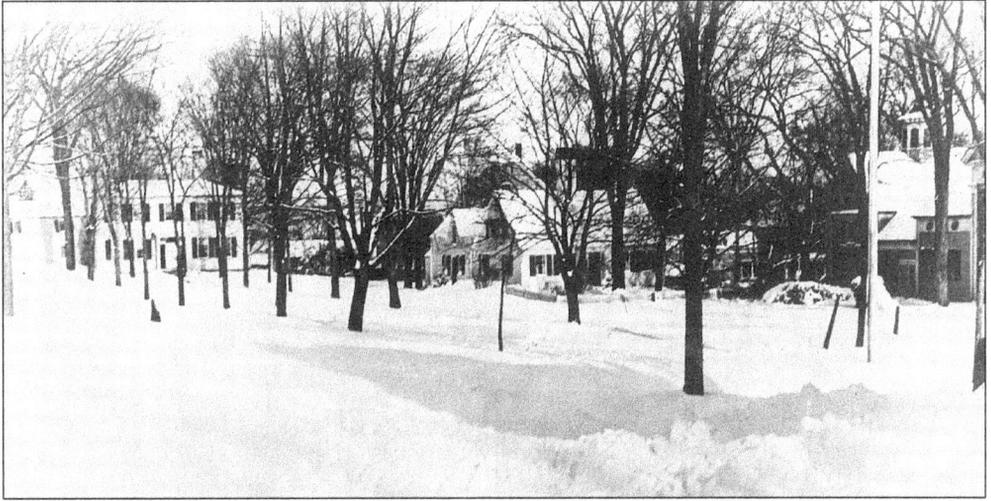

The Neal House, Lilac Cottage, and Dr. Bailey's house during the winter of 1923.

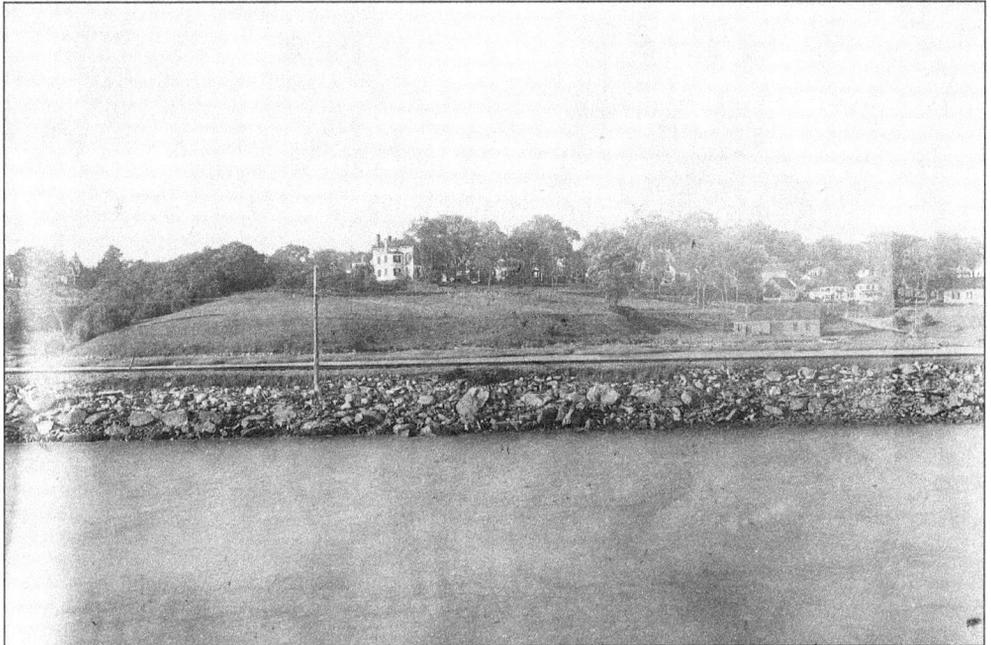

Castle Tucker as seen from the waterfront, c. 1938.

The old water tower on Main Street, Wiscasset. The tower was torn down during the 1940s.

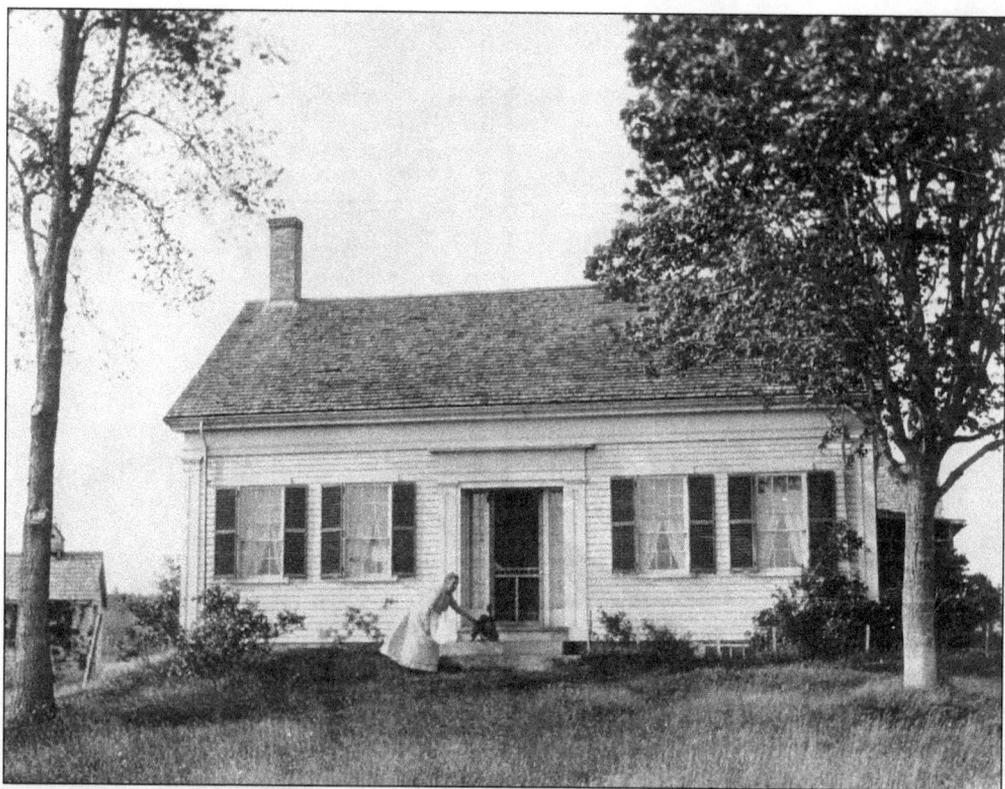

Mary Powell Chisam Tarbox patting her pet dog. The two are in front of the James Loring Tarbox homestead in Westport during the summer of 1915. Mary was the daughter of Captain James Chisam.

24

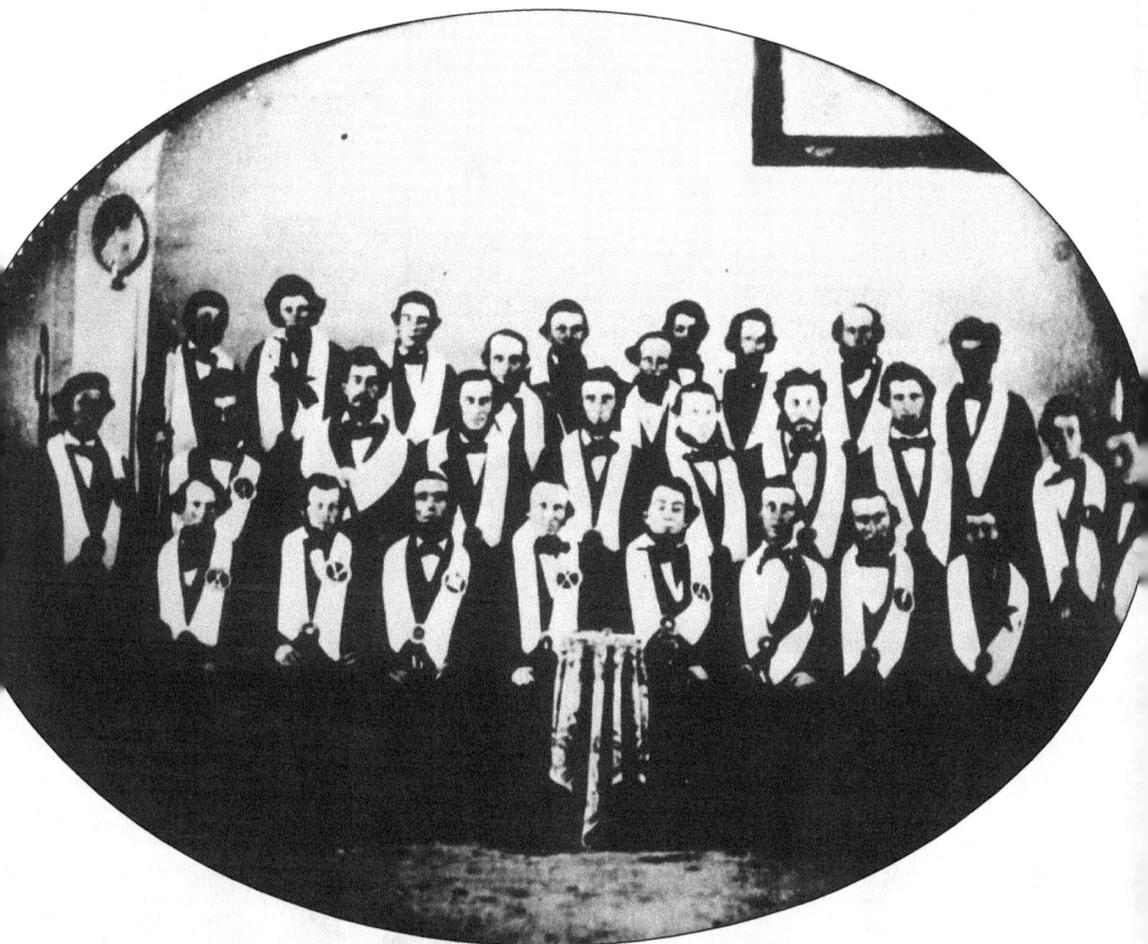

The "Knights of Temperance." This group met during the 1860s in a small building opposite the Squire Tarbox House. The building was used by Valentine Tarbox as his photographic studio. Two people have been identified as members of this ancient organization: James Shattuck Knight (front row, third from the left) and James H. Tarbox (back row, far left).

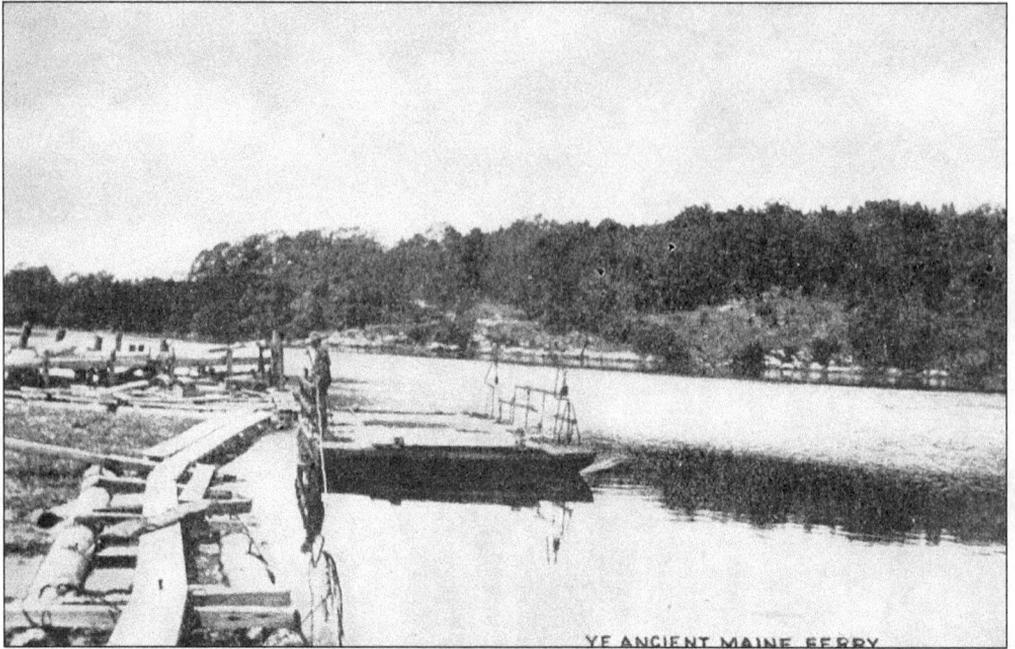

The Westport-Wiscasset Ferry. This important mode of transportation in the region was established in 1899 and remained in operation until 1950. It could carry a maximum of three cars per trip.

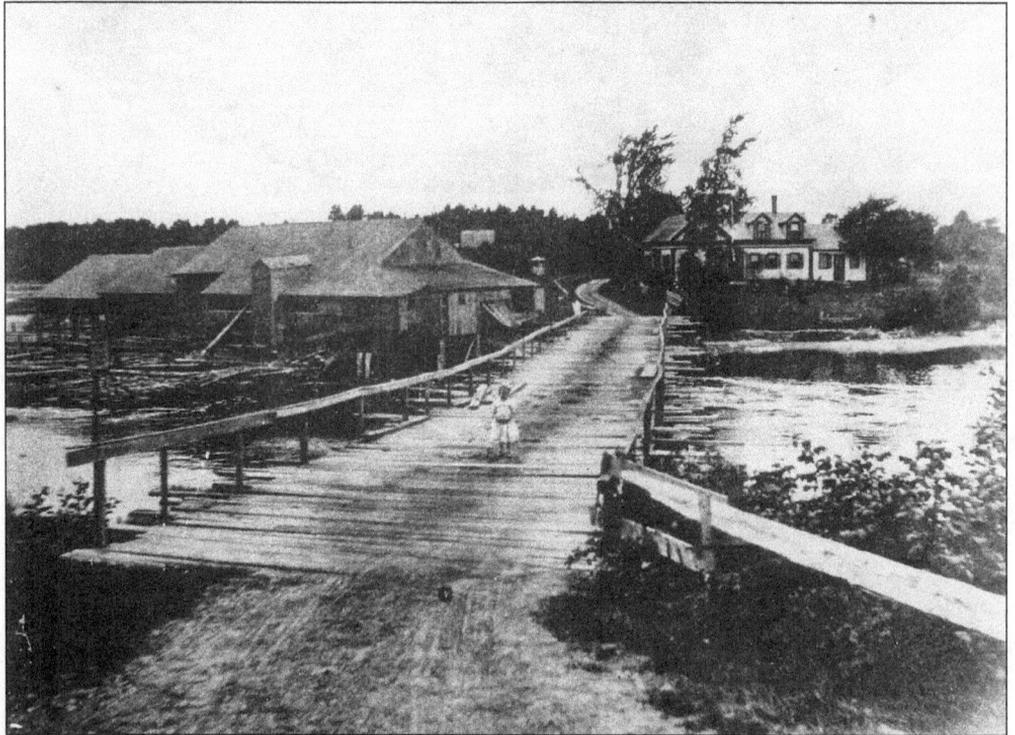

The Shattuck-Heal Mill, Westport Island, c. 1890. The Heal House can be seen in the background.

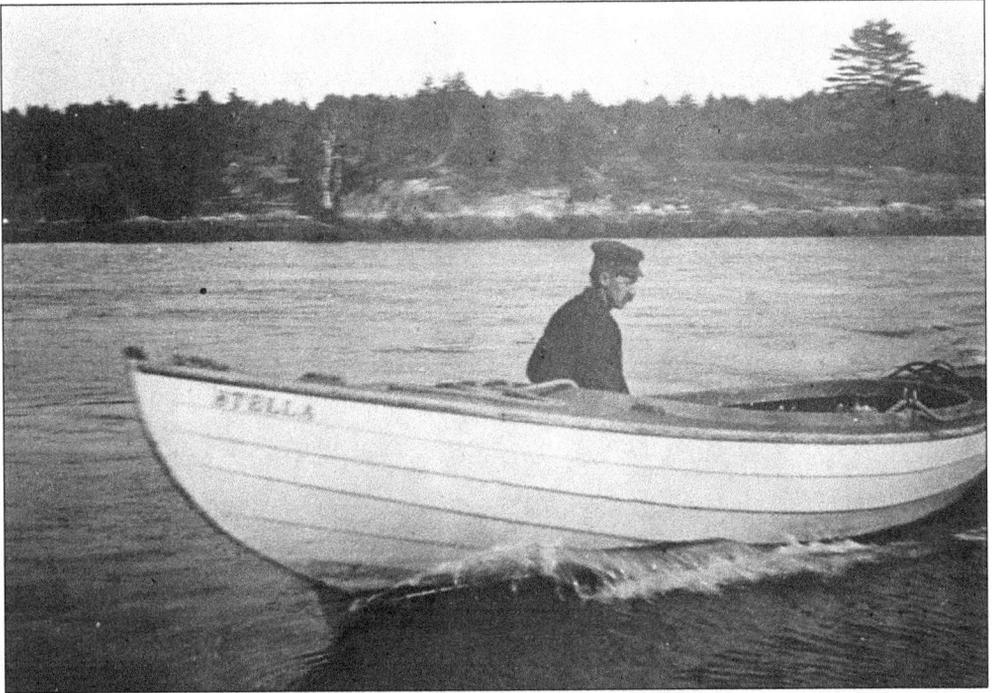

Frank Thomas of Westport out in his boat, 1920s.

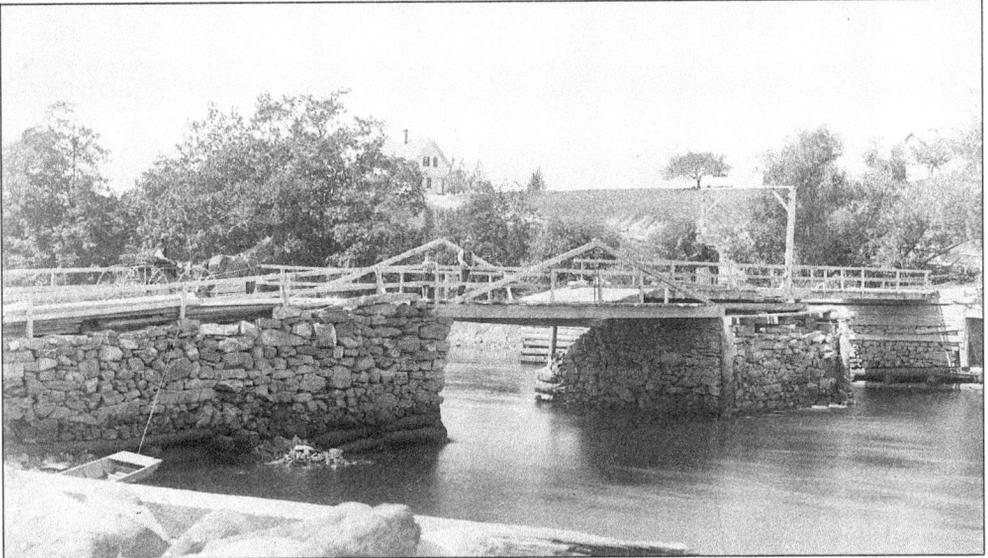

The Middle Bridge spanning the Eastern River, Dresden, 1880s.

Looking southeast down the Eastern River, Dresden, 1880s.

The Dresden shore front, 1880s.

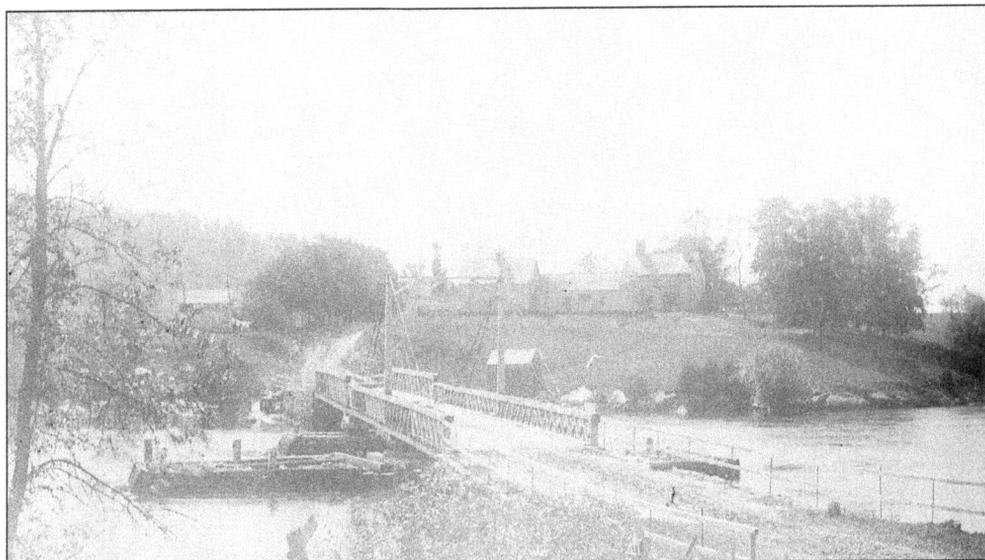
The old Patterson homestead, Dresden, 1880s.

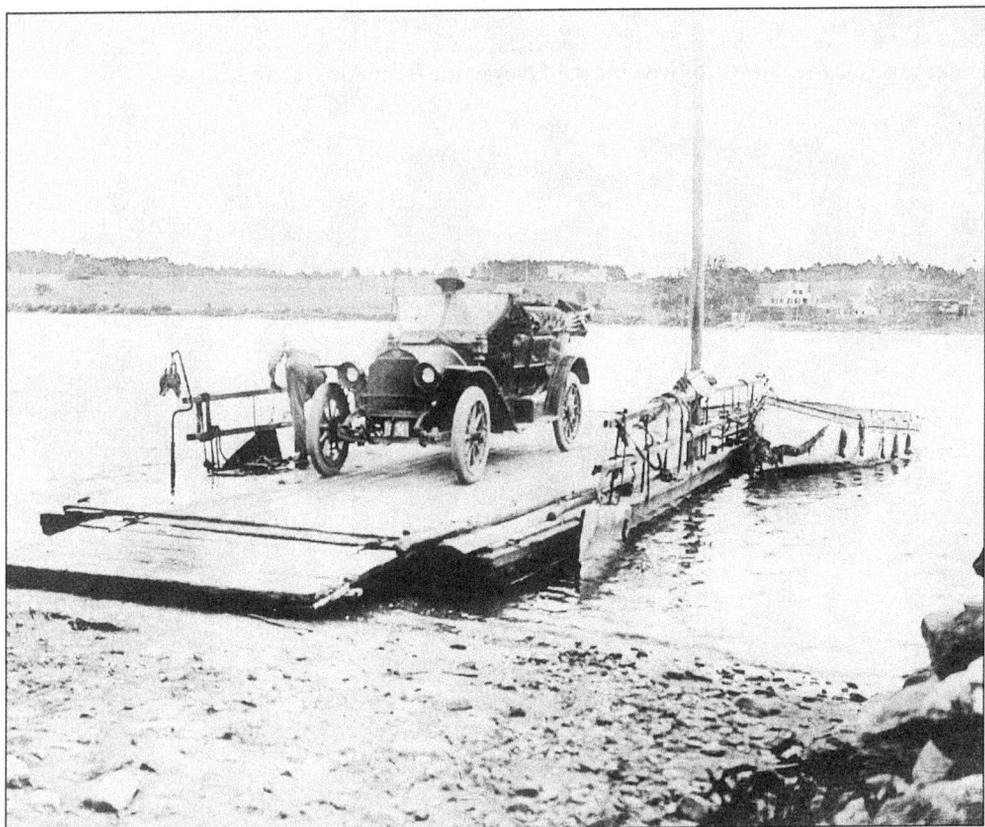
The Richmond-Dresden Ferry, 1920s.

Looking across the Sheepscot River toward Newcastle from Alna, *c.* 1890.

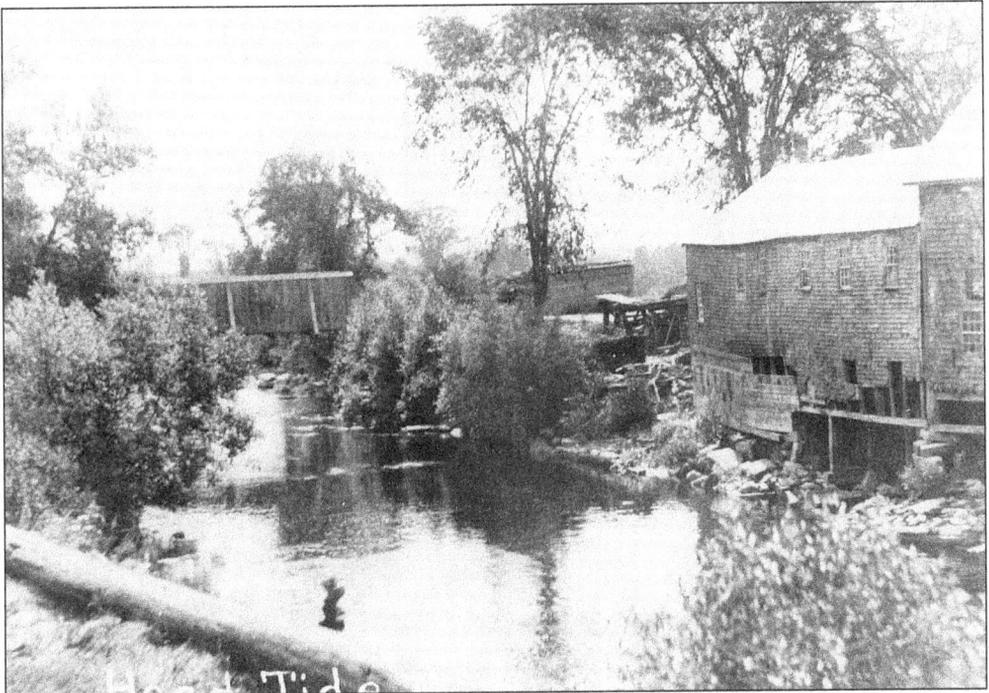

The Mill at Head Tide, *c*. 1900.

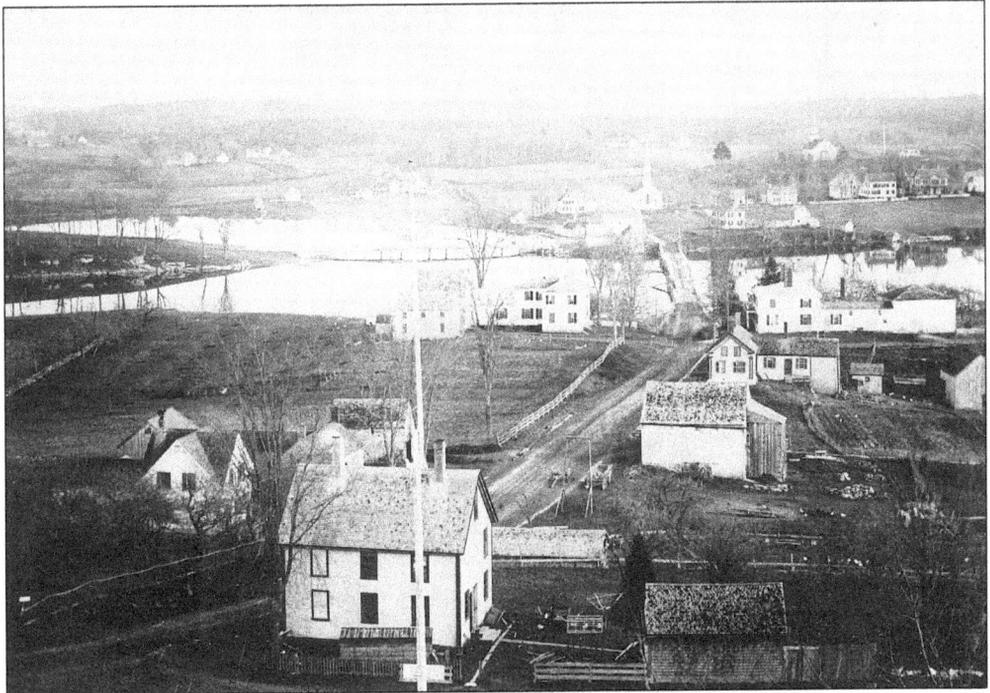

Head Tide, *c*. 1900.

Puddle Dock, Alna, looking north from the Ayers house, 1920s.

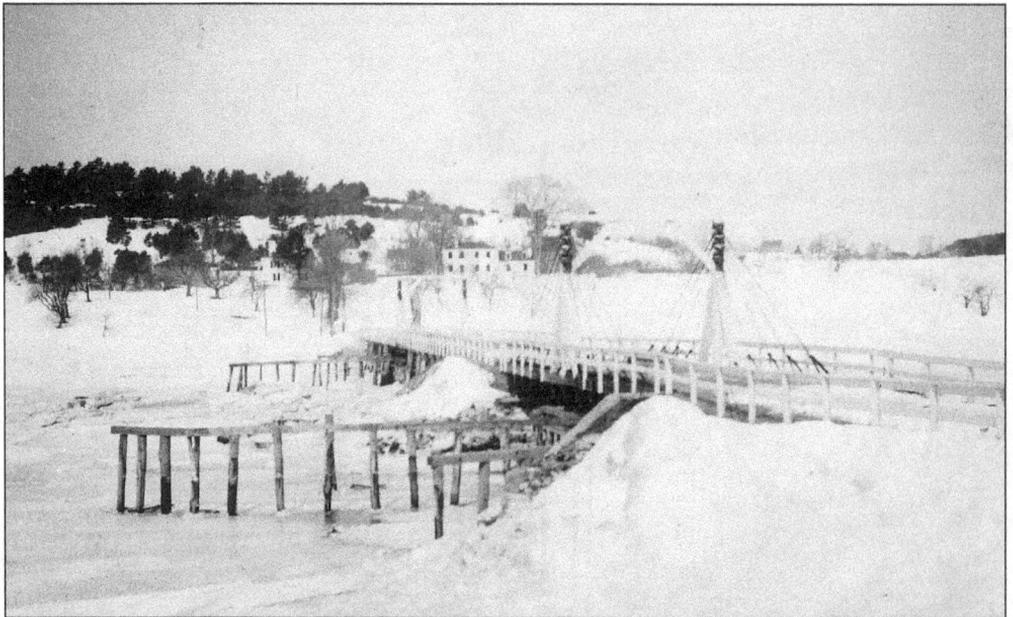
The Sheepscot Bridge looking toward Alna during the winter of 1920.

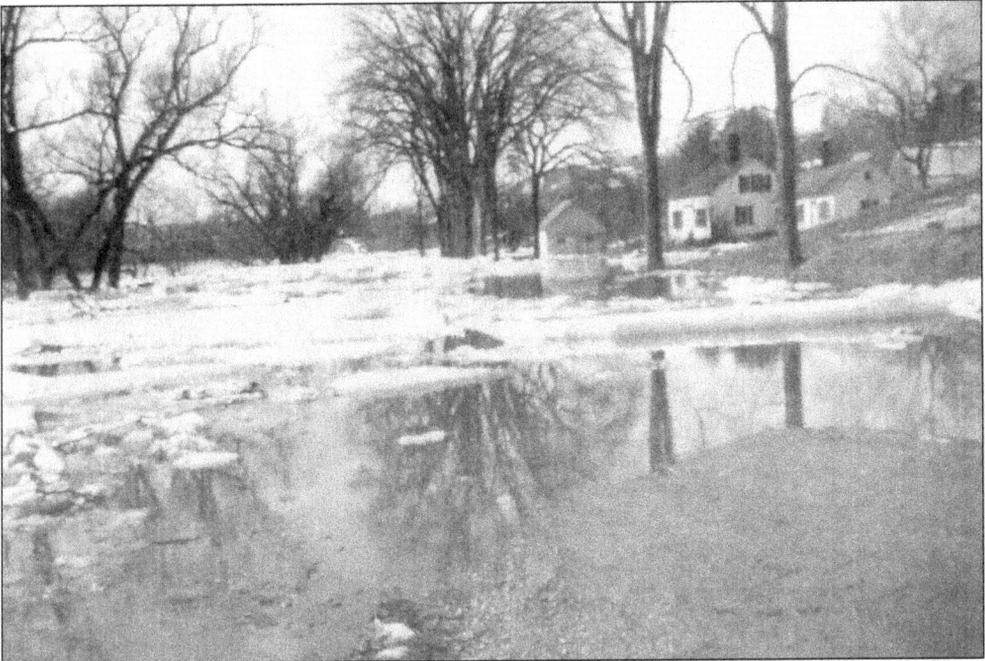

Route 194, Puddle Dock, Alna, during the 1936 flood.

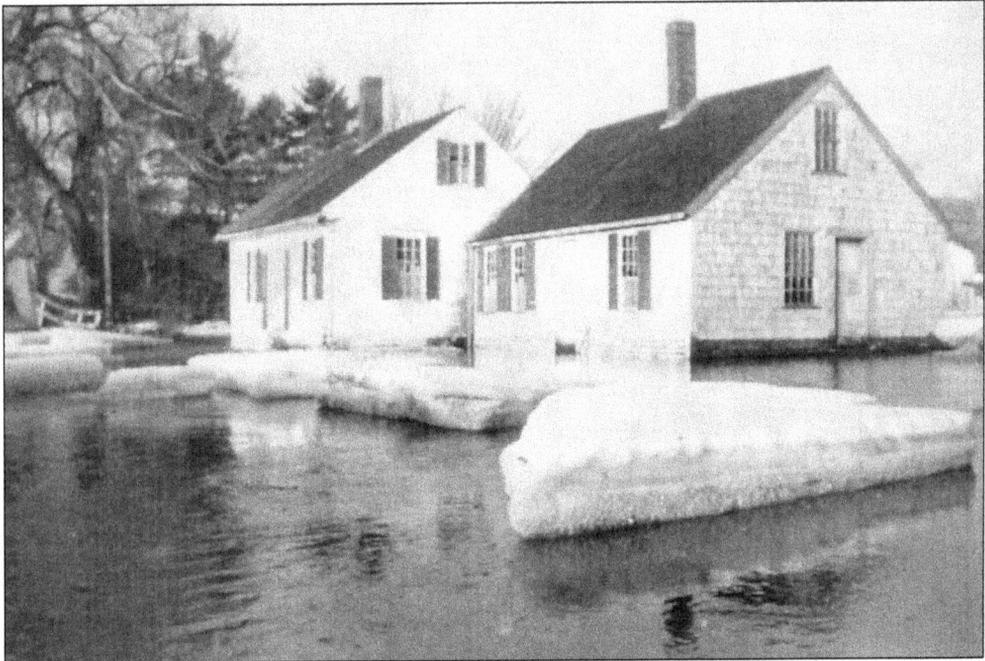

The James residence at Puddle Dock, Alna, during the 1936 flood.

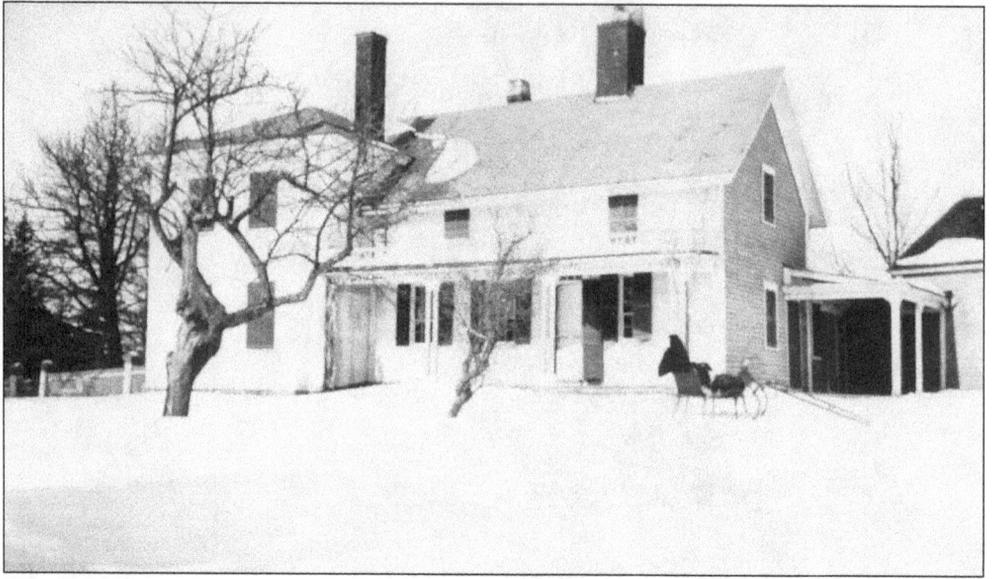
The Avarell homestead on the old Alna Road, 1930s.

The intersection of Dock Road and Route 194 in Alna, c. 1950.

Two

Profiles

The collective contributions of many talents and skills, harnessed toward a common good, are the seeds that make for a great community and society. The Wiscasset region has been blessed with men and women of vision, integrity, and dedication to the goal of making a better place for themselves, their families, their neighbors, and for those who will follow. Here we salute a few of those who have quietly inspired us and made life better for us all.

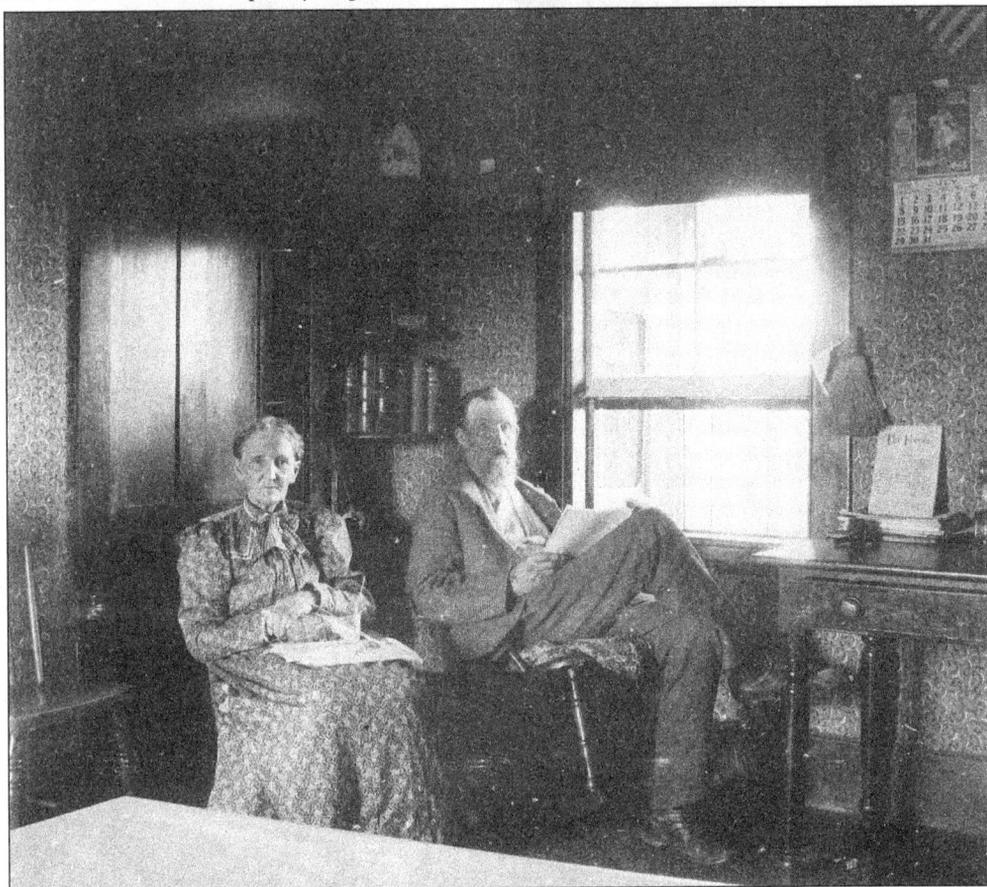

Asa and Nancy Plumstead at their Youngs Point home in Wiscasset, *c.* 1890.

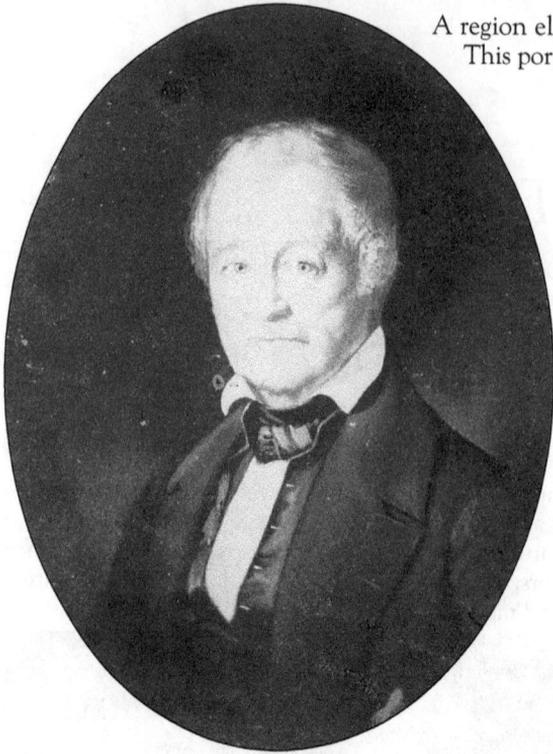

A region elder, Alexander Johnston Sr. (1780–1857). This portrait dates from 1840.

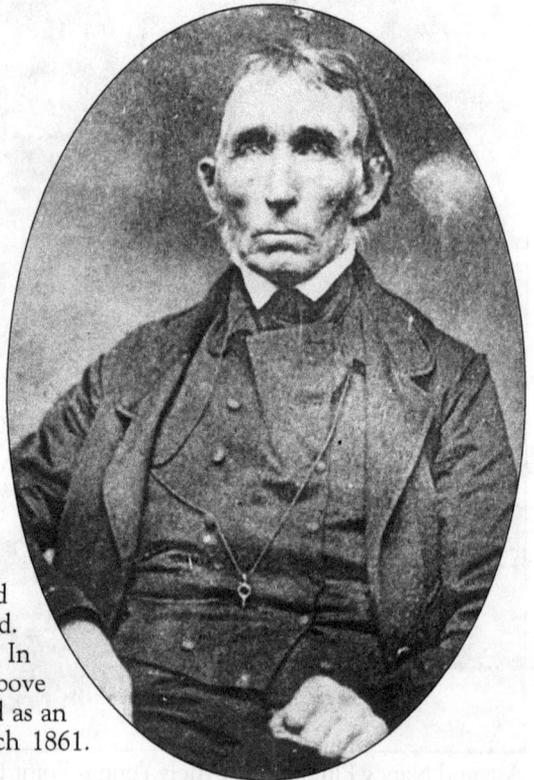

Samuel Tarbox, born February 10, 1780. By the 1820s he was the most influential and probably the richest man on Westport Island. He was always addressed as "The Squire." In 1825, he built the large home that stands above the Town Hall. His home has been operated as an inn since 1970. "The Squire" died in March 1861. This portrait dates from 1840.

Samuel Tarbox Jr. Carrying on the "The Squire's" position of influence in the Westport community, Mr. Tarbox owned and operated the Hilton Mill. This portrait was done during the 1850s.

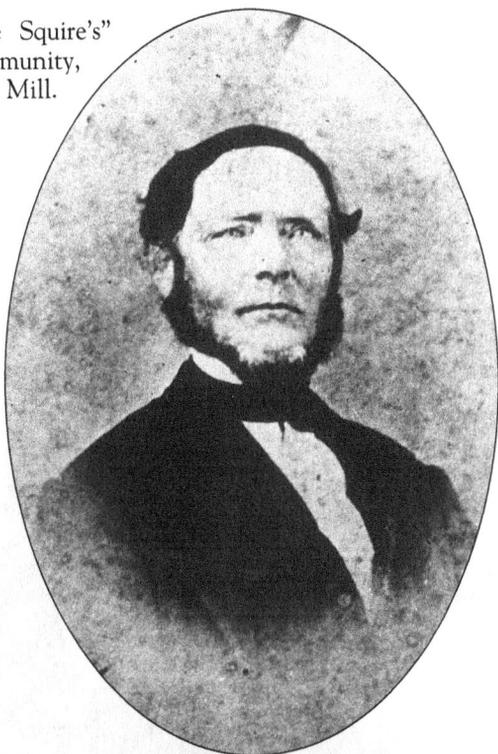

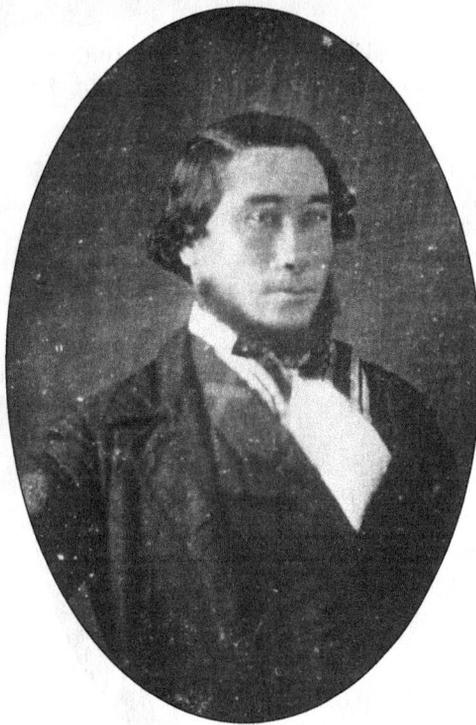

Left: Mary Anne Bray Norman Chisam, *c.* 1850.
Right: Captain James Chisam of Westport grew up on the *Neville* out of Phippsburg.

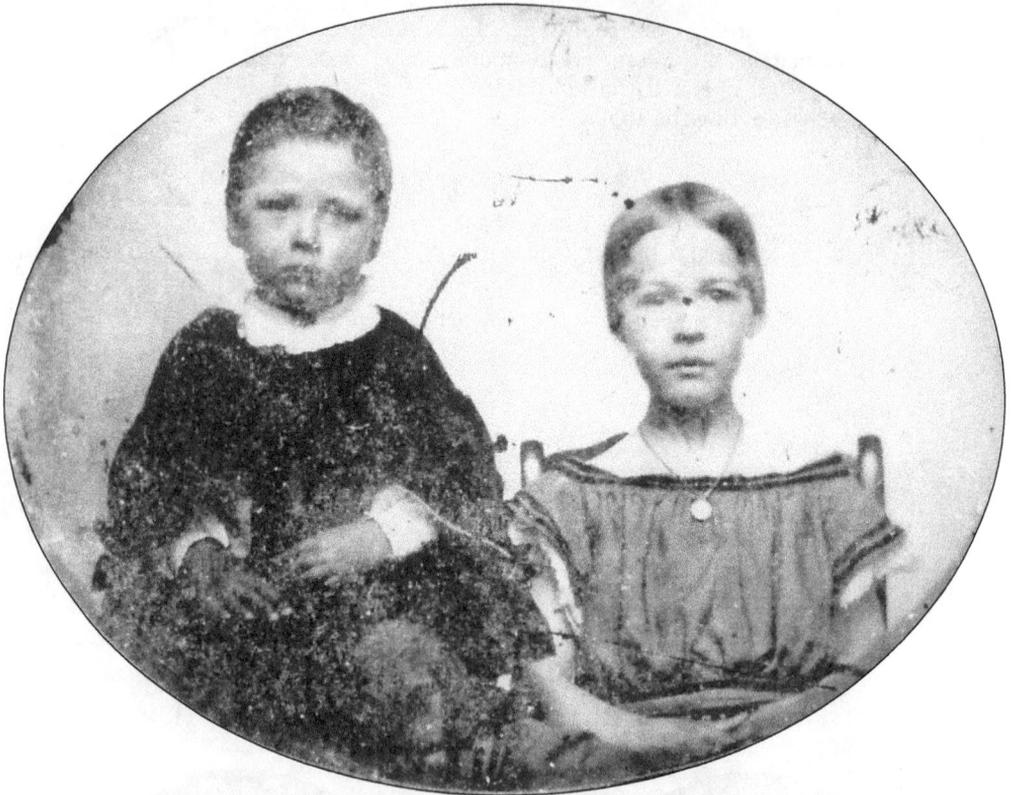

James Heal Tarbox and his sister, Annie Robbins Tarbox Jewett, 1859. Annie married Captain Lincoln Jewett of Westport. He was the skipper of the schooner *Eleanor A. Percy*.

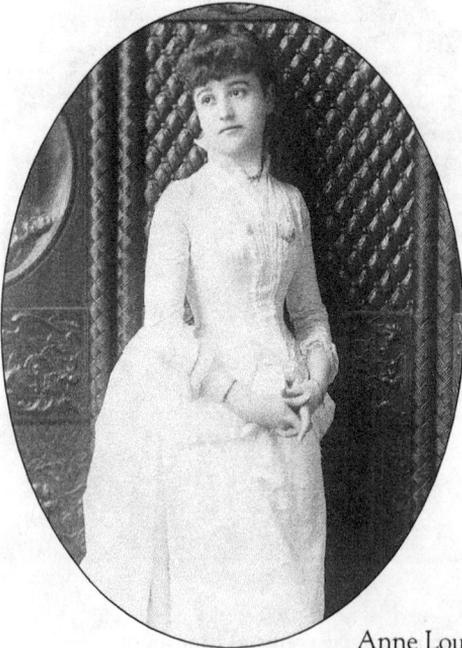

Anne Louise Wood, February 17, 1886.

Rachel Quinn of Wiscasset at age ninety-two in 1873. She died at age ninety-five in 1876.

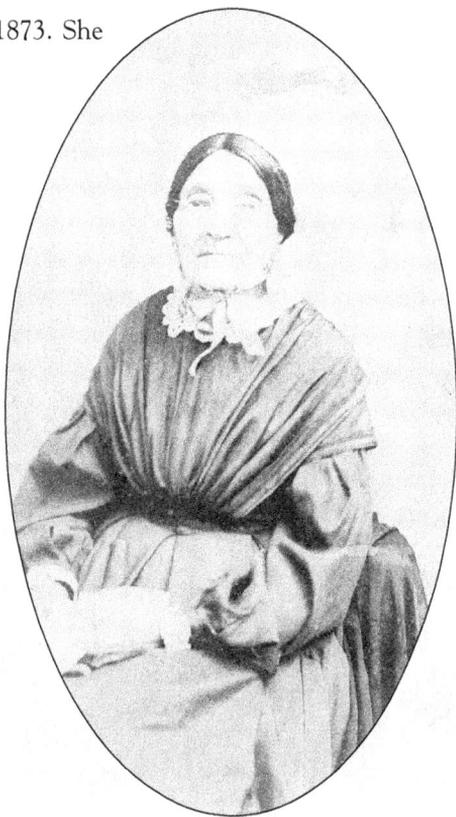

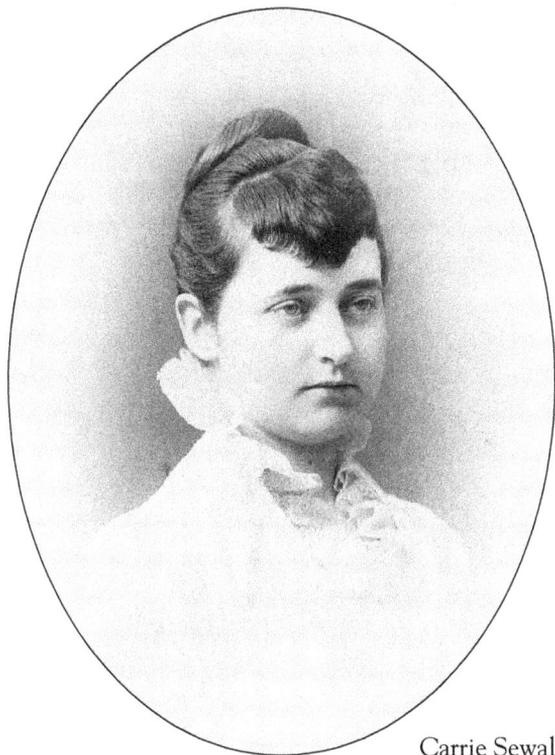

Carrie Sewall Knight, May 1889.

A mother-daughter portrait, c. 1850. Ruth Riggs Jewett Tarbox is on the left; Phebe Tarbox is on the right.

Charles Sewall of Wiscasset, June 27, 1892.

Mrs. Catherine Sargent, the matriarch of
Sargent Corners, Sheepscot, 1895.

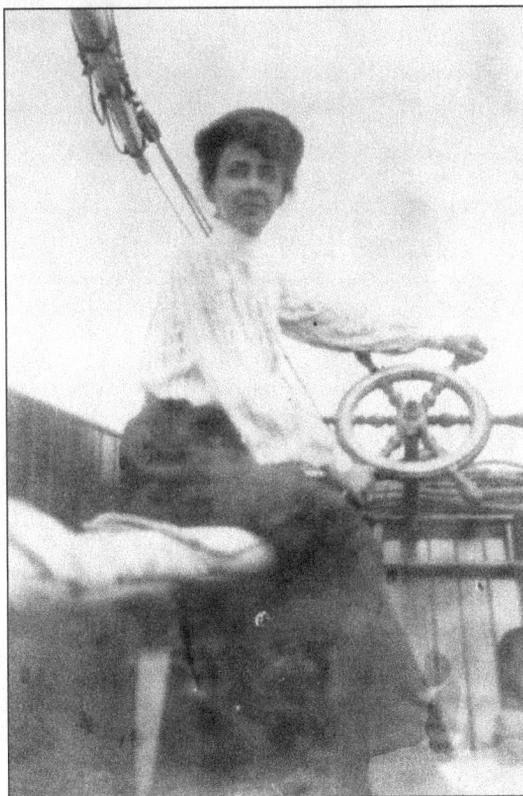

Helen Lennox at the helm, c. 1910.

Miss Jane Tucker, one of Wiscasset's most influential citizens. She carried on the civic tradition of Captain Richard Holbrook Tucker for many years.

Miss Francis Plumstead, a dedicated and well-loved Wiscasset teacher, *c.* 1910.

Arnold Haggett of Wiscasset, *c.* 1915.

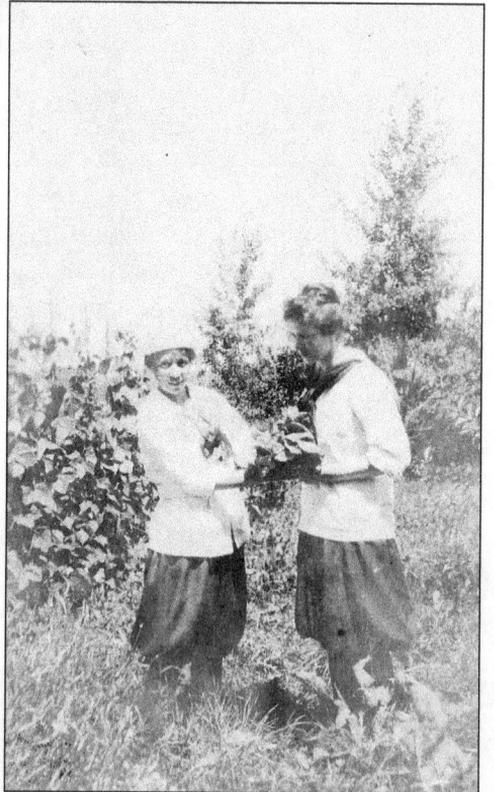

Blanche and Francis Plumstead.

44

Three

Great Homes and Public Buildings

Great men and women of wealth and vision have always desired to capture their era through their homes and lifestyles and by influencing their government to enrich community life with fine public buildings.

The Prettiest Village
... in MAINE ...
WISCASSET

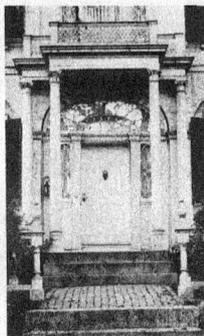

W ISCASSET is a delightful old seaport town on the Great Atlantic Highway, midway between Boston and Bar Harbor. Half hidden under lofty elms, it is a center of scenic beauty and historical interest

Information on what to see and where to stay, will be cheerfully furnished at the two Drug Stores

PUBLISHED BY THE TOWN OF WISCASSET
and the LEGION CIVIC CLUB

*In this year of 1937
the tenth annual*

WISCASSET

OPEN HOUSE DAY

will be on

Wednesday, August 11

From 11:00 A. M. to 6:00 P. M.

DAYLIGHT SAVING TIME

*M*any interesting old colonial homes and public buildings, dating from late 1700 and early 1800, will be open to visitors on this one day of the year.

TICKETS $2.00

Benefit W. V. I. S. and Library

Luncheon at noon - - - 50 cents
Tea 3 to 6 p. m. - - - 25 cents

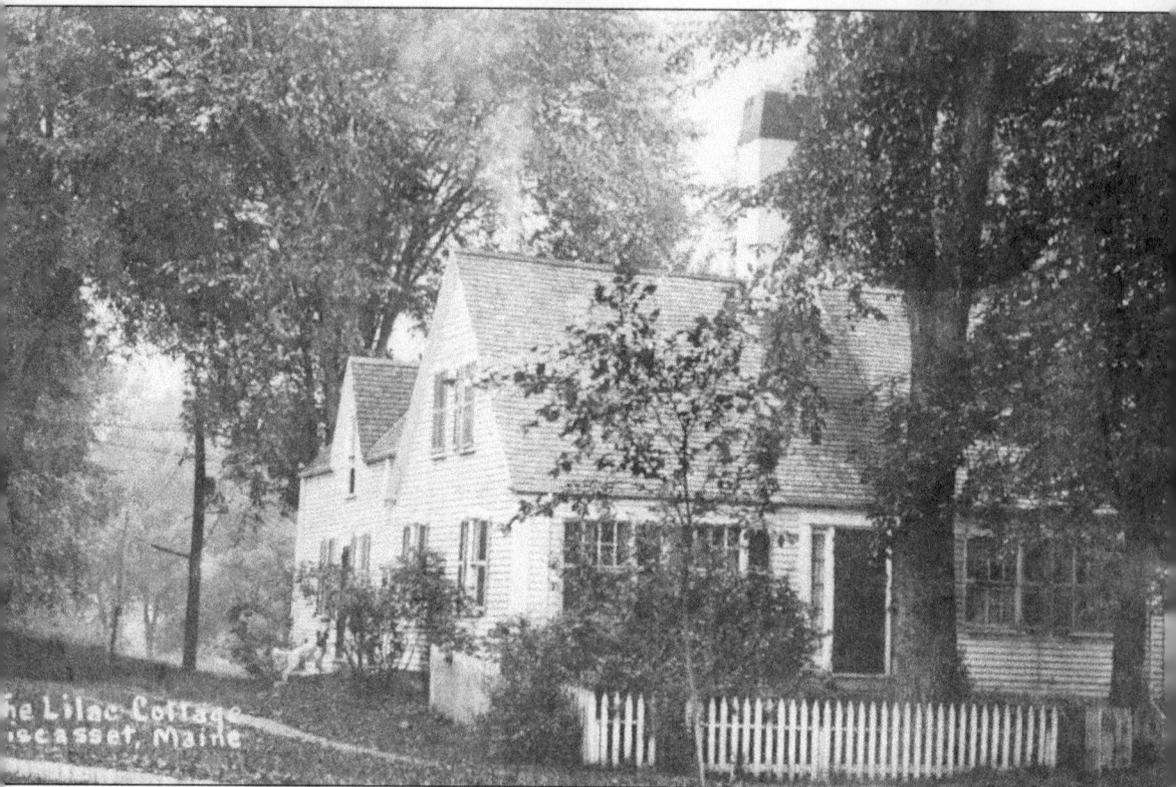

The Colby-Adams-Clapp House. This home, known throughout the region as the "Lilac Cottage," was built in 1768. In 1789, a mariner by the name of John Adams acquired the property for £50. The house fell on hard times in later years, but was rescued from ruin by Frances Sortwell during the 1920s.

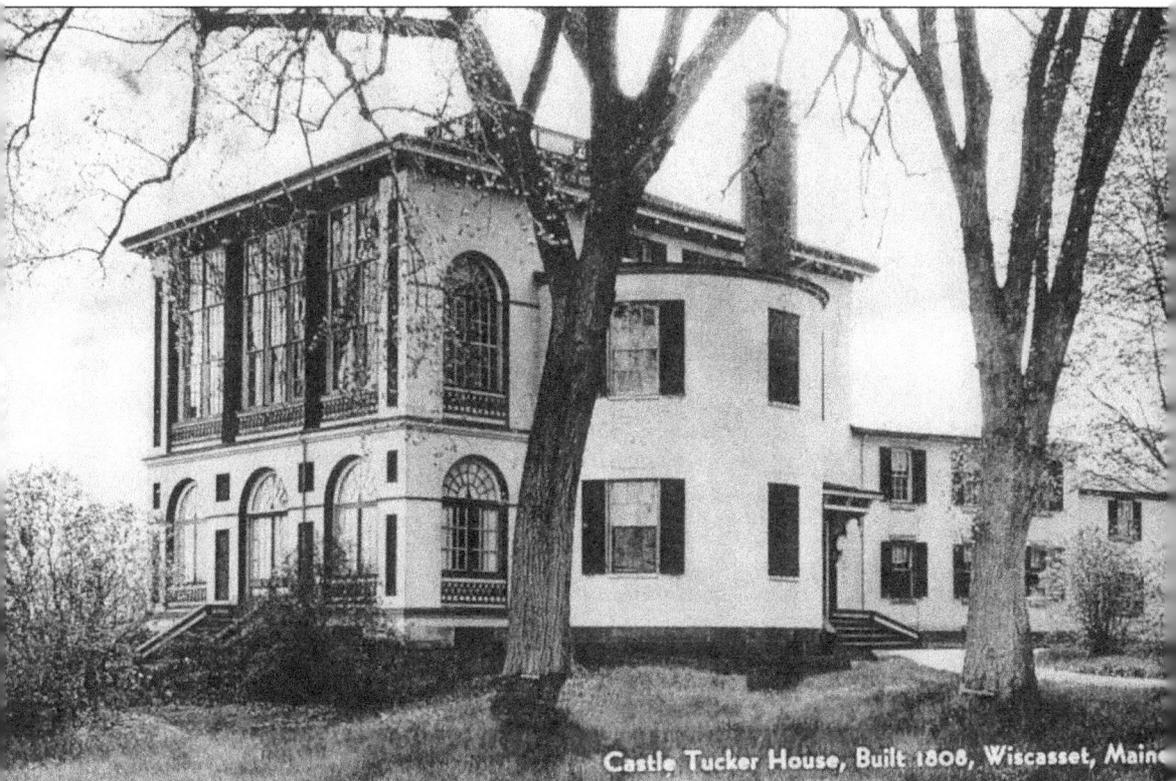

Castle Tucker House, Built 1808, Wiscasset, Maine

The Lee-Tucker House. Known locally as Castle Tucker, this abode was built in 1807 by Silas Lee, who came to practice law in Wiscasset in 1789. He was appointed to the bench a few years later, but died in 1814 of spotted fever. After a succession of owners, Captain Richard Holbrook Tucker purchased the home in 1857. He added the outbuilding and glass-enclosed gallery on the east side. This beautiful home with its Victorian furnishings is open to the public as a museum during the summer season by its descendant owner, Miss Jane Tucker.

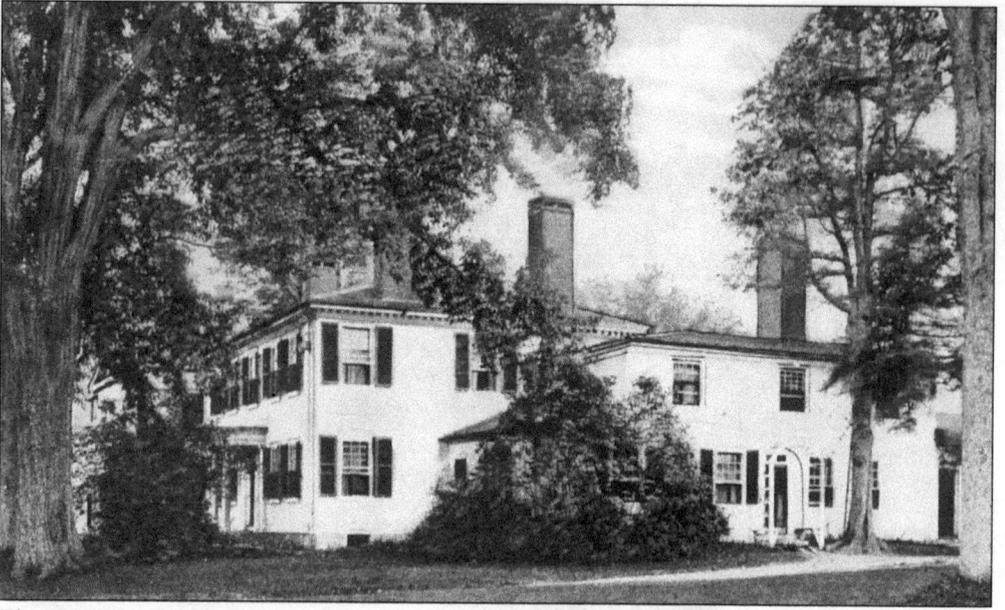

The Governor Smith House on High Street, Wiscasset, built in 1832.

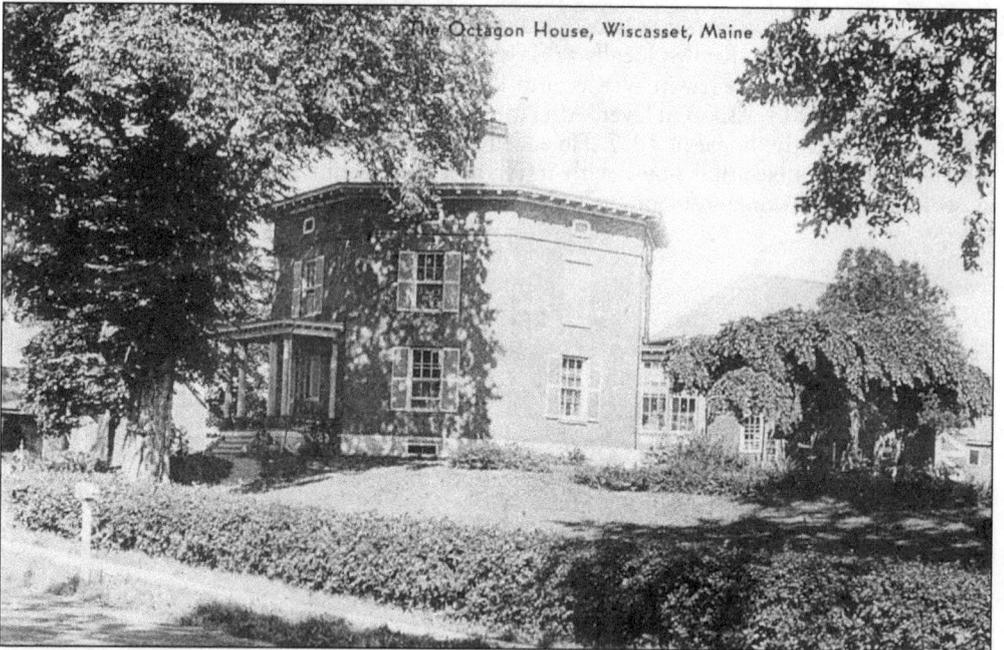

The Octagon House, built in 1885 by Captain George Scott. This unique home was designed as a state-of-the-art facility by architect Orson Fowler, who believed that an octagon provided more living space than a conventional rectangular home. Among this home's advanced features were central heating and a built-in water closet supplied by a gravity-powered cistern in the attic.

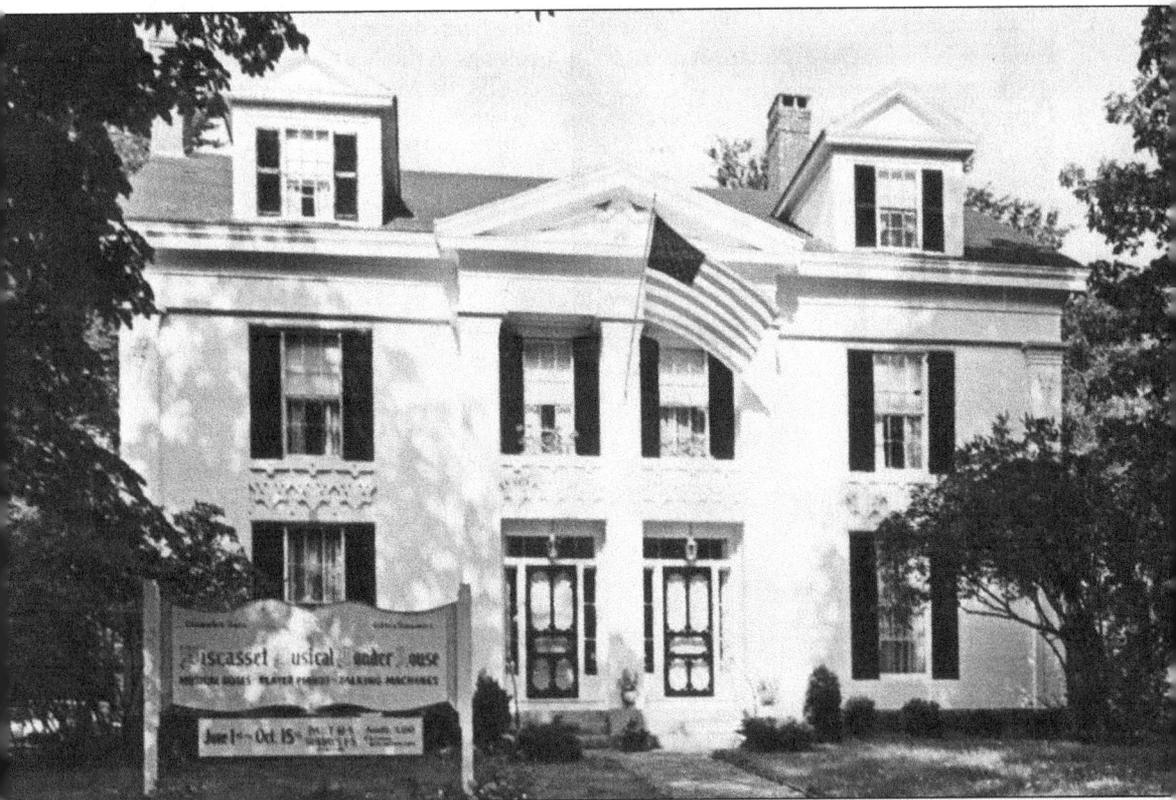

The Scott-Chase House. This duplex home was built on High Street, Wiscasset, in 1852 by Henry Clark and Captain George Wood. The property was later acquired by Captain Jonathan Scott. He and his descendants lived there until 1956. In 1963, the Konvalinka family acquired this ancient property and founded the Musical Wonder House of Wiscasset—a unique museum containing not only one of the world's finest collections of restored music boxes, but also early talking machines, phonographs, barrel organs, player pianos, and other mechanical instruments. Maestro Danilo Konvalinka provides guided tours and conducts concerts during the summer season.

49

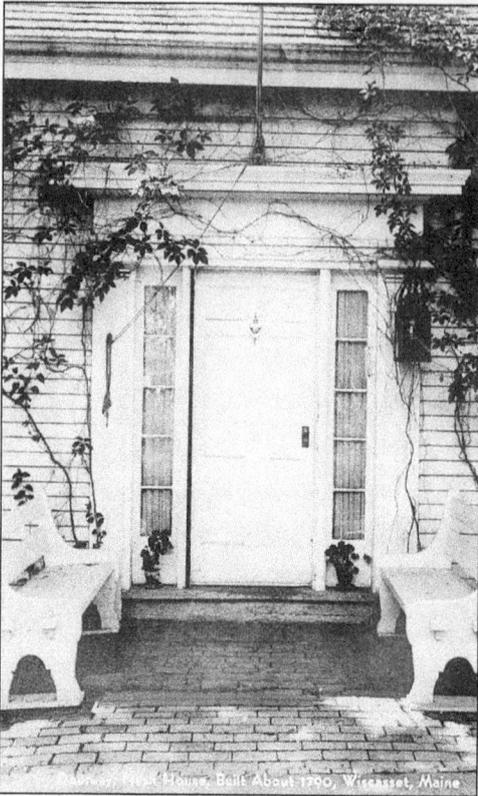

The Nash doorway. This inviting entryway belongs to the Nash House, which was built c. 1790 on Main Street, Wiscasset.

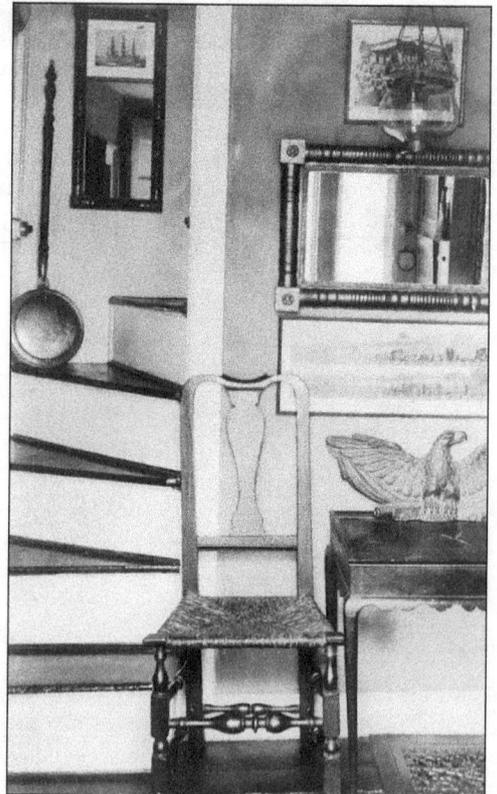

The hallway of the Nash House.

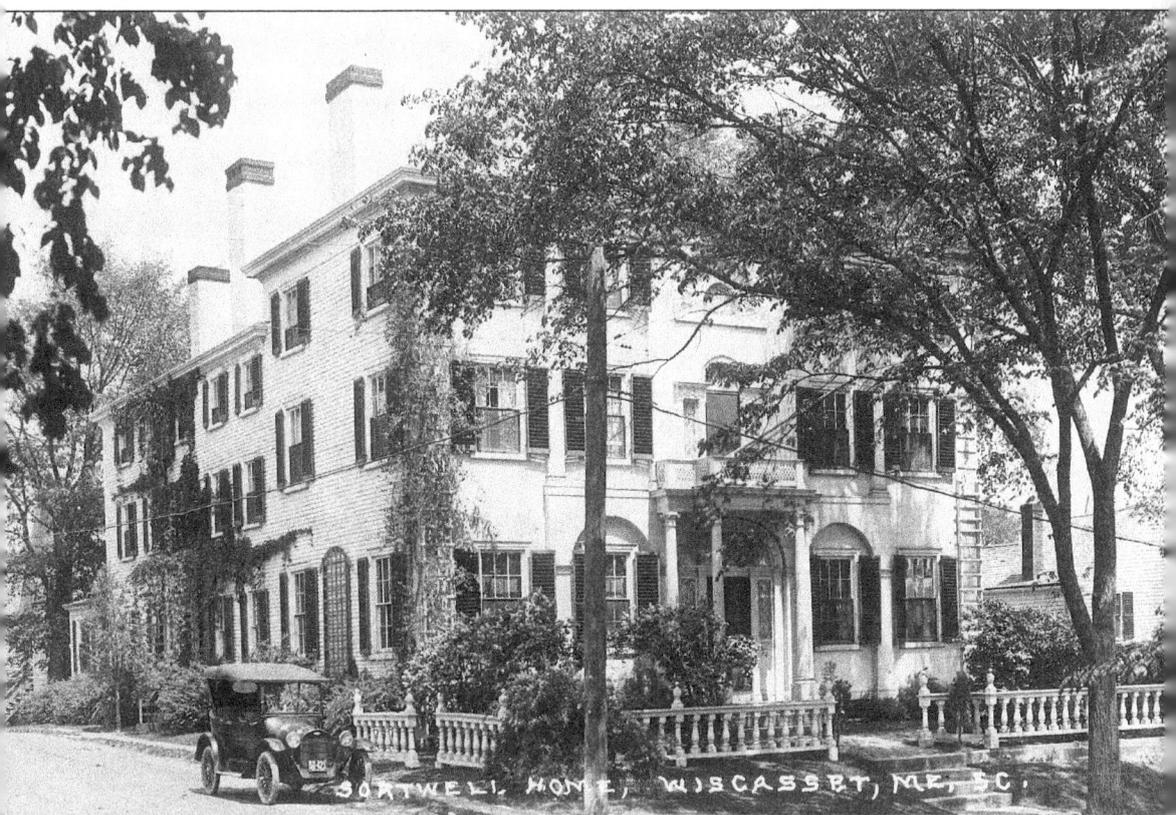

SORTWELL HOME, WISCASSET, ME, 5C.

The Nickels-Sortwell House, a Wiscasset landmark and treasure. This fine Federal-style home was built by Captain William Nickels in 1807. The captain and his young wife died shortly after their home was completed in 1812, and the building was then turned into an inn. It remained a hostelry until 1900, when it was acquired by Alvin Sortwell of Cambridge, Massachusetts. His daughter, Frances A. Sortwell, had a deep interest in preserving our rich history and she left the home and many of its furnishings to The Society for the Preservation of New England Antiquities. The house is open for public tours during the summer season.

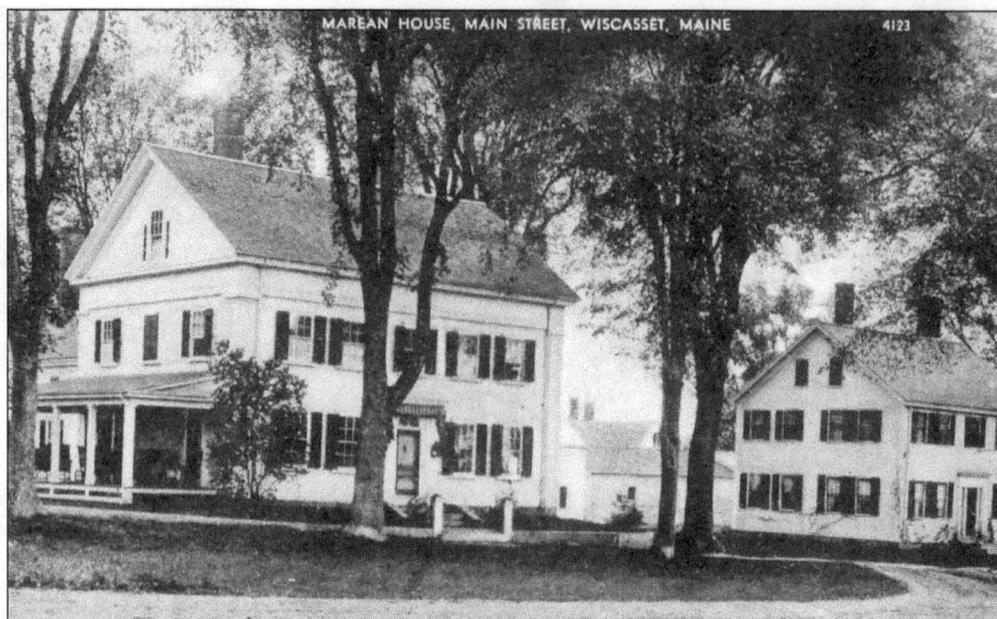

The historic Marean House on Main Street, Wiscasset.

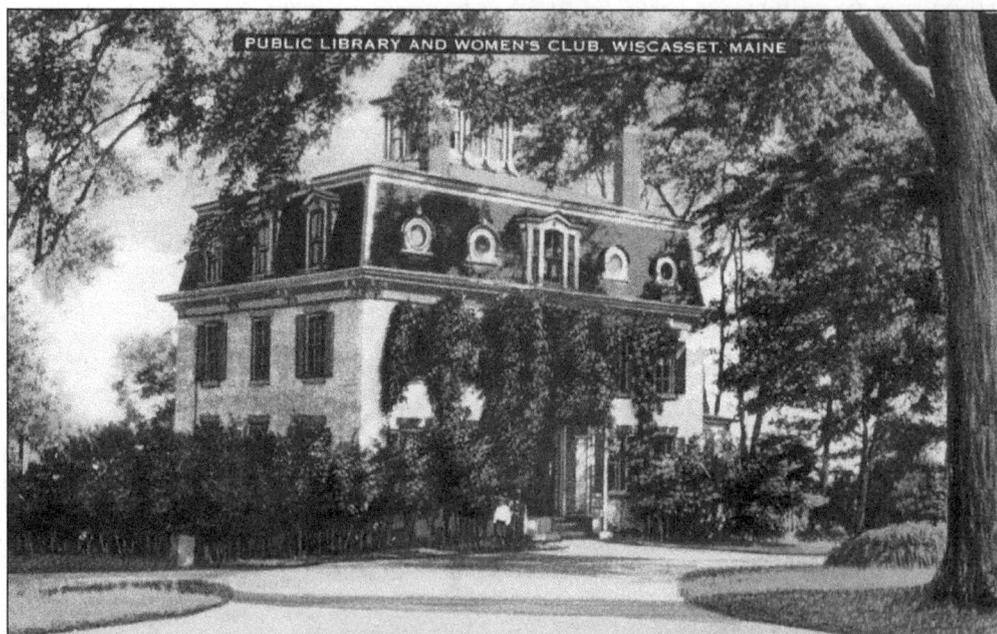

The Wiscasset Social Library and Woman's Club building. The library opened here in 1799 with a collection of some 1,300 books. During its early years, the library had its periods of ups and downs. It was physically rehabilitated during the 1930s.

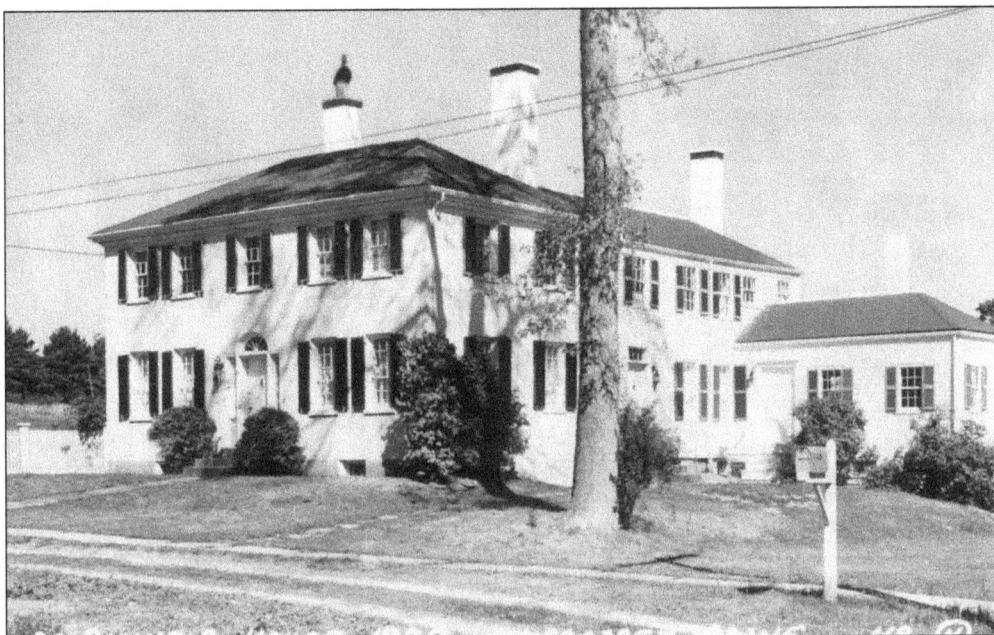

A historic home in Wiscasset, built by Dr. Samuel in 1828.

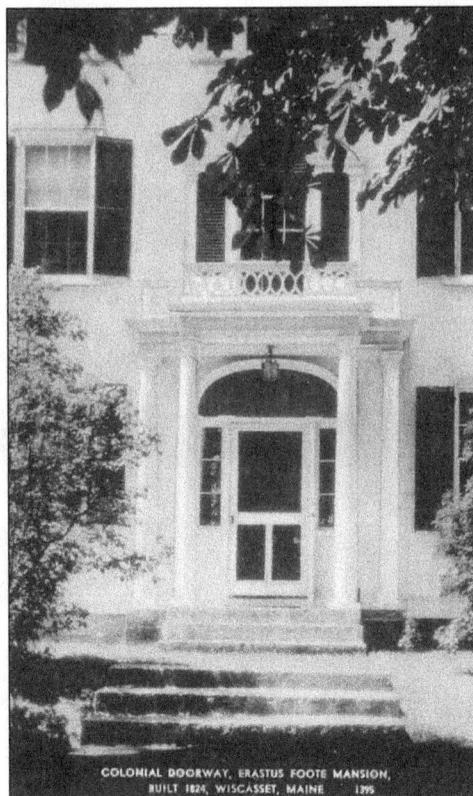

COLONIAL DOORWAY, ERASTUS FOOTE MANSION,
BUILT 1824, WISCASSET, MAINE 1395

The Wood House. This fine Federal-style home was started in 1810 for Major Abiel Wood Jr., the son of General Abiel Wood. Construction was not completed until some fourteen years later, due to interruption by the War of 1812. In 1908, the house was acquired by Erastus Foote Jr.

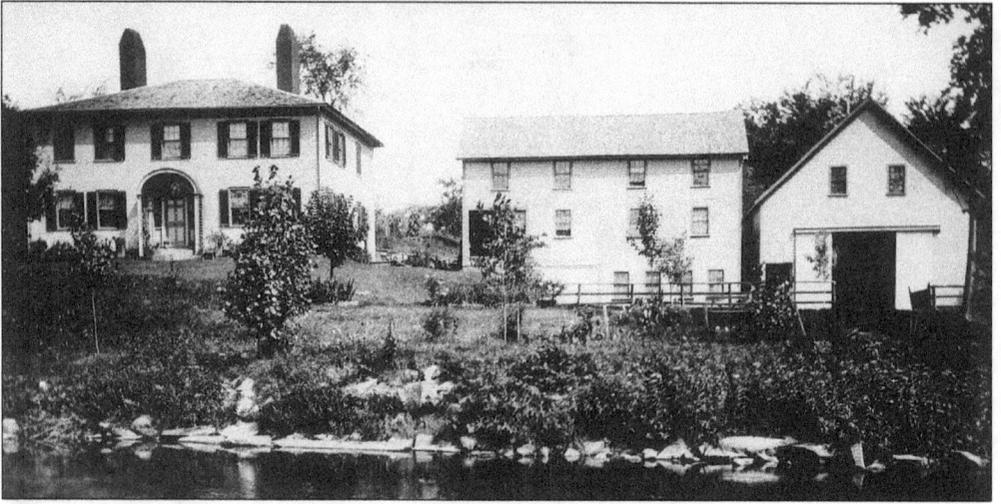

A historic home in Head Tide. This photograph was taken *c*. 1900.

A Head Tide homestead, *c*. 1900.

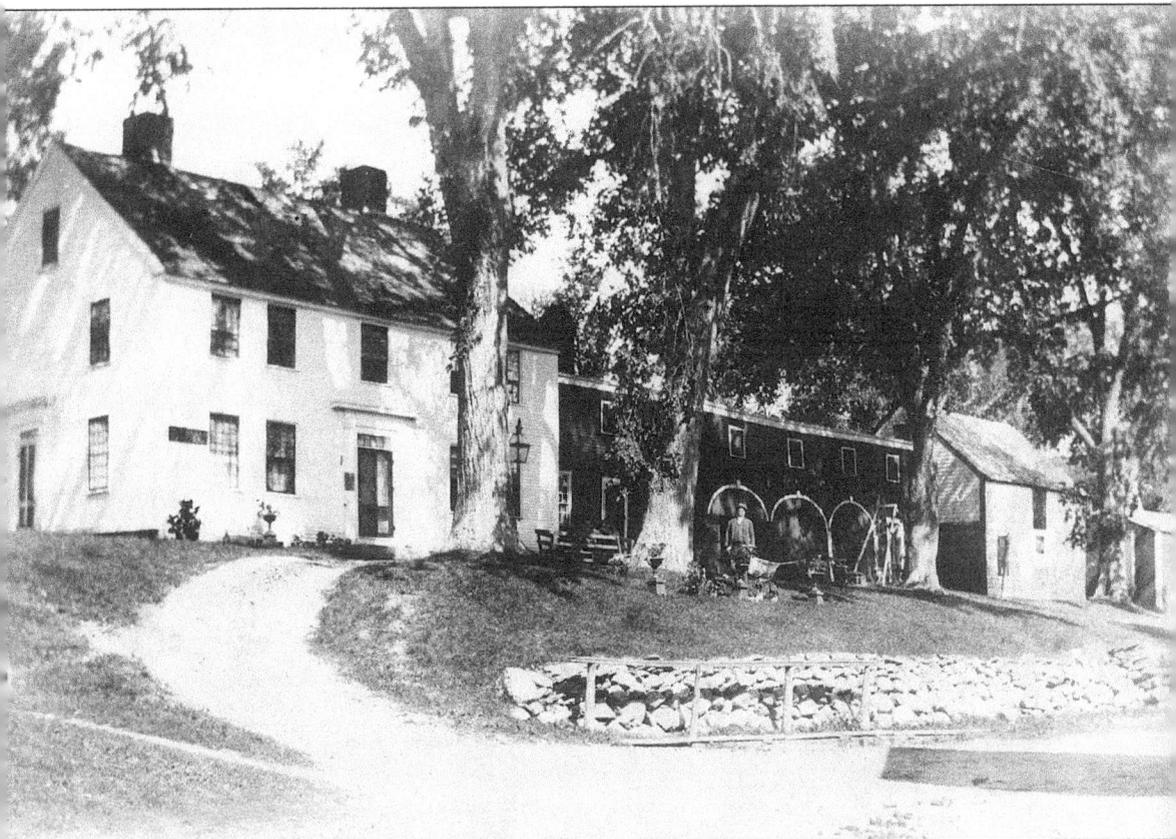

The Robinson House at Head Tide, *c*. 1900.

President of the United States of America

To all to whom these Presents shall come, Greeting:

KNOW YE, *That reposing special trust and confidence in the Integrity, Diligence and Discretion of* James Saylor

I have Nominated, and by and with the advice and consent of the Senate **DO APPOINT HIM** Collector of the Customs for the District and Inspector of the Revenue for the Port of Wiscasset in the State of Maine *and do authorize and empower him to execute and fulfil the duties of that Office, according to law,* **AND TO HAVE AND TO HOLD** *the said Office with all the rights and emoluments, thereunto legally appertaining, unto him, the said* James Saylor *during the term of four years from the* 9th *day of* April *1846 unless this Commission be sooner revoked by the* President *of the United States for the time being:*

IN TESTIMONY WHEREOF, I have caused these Letters to be made Patent, and the Seal of the Treasury Department of the United States to be hereunto affixed. Given *under my hand, at the City of Washington, the* Tenth *Day of* April *in the year of our Lord one thousand eight hundred and* forty six *of the Independence of the United States of America the seventieth.*

By the President:

R. J. Walker *Secretary of the Treasury*

James K. Polk

President James Polk's official appointment of the first custom house officer at Wiscasset.

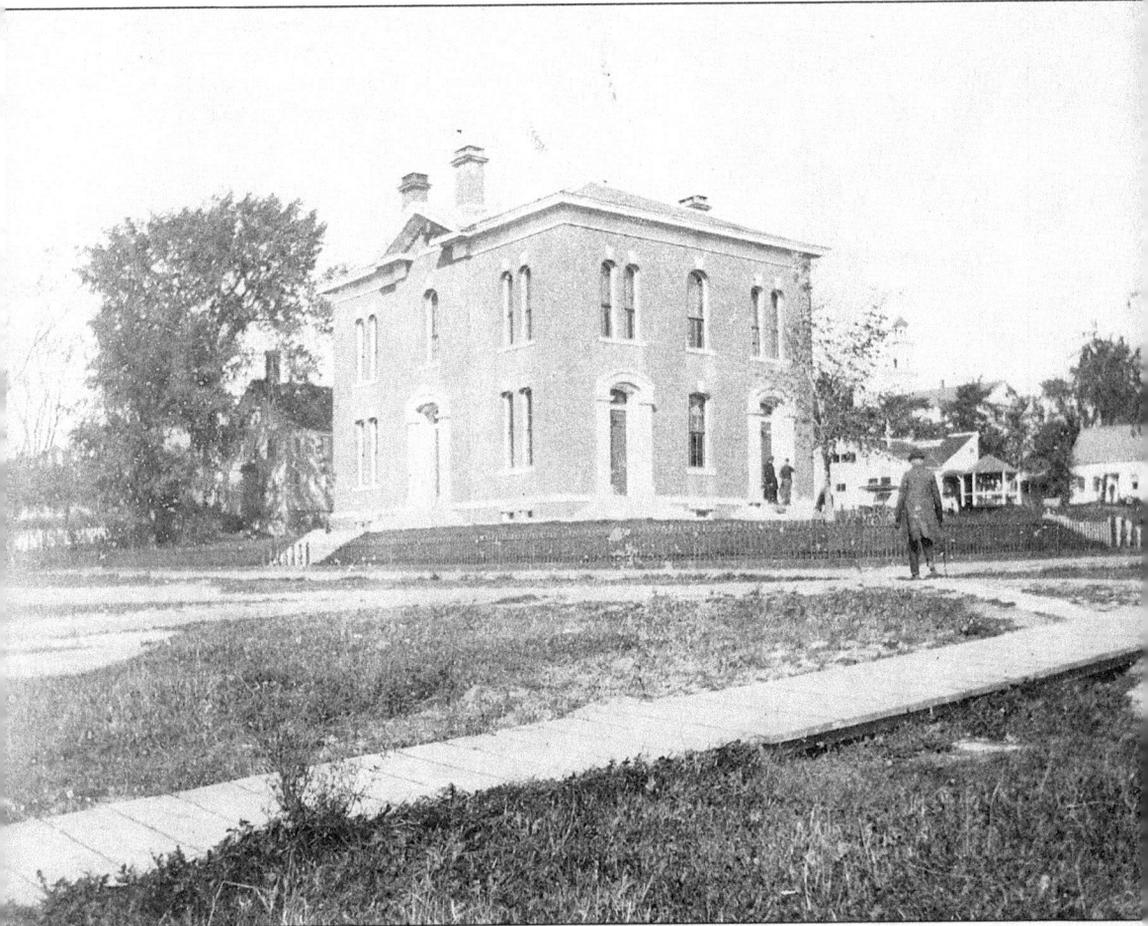

The U.S. Custom House and Post Office at Wiscasset in 1880. The post office was on the first floor and the custom house operations were on the second floor.

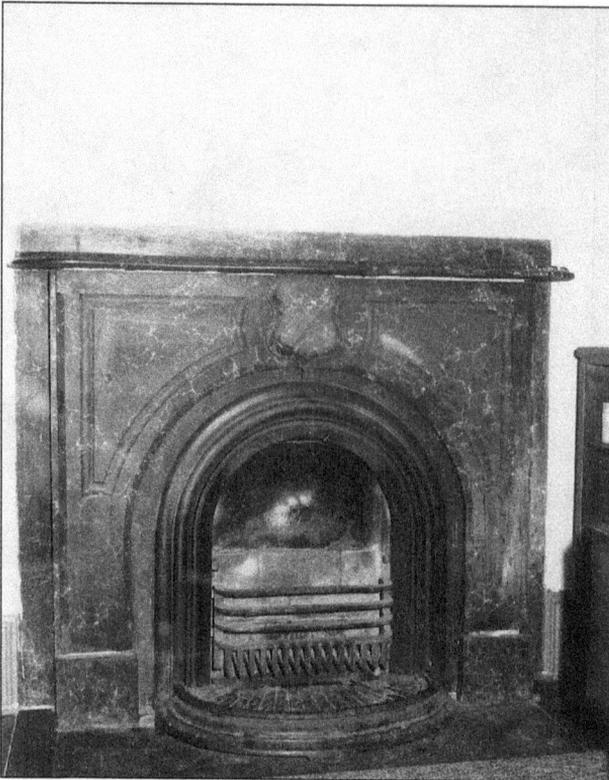

The old source of heat. Prior to 1902, fireplaces were the U.S. Custom House and Post Office's only source of heat.

A request for a new source of heat. In 1902 a request was made for proposals for a steam-heating system at the U.S. Custom House and Post Office at Wiscasset.

TREASURY DEPARTMENT, Office of the Supervising Architect,

Washington, D.C. *June 7,* 1902,—SEALED PROPOSALS will be re-

ceived at this office until 2 o'clock P.M. on the *2d* day of *July,*

1902, and then opened, for furnishing the steam heating apparatus

complete in place for the U.S. Custom House and Post Office build-

ing at WISCASSET, MAINE, in accordance with the drawings and speci-

fication, copies of which may be had at this office or at the office

of the Custodian at Wiscasset, Maine, at the discretion of the Super-

vising Architect.

James Knox Taylor,
Supervising Architect.

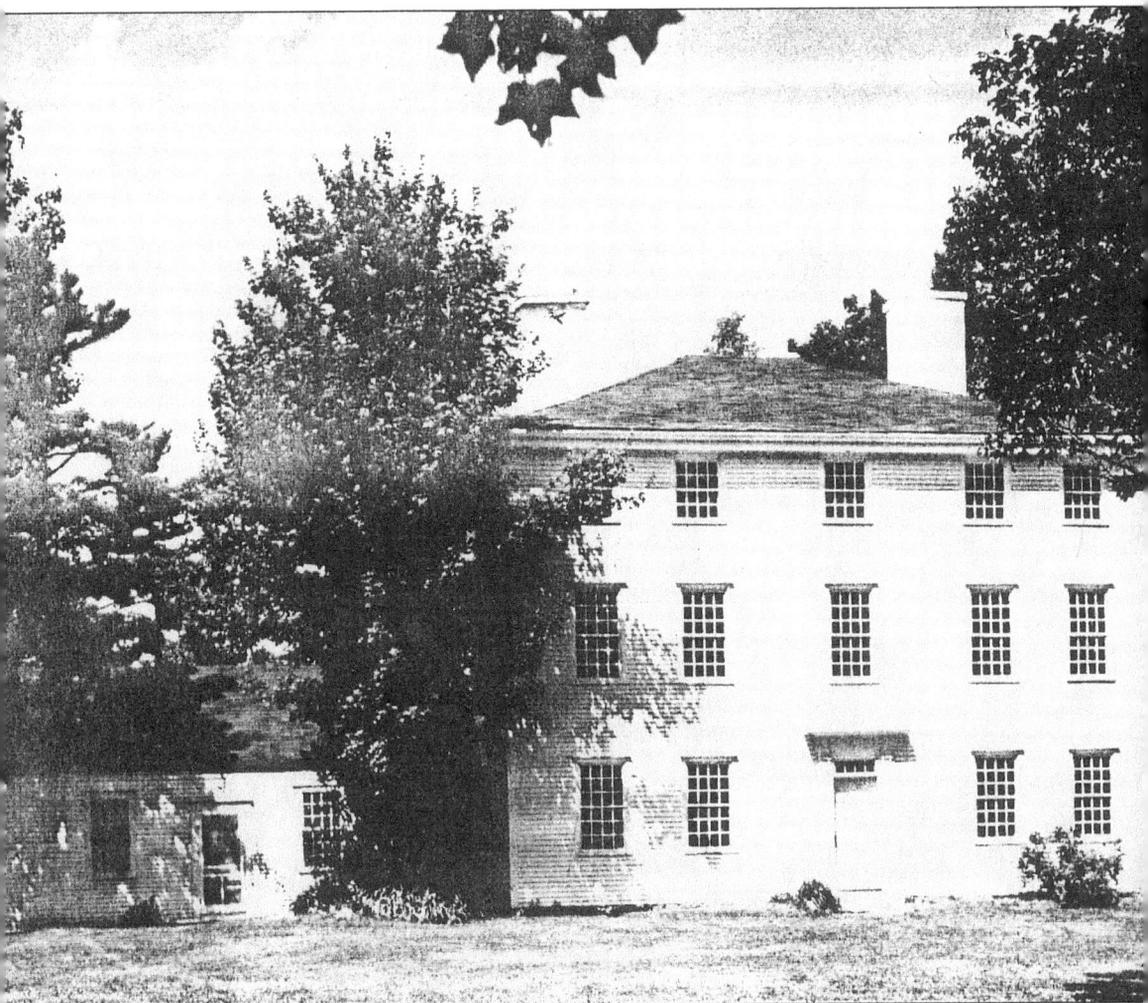

The Pownalborough Court House and Jail. These facilities were constructed in 1761 on the site of the former Fort Shirley. Added in 1839 as a woodshed, the wing to the left was not part of the original building. The Court House is of major historical significance, as it is the only pre-Revolutionary War courthouse in Maine. Over the years, many prominent lawyers and judges have conducted legal functions at the court. Among them are Judge Robert Treat Paine, a signer of the Declaration of Independence, and William Cushing, an appointee of President George Washington to the U.S. Supreme Court. It is believed that some British prisoners of war were held at the jail in 1775 while in transit to a jail in Watertown, Massachusetts. This historic building on the banks of the Kennebec in Dresden is maintained and operated by the Lincoln County Cultural and Historical Association and is open to the public during the summer months.

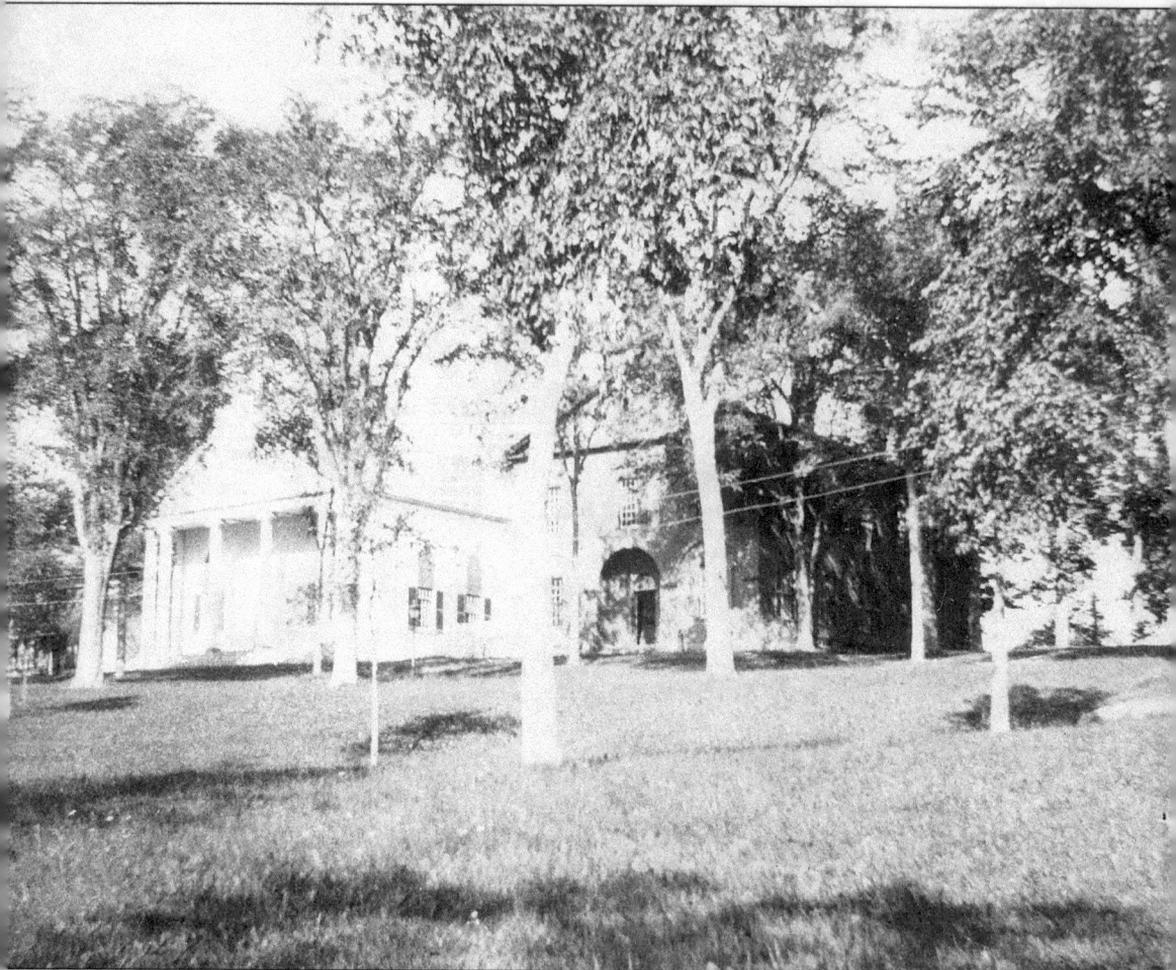

The Congregational church (left), the third church built on this site. The first church was built here in 1767. The Lincoln County Court (right) was built in 1824 and is believed to be the oldest court in continuous use in New England. Records stored here go back to a grant from Chief Samoset, of the Wawenock Tribe, dated 1625.

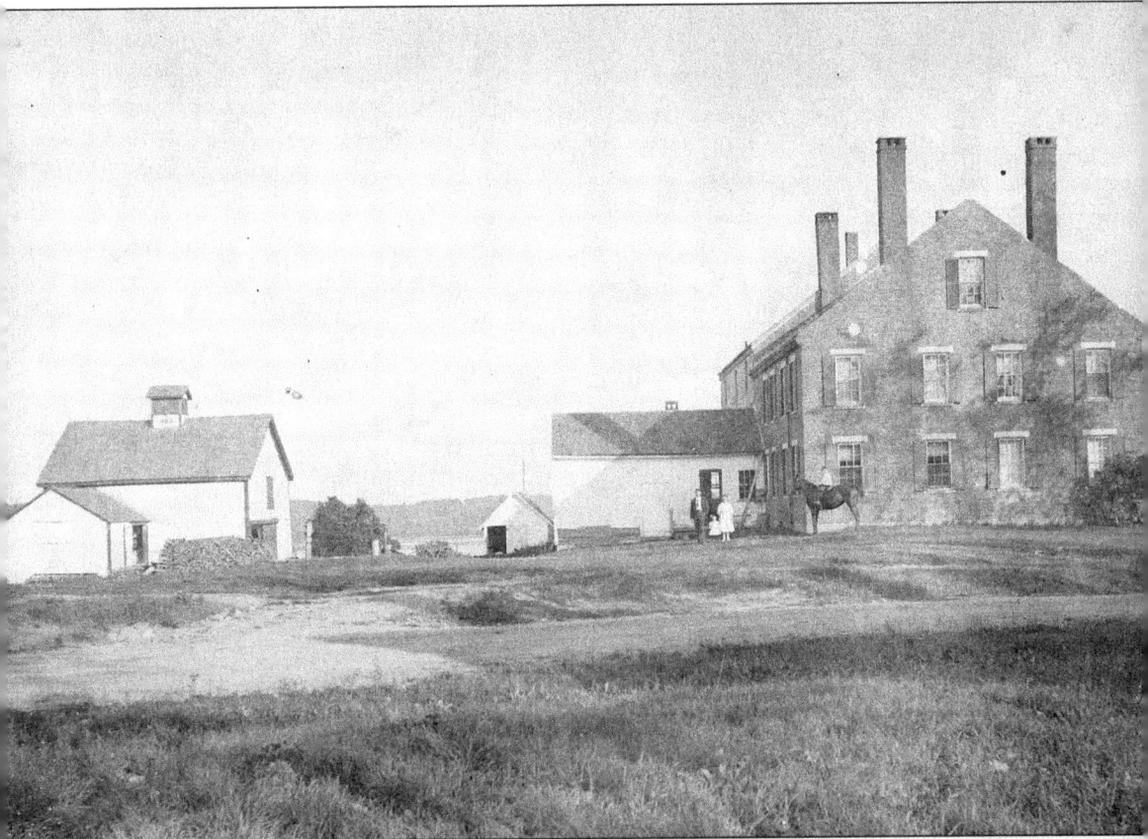

The new jail, c. 1905. In 1809, the cornerstone for a new granite jail was laid on Federal Street, Wiscasset. A sum of $6,000 was appropriated to build a strong twelve-cell facility from Edgecomb granite. The jail remained in continuous use from 1811 to 1953. The jail and jailer's house—now a museum—are maintained and operated by the Lincoln County Cultural and Historical Association and are open to the public during the summer.

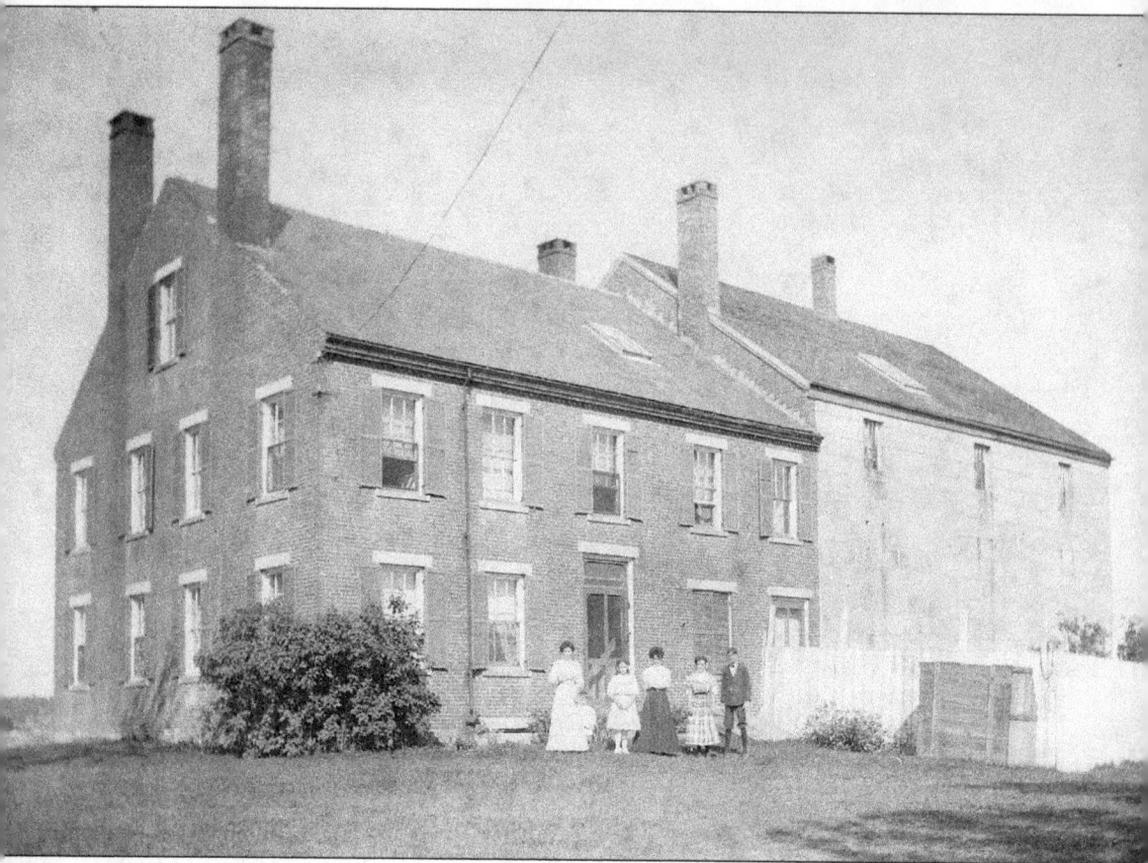

Sheriff John Dow's family in front of the jailer's home, c. 1905.

Four

We Worship Here

The earliest reference to religious life in the region places French Jesuit missionaries along the Kennebec, perhaps in present-day Dresden, in 1750 or before. The next reference to religious services also stems from the Dresden area, where a group of French and German Huguenots had settled in 1754. With resettlement of the Wiscasset region at the end of the King Philip Wars, meetinghouses were built in every community. Woolwich became the site of the first Protestant church east of the Kennebec River with the construction of the Nequasset Congregational Church in 1757. The Wiscasset meetinghouse followed in 1767, the Alna meetinghouse was completed in 1777, and in 1784, the citizens of Westport Island voted to have a church on the island. In those early days, it was regarded as totally reprehensible behavior to be absent from Sunday service. As the years passed, many different denominations built houses of worship to serve the spiritual needs of a growing community.

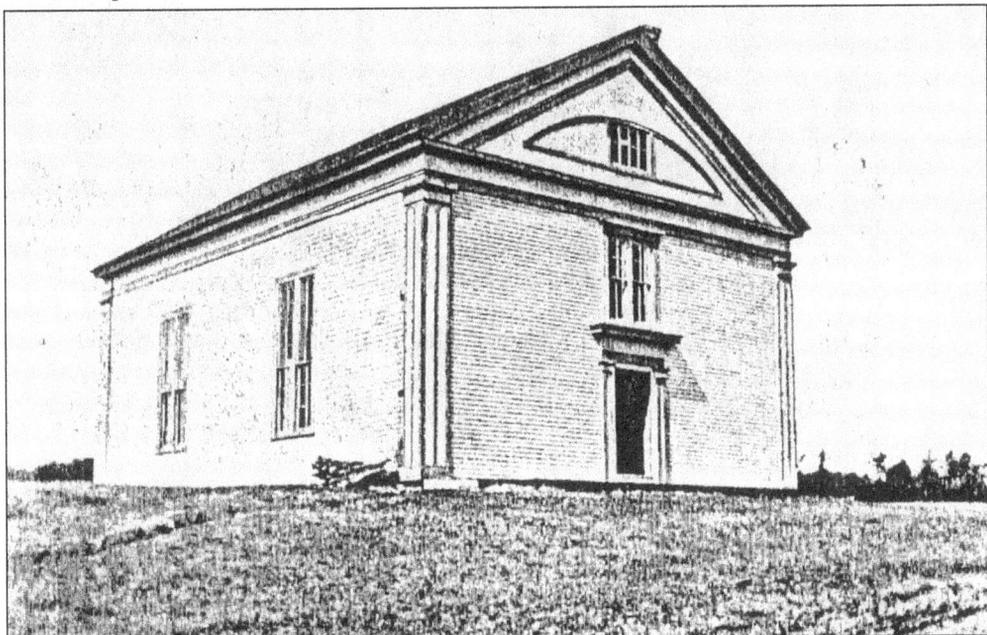

The Nequasset Congregational Church, constructed as a meetinghouse in Woolwich in 1757. The church had a series of trial ministers until 1765, when a young Harvard graduate, Josiah Winship, accepted the pastorship. He remained as pastor until his death in 1824.

63

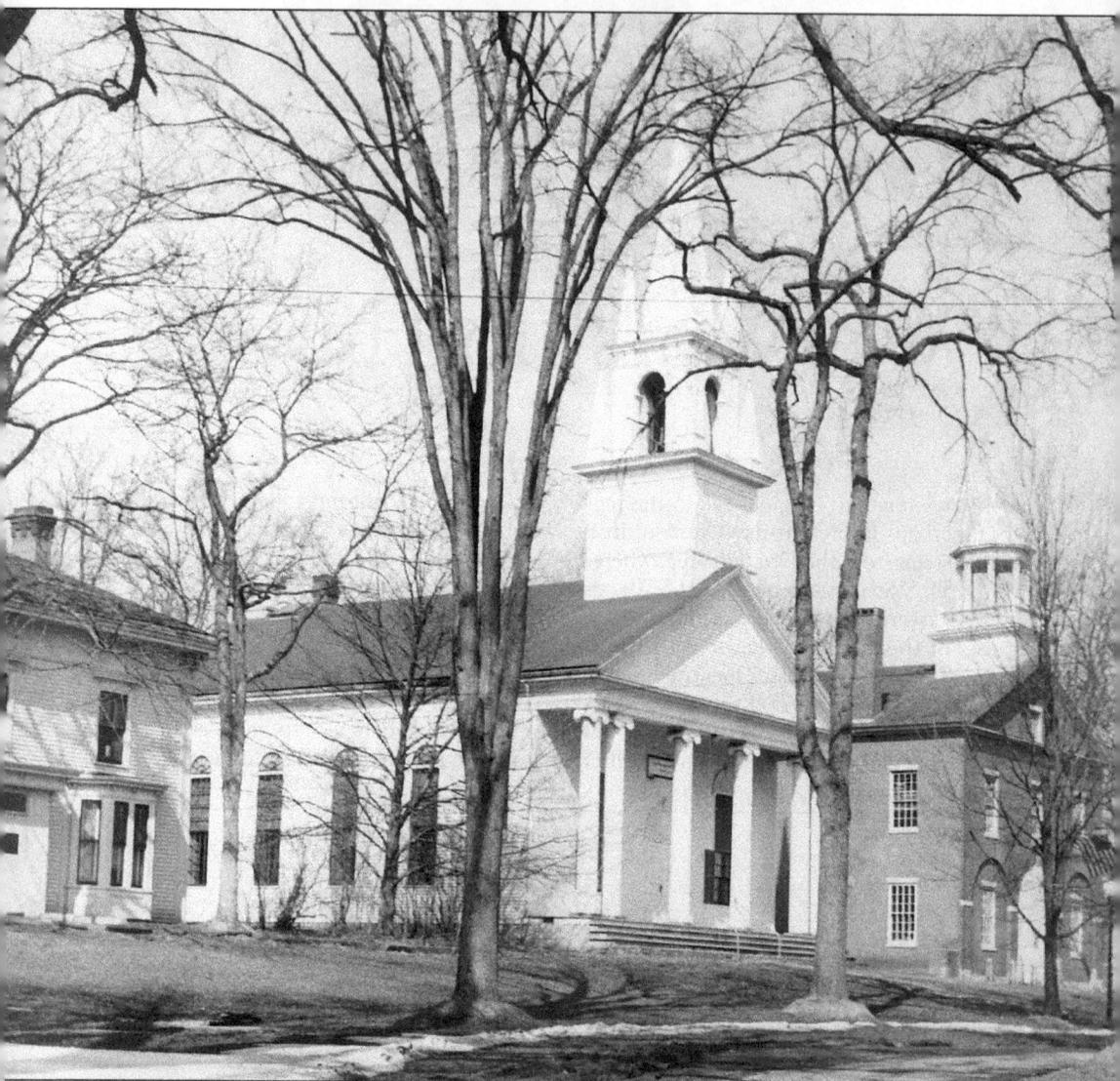

The Second Congregational Church, built during the 1840s, in a *c.* 1890 photograph. The present Wiscasset Congregational Church is the third one on the same site. The first meetinghouse was built in 1767.

The Second Congregational Church's steeple. In 1792, Abiel Wood and Henry Hodge built this steeple. They purchased a bell, cast by Paul Revere, for installation in its belfry and a weather vane to top its steeple.

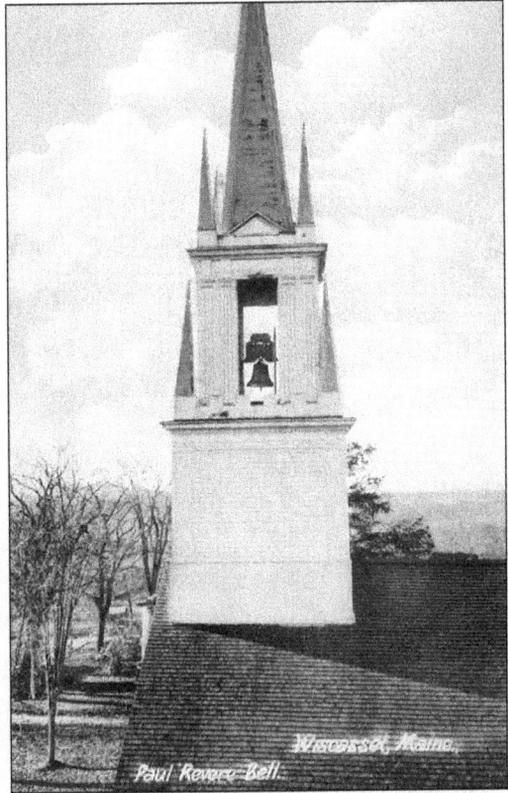

Wiscasset, Maine.
Paul Revere Bell.

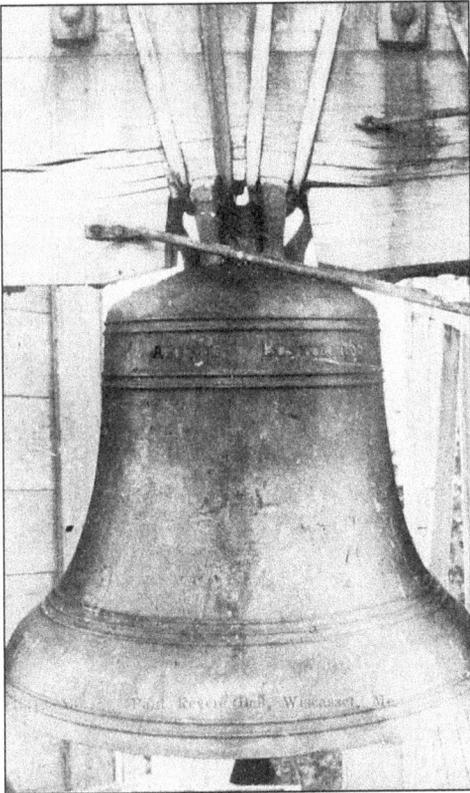

Paul Revere Bell, Wiscasset, Me.

The recast Revere Bell. In 1907, a fire destroyed the Second Congregational Church. Only a few pounds of the Revere Bell were salvaged from the meltdown. The original Revere weather vane was saved to top the steeple of the third church. The saved remains of the Revere Bell were cast into the present bell.

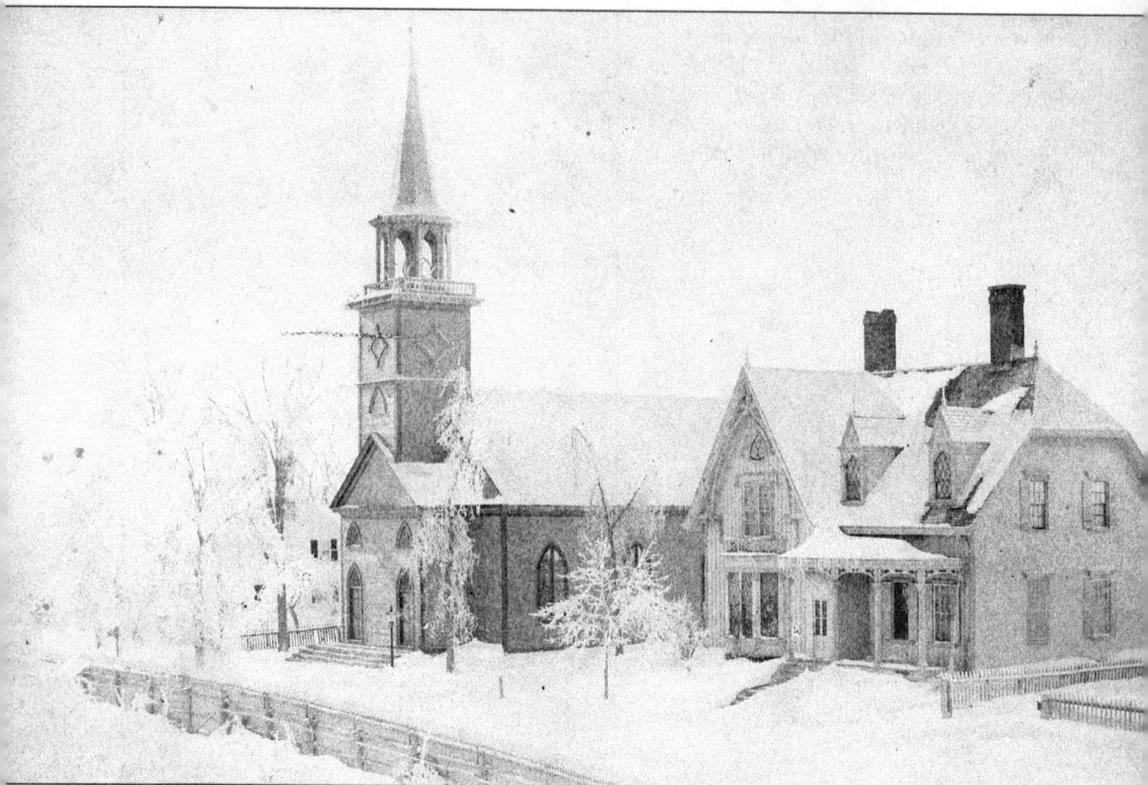

St. Phillip's Episcopal Church and rectory, c. 1886. The church was built by the Baptist Society in 1822. In 1856, when the church had been vacated by the Baptists, it was taken over by the newly formed Episcopal parish and renamed St. Phillip's. Reverend Pelham Williams, an ordained deacon, became the new church's first minister.

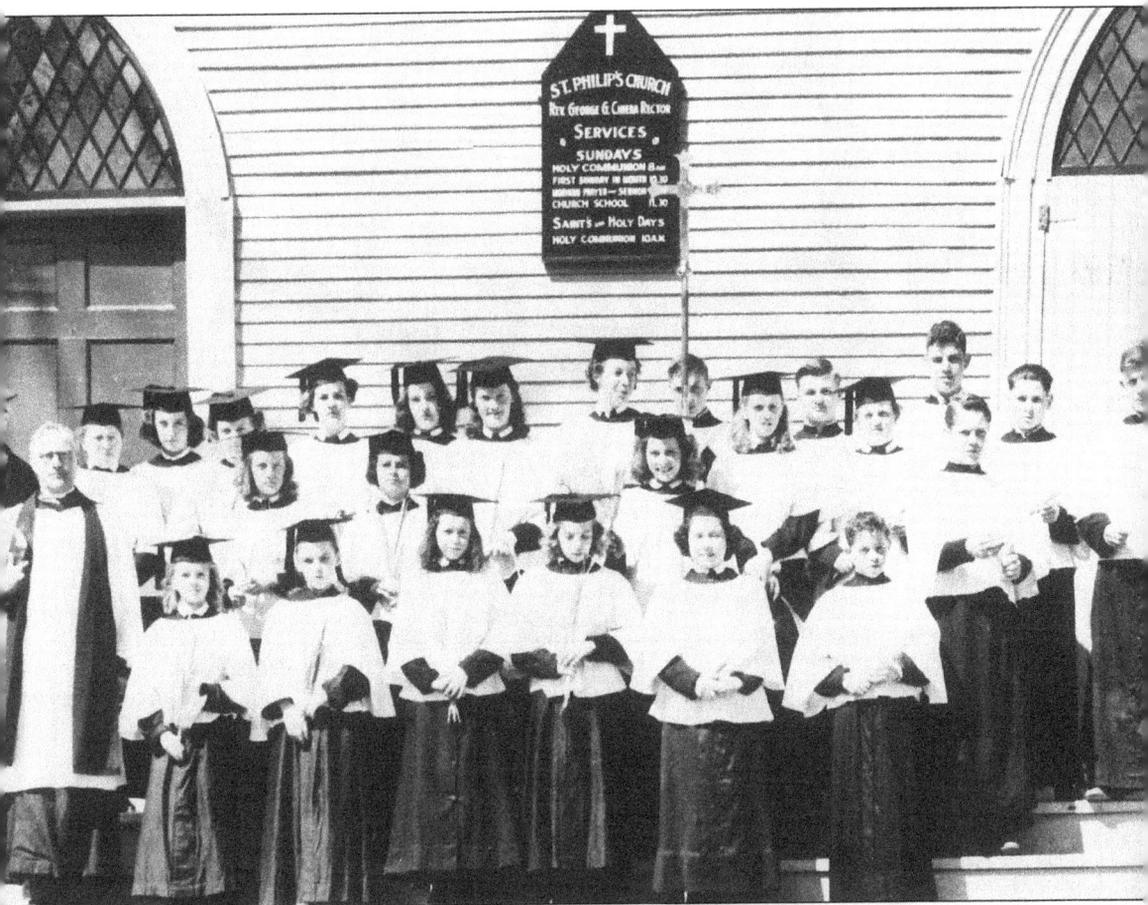

The St. Phillip's Church Choir, 1938. From left to right are: (front row) Father Chiera, Maizie Colby, June Farmer, Helen Petrie, Marjorie Holbrook, Bee Plumstead, and "Sonny" Soule; (middle row) Marilyn Bailey, Mary Lou Soule, Marilyn Petrie, Virginia Butler, Valeria Bean, Clifton Hutchins, Roy Farmer, and Walter Dow; (back row) Mrs. Alvin Kierstead (choir director), Mrs. Anna Plumstead (organist), Jean Bailey, Eleanor Pomeroy, Julie Chiera, Lee Chiera, Barbara Sullivan, Margaret Alexander White, Norman Holbrook, Jed Colby, and George Torrey.

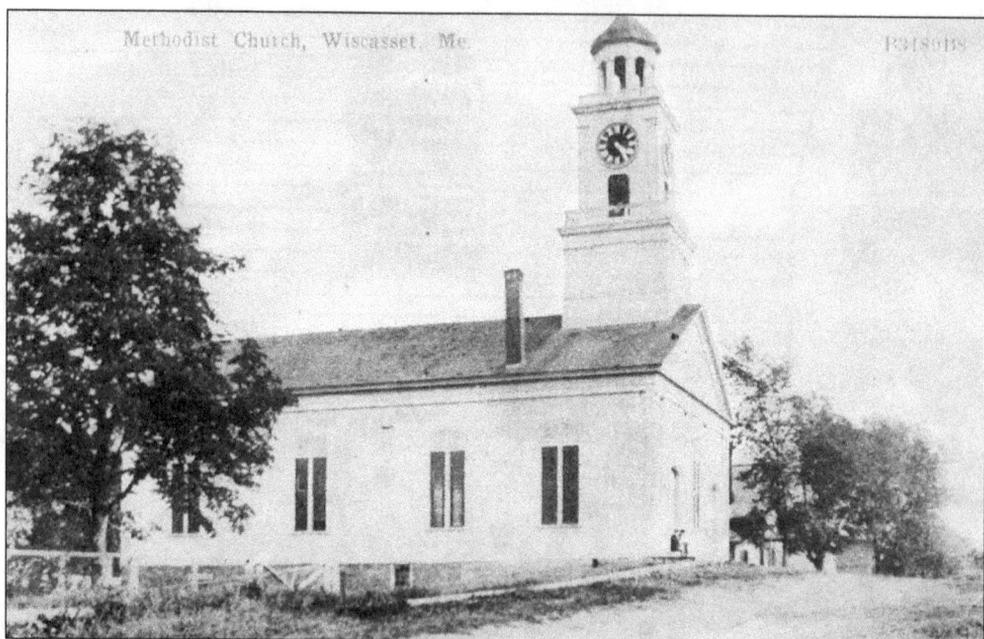

The Methodist meetinghouse. In 1858, the Methodist meetinghouse was enlarged and the belfry added. On February 19, 1877, a bell was placed in the tower. In 1907, Captain William Clark provided the church with a clock for placement in the bell tower. This Fort Hill landmark is now the home of Wiscasset's American Legion Post.

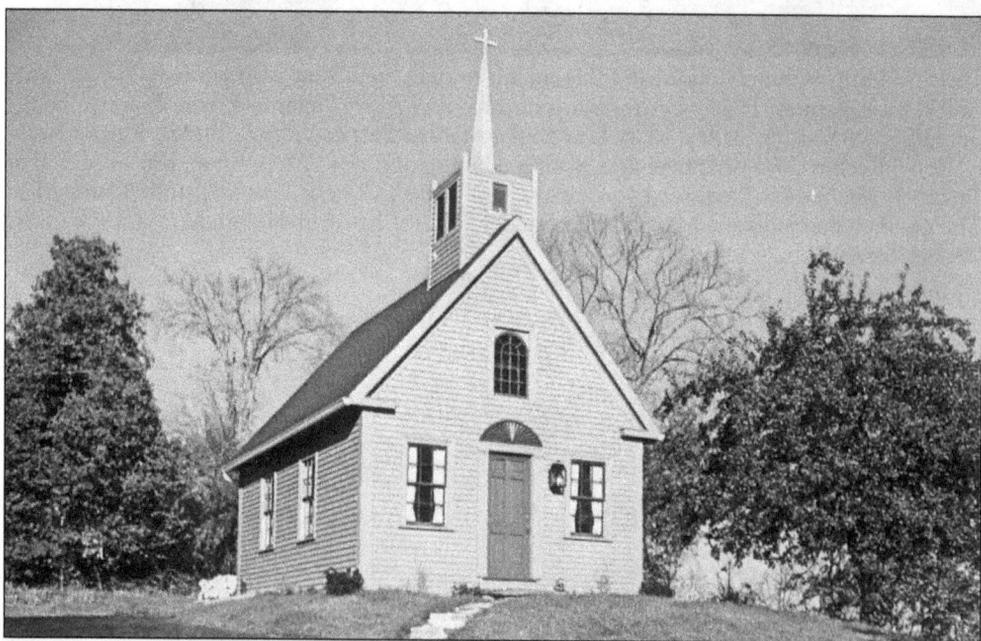

The interdenominational Encircling Arms Chapel on Federal Street, Wiscasset. This place of worship holds prayer and healing services weekly.

Reverend West's small church. On Route 218, one mile from the Village of Wiscasset, is what is believed to be the "smallest church in the world." It was constructed in 1958 by the late Reverend Louis W. West, a retired Baptist minister. The small church contains enough space for two worshippers at a time. The Reverend West performed ten weddings and one baptism in the church.

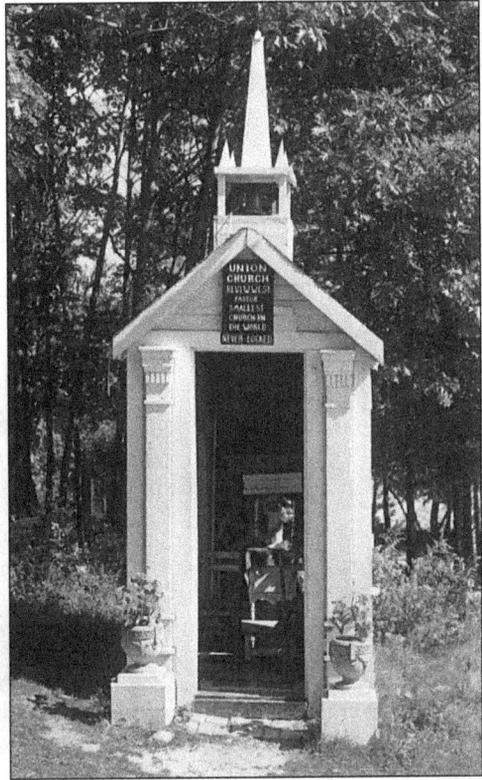

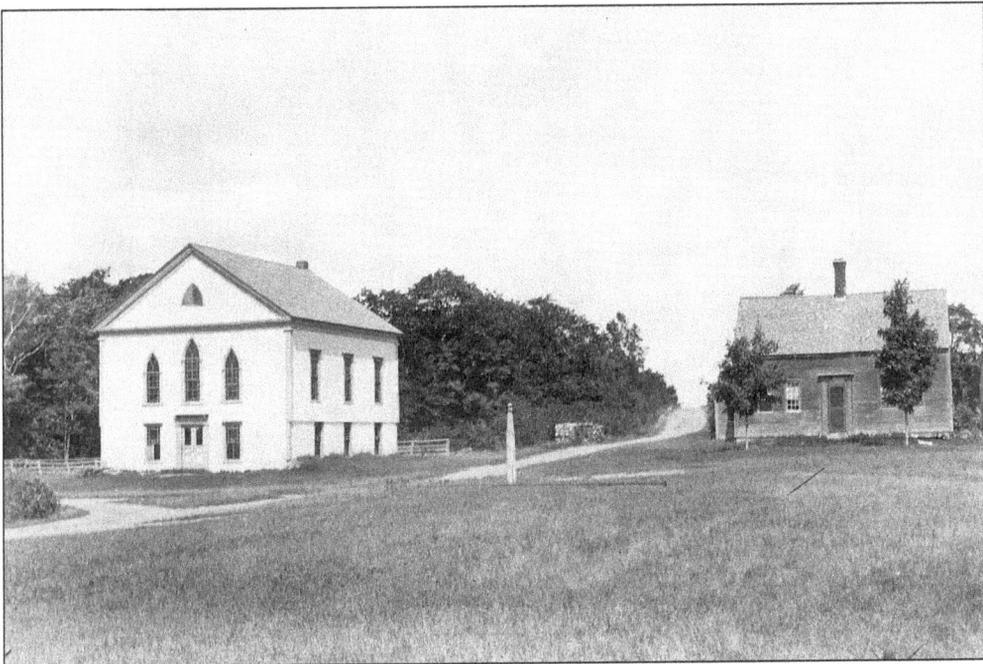

The Methodist church in South Dresden.

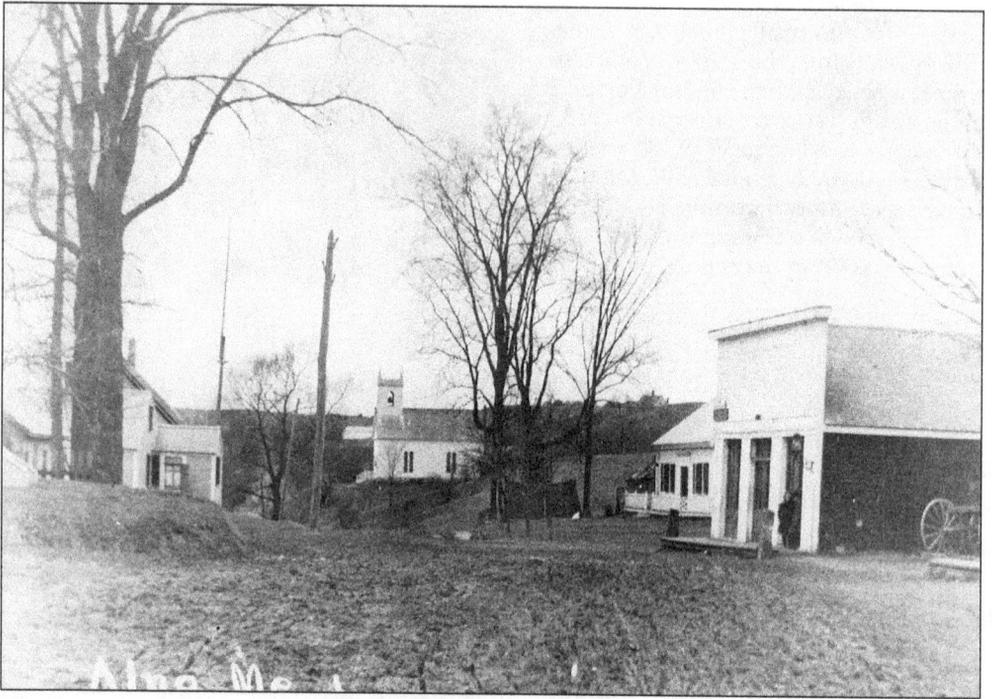

The Baptist church (in the background), Puddle Dock, Alna, c. 1900.

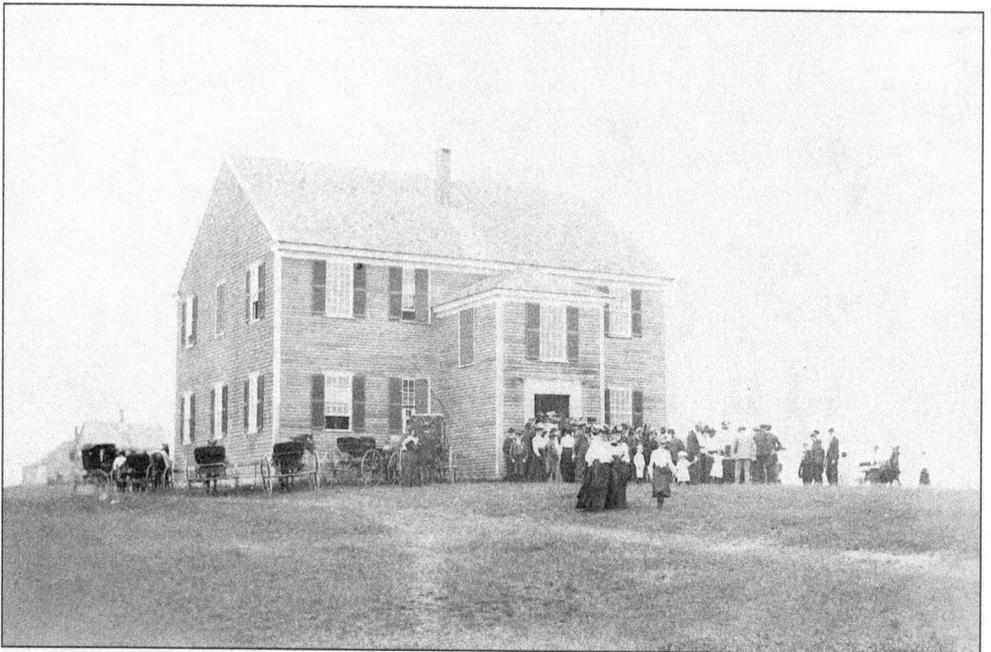

Alna's ancient meetinghouse. Construction on this building was started in 1775, but was not finished until 1777 due to the Revolutionary War.

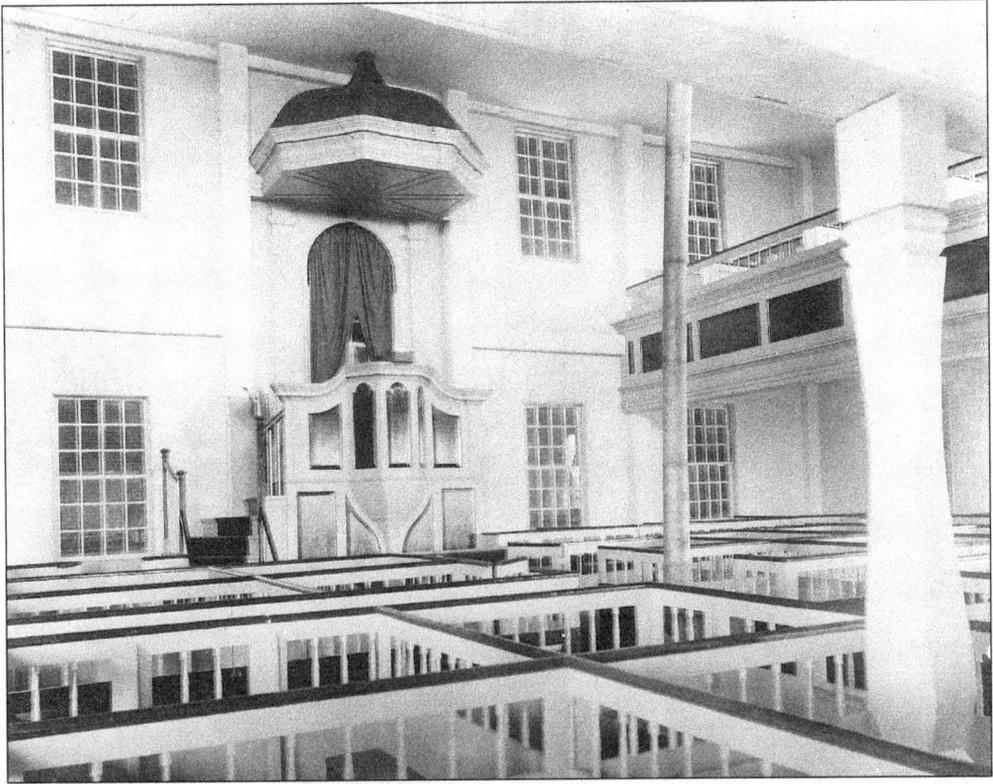

The interior of Alna's meetinghouse. The pews are made in a box-like configuration, and the pulpit is elevated and surmounted by a bell-shaped sounding board. Directly below the pulpit is the seat for the tithing man.

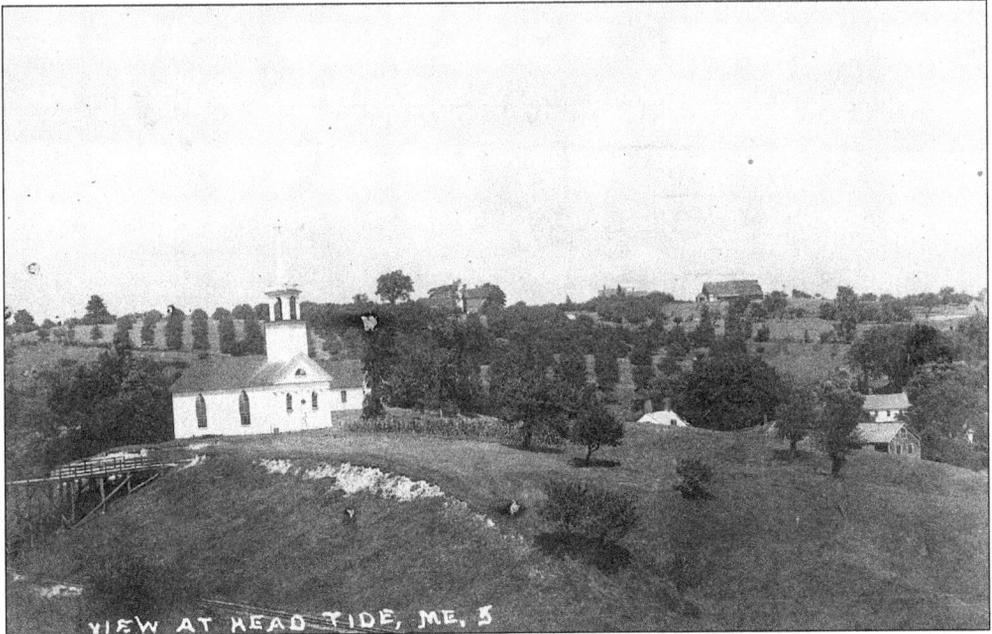

VIEW AT HEAD TIDE, ME, 5

The Head Tide Church, c. 1910.

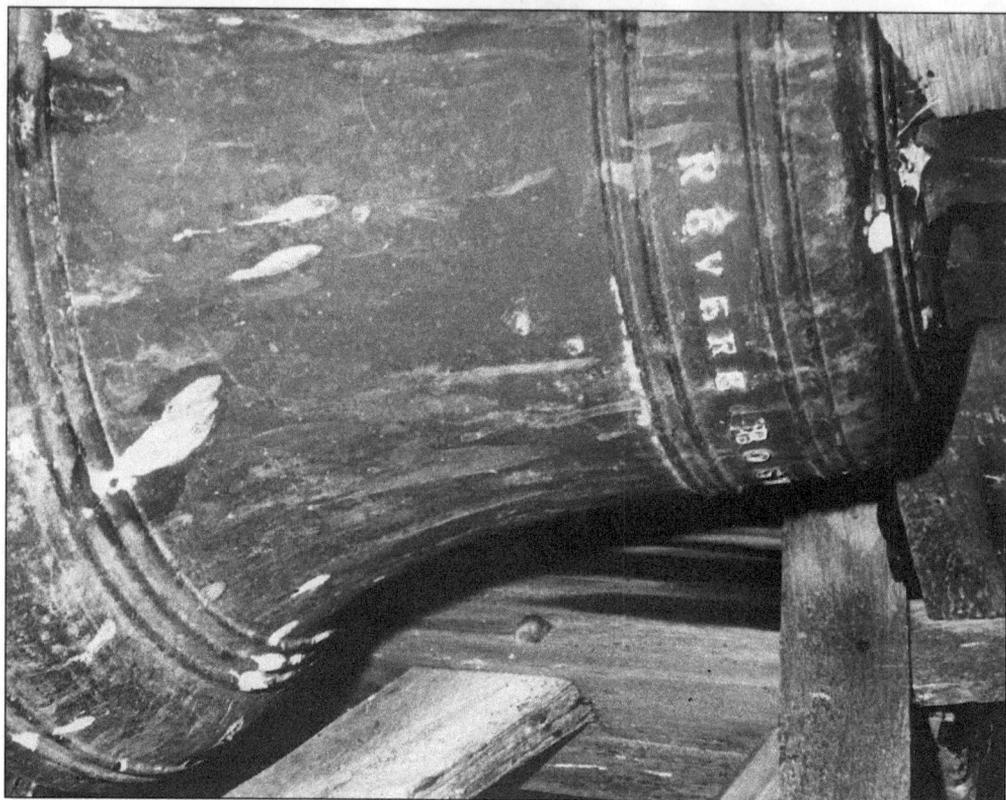
The Revere Bell of the Head Tide Church, prior to its meltdown in the fire of July 9, 1962.

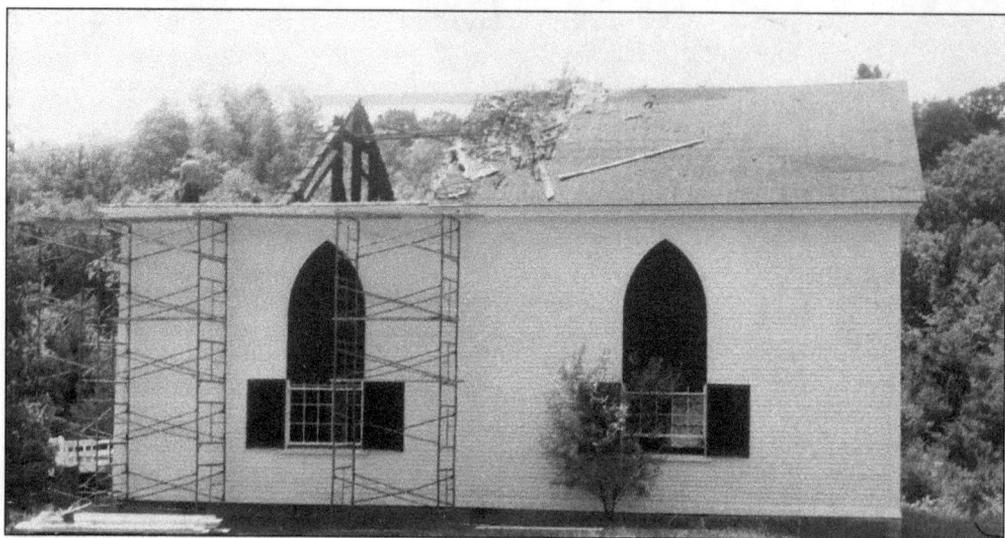
The rebuilding of the Head Tide Church after the 1962 fire.

Five

The Three R's:
Reading, 'Riting, and 'Rithmetic

Next to the worship of God and the establishment of government, the colonists understood the importance of education. The General Court of Massachusetts passed legislation in 1647 that every town of fifty or more families was required to support a school. It further stated that every child between fifteen and seventeen who could not read or write English must attend school for the entire period of its sessions. Due to King Philip's War there was not a great deal of effort placed on the establishment of schools until the conflict ended and resettlement began. The start of the 1760s saw the establishment of schools in Woolwich and in Pownalborough. The first teachers were often itinerant instructors having schools on a circuit. Many times the local minister served as the teacher. School days during the late nineteenth and early twentieth centuries did not differ much from those of the Colonial era, with local one-room schools being the rule rather than the exception.

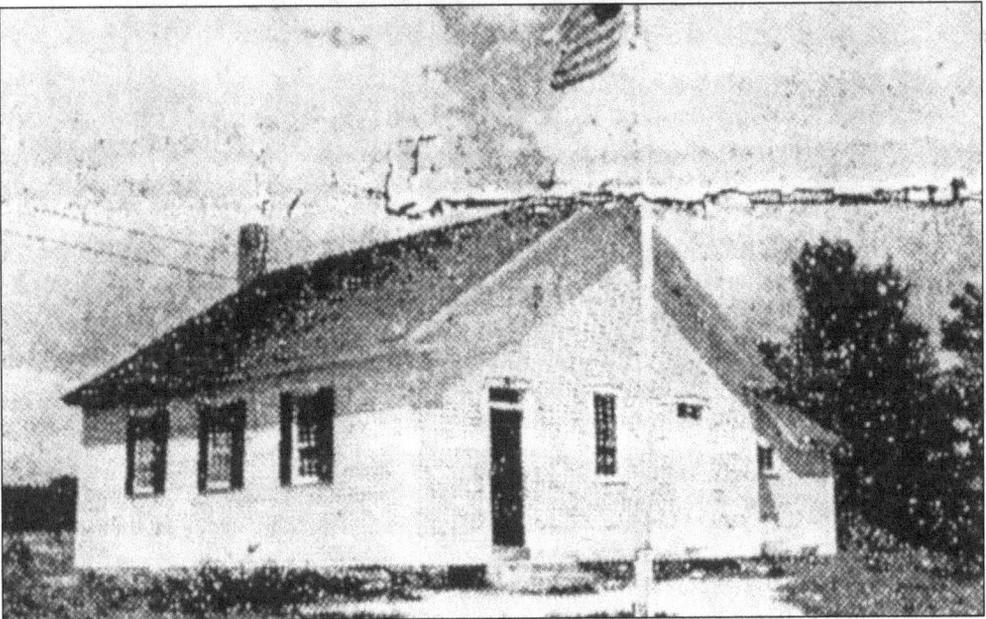

The Murphy's Corner schoolhouse in Woolwich, built c. 1868. In more modern times it became known as the Pleasant View school.

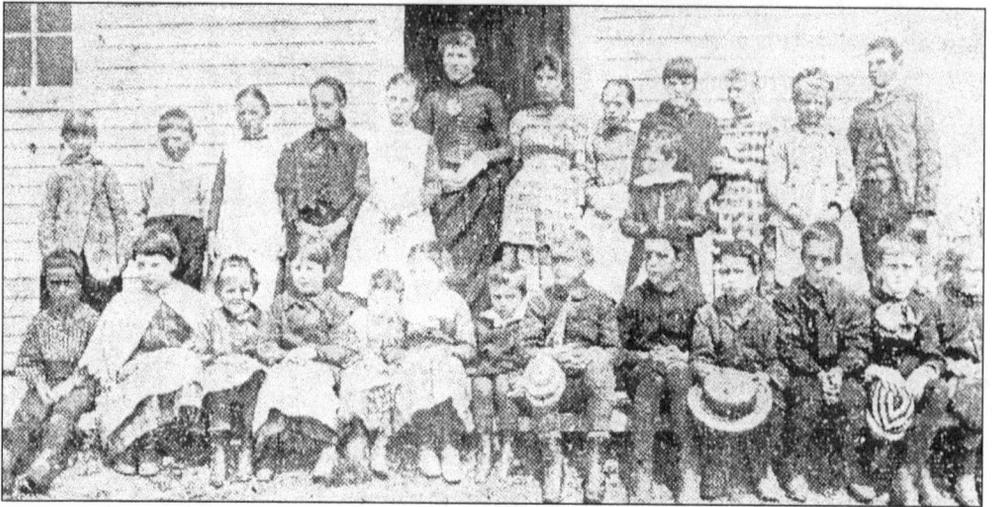

Pupils at the Murphy's Corner school in 1889. From left to right are: (front row) Raymond Harnden, Lillian Bailey, Louise Soule, Rose Bailey, Flora Bailey, Lottie Bailey, Robert Harnden, A.M.G. Soule, William Harnden, Roland Knight, Richard Harnden, Lowell Brown, and Earl Dunton; (back row) Elizabeth Soule, Richard Hunnewell, Sadie Blinn, Jennie Harnden, Angie Hunnewell, Miss Katherine Soule (teacher), Loretta Soule, Martha Soule, Annie Plumstead, Laura Bailey, Pamelia Blinn, Ellen Soule, and Eugene McCarty.

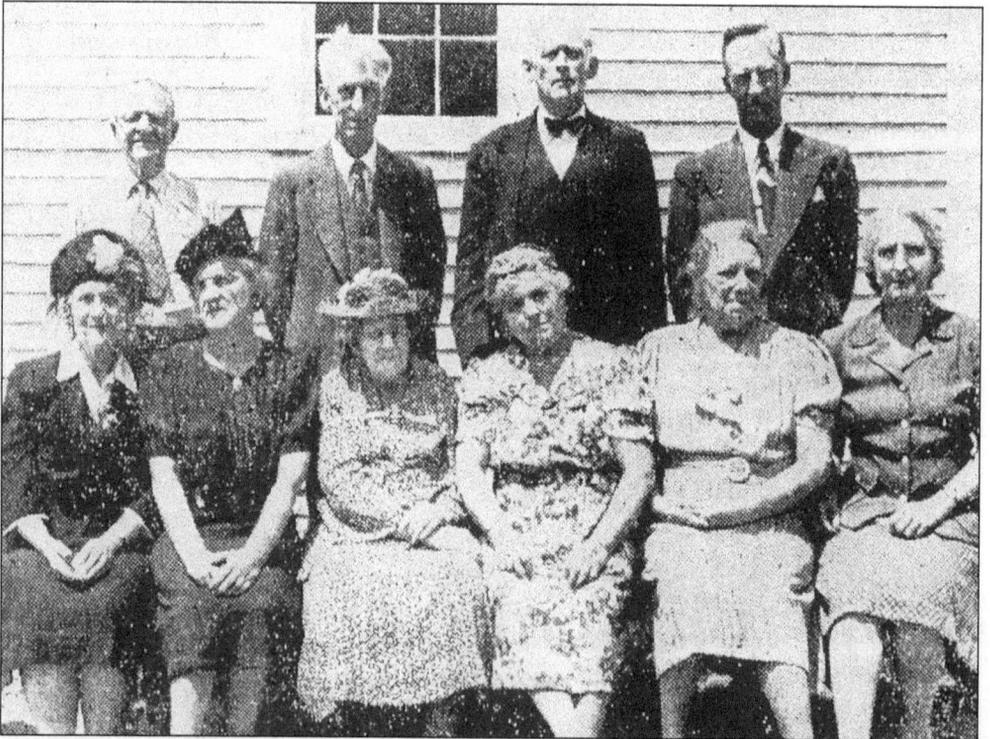

The 50th reunion. On June 27, 1939, ten former pupils returned to the Murphy's Corner school for an all-day 50th reunion. From left to right are: (front row) Mrs. Harriett Wright, Mrs. Harry Austin, Mrs. Antoinette Plumstead, Mrs. Frank S. Carter, Mrs. Edward Shaw, and Mrs. Orrin Woodbury; (back row) J.G. McCarty, W.F. Harnden, A.M.G. Soule, and Robert D. Harnden.

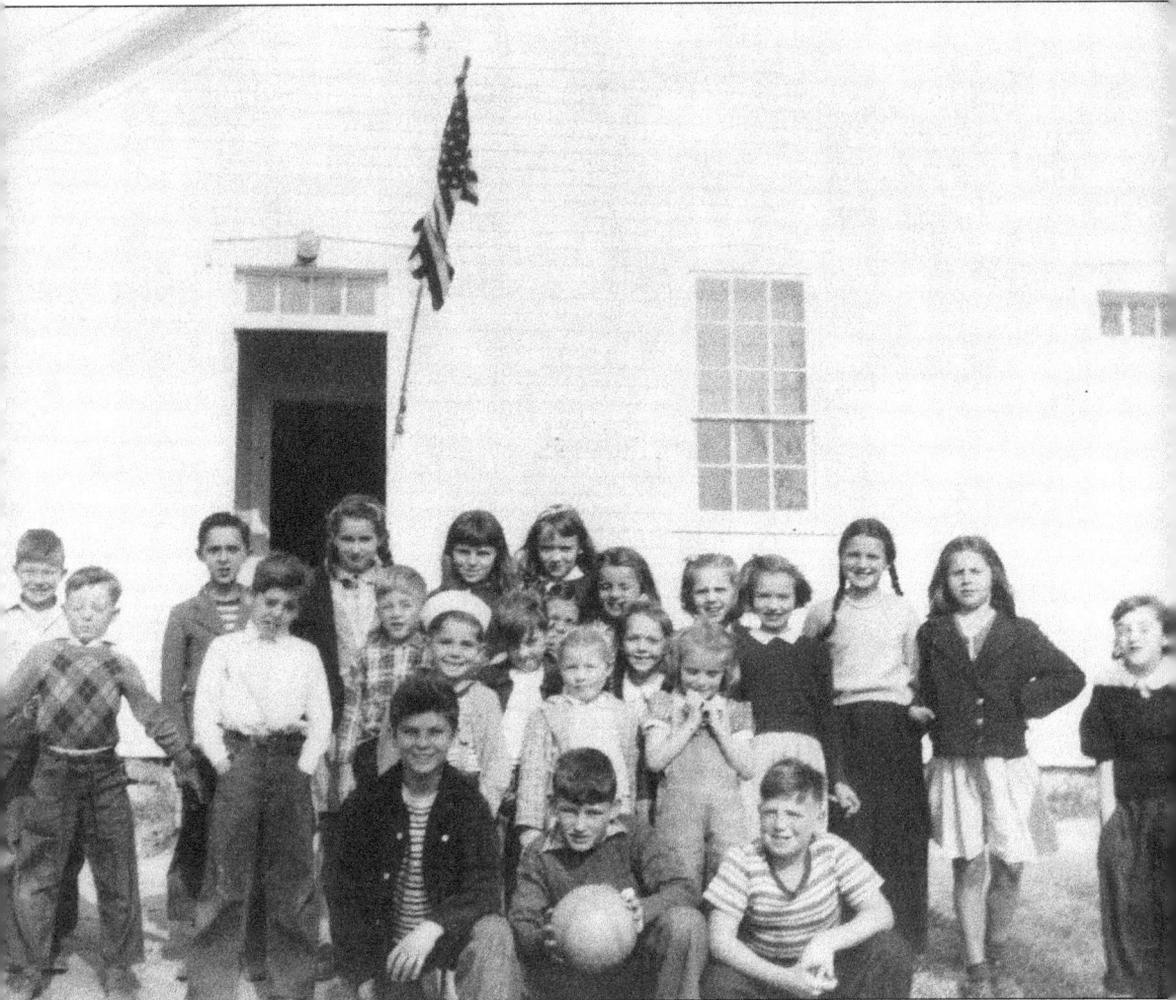

Pupils at the Murphy's Corner schoolhouse, 1948.

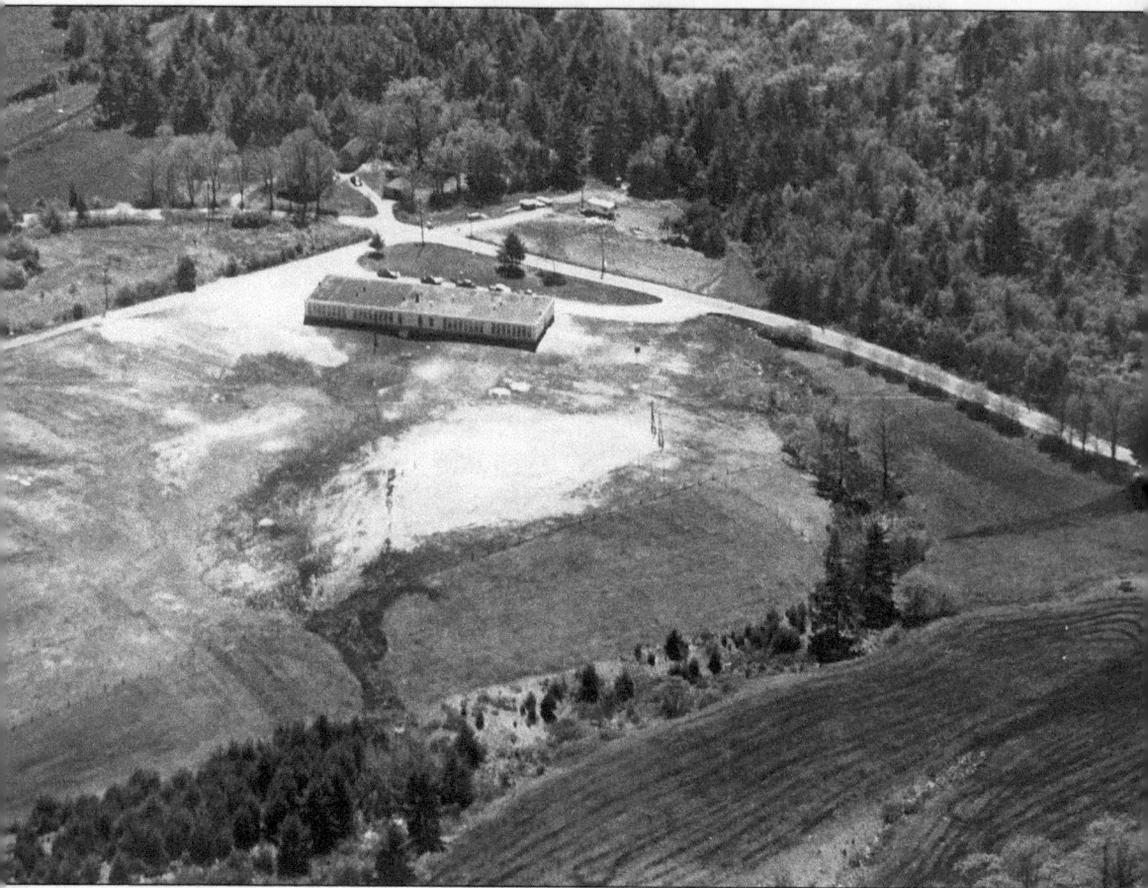

An aerial view of the Woolwich Central School, 1953.

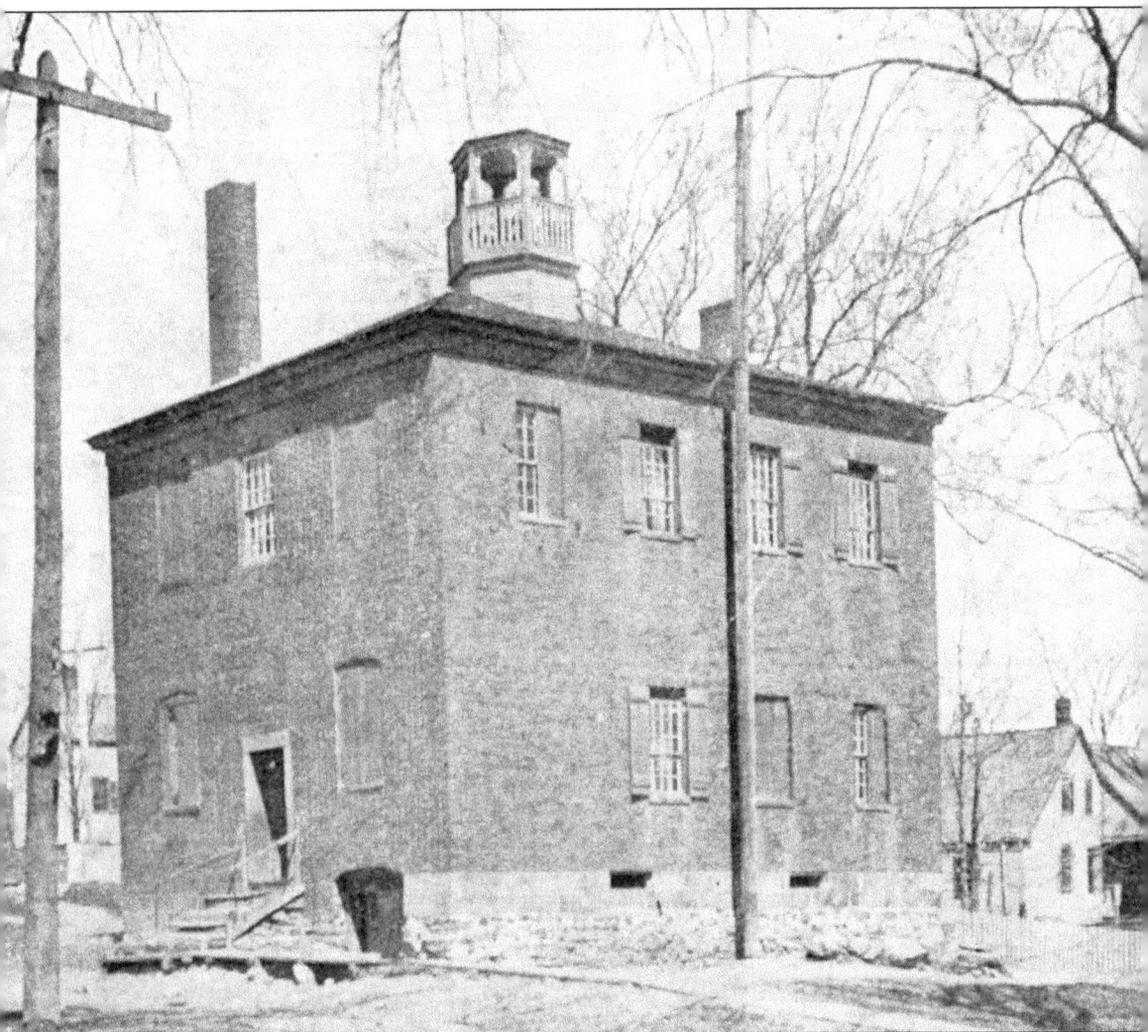

The Wiscasset Academy. In 1807, Reverend Hezekiah Packard helped enable a group of citizens to form the Wiscasset Academical Association for the purposes of developing facilities of higher education and building a brick school on Warren Street. The Massachusetts General Court issued a charter to the group in 1808. By 1809, the academy was in full operation, supported by private subscription. The building was used as a private, and later public, school until 1923. Today the old academy is home to the Maine Art Gallery.

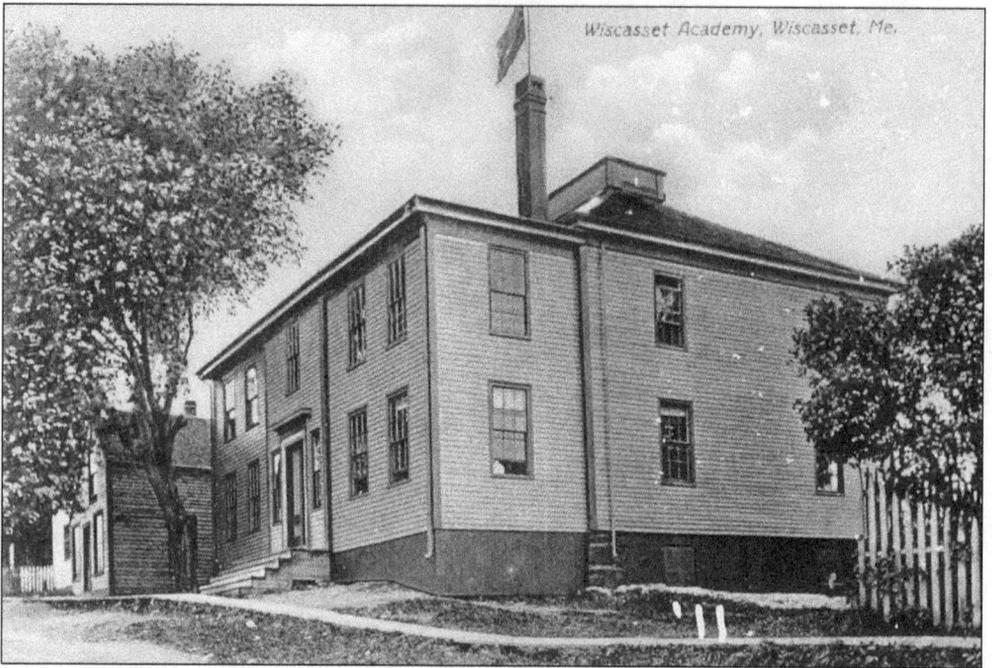

The second home for the Wiscasset Academy on Fort Hill, c. 1910. This facility later became the home of the Masonic Lodge.

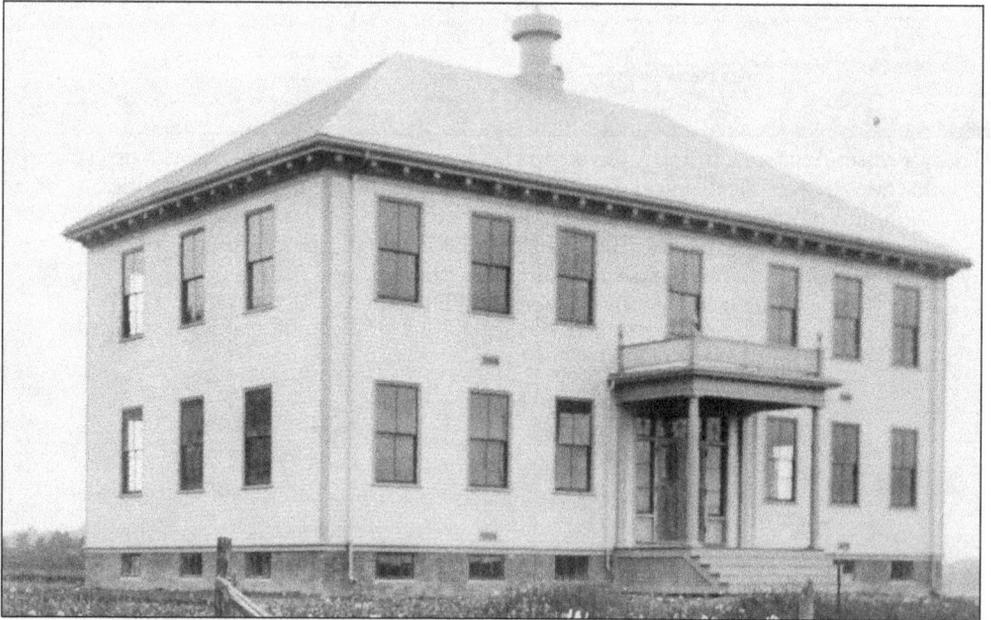

Wiscasset High School during the 1930s.

The following is a job description for teachers from the year 1882:

1. Teachers each day will fill lamps, clean chimneys, and trim wicks.

2. Each teacher will bring a bucket of water and a scuttle of coal for the day's session.

3. Make your pens carefully: you may whittle nibs to the individual tastes of the pupils.

4. Men teachers may take one evening each week for courting purposes, or two evenings a week if they go to church regularly.

5. After the hours of school, the teachers should spend the remaining time reading the Bible or other good books.

6. Women teachers who marry or engage in unseemly conduct will be dismissed.

7. Every teacher should lay aside from each pay a goodly sum of his earnings for his benefit during his declining years so that he will not become a burden on society.

8. Any teacher who smokes, uses liquor or in any form, frequents pool or public halls, or gets shaved in a barber shop will give good reason to suspect his worth, intentions, integrity, and honesty.

9. The teacher who performs his labors faithfully and without fault for five years will be given an increase of 25¢ per week in his pay providing the Board of Education approves.

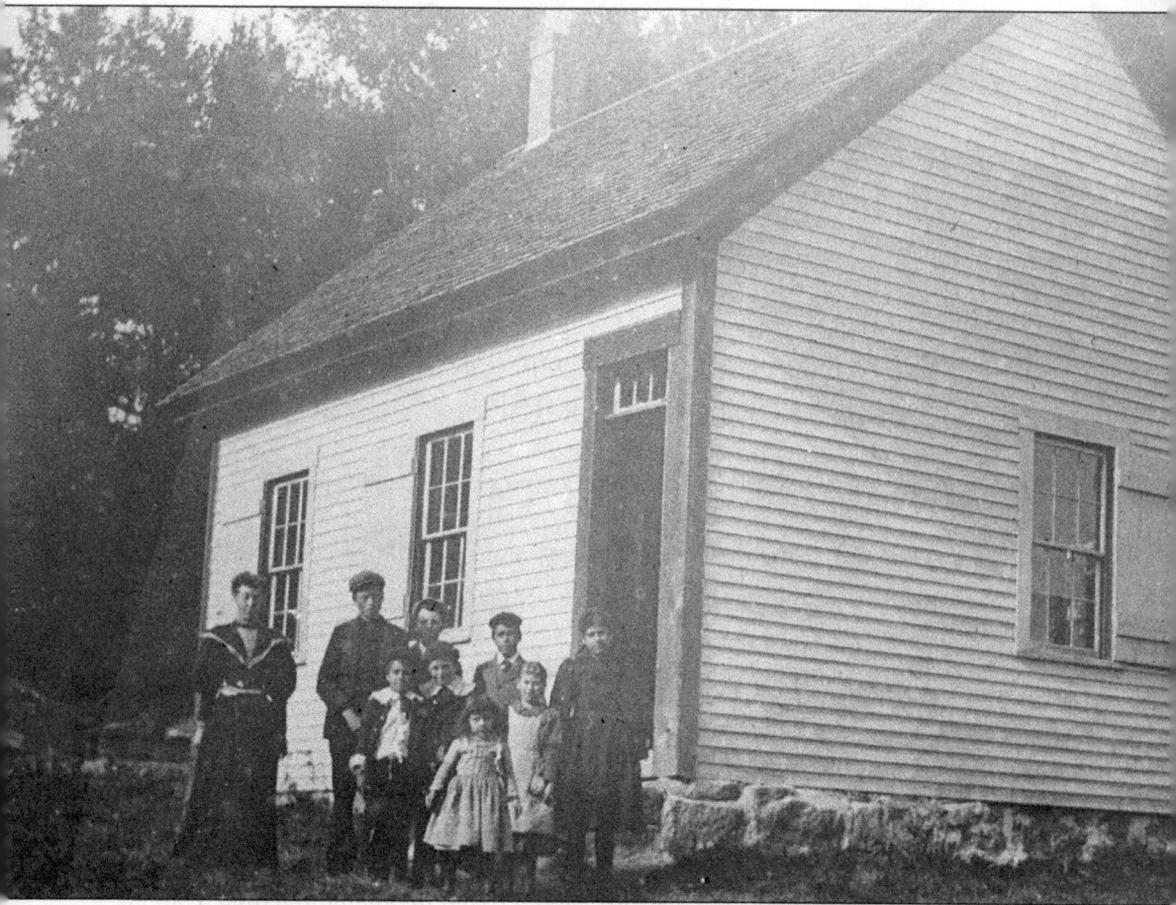

A Westport Island one-room schoolhouse, *c.* 1890.

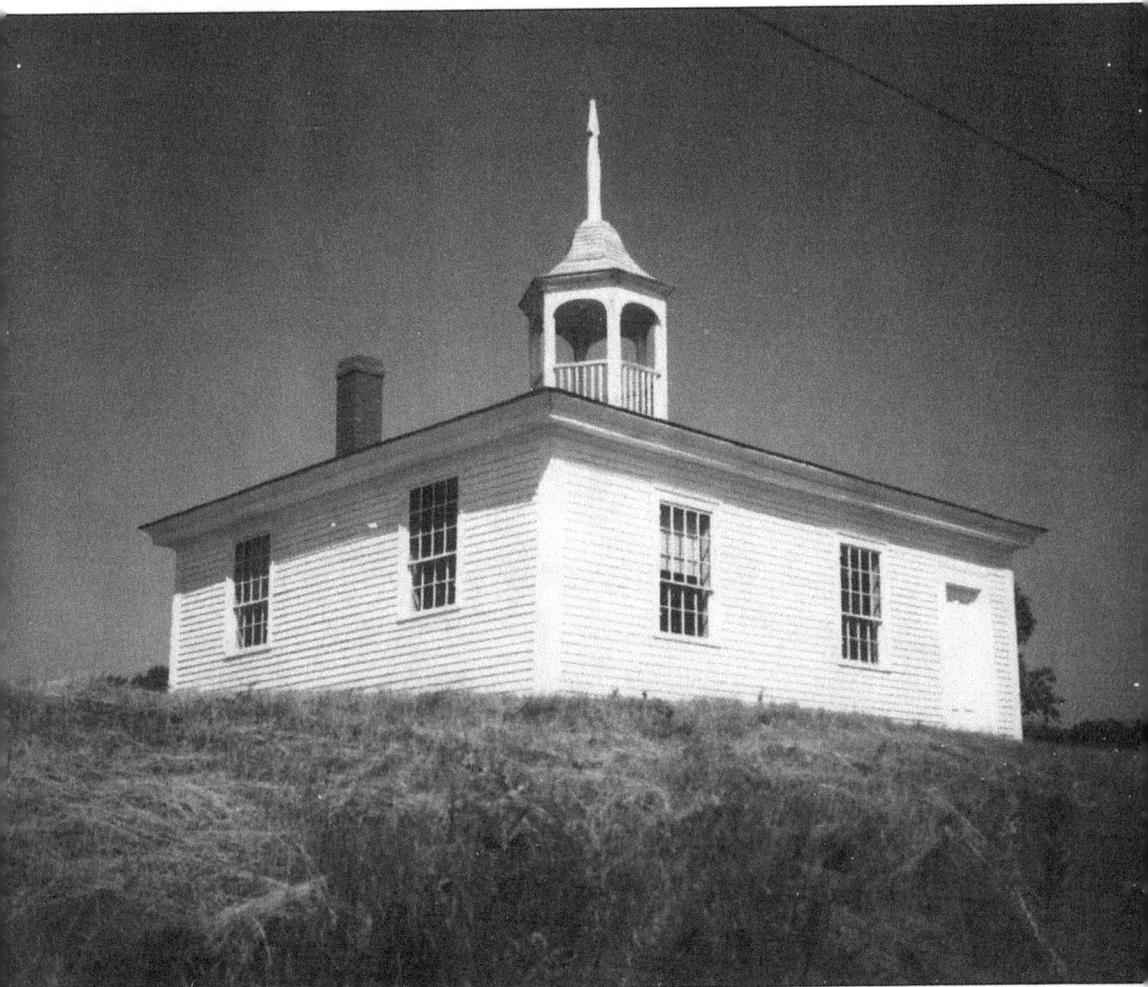

A historic Alna schoolhouse, built in 1795. Its unique cupola was not part of the original design, but it was added to this landmark many years later.

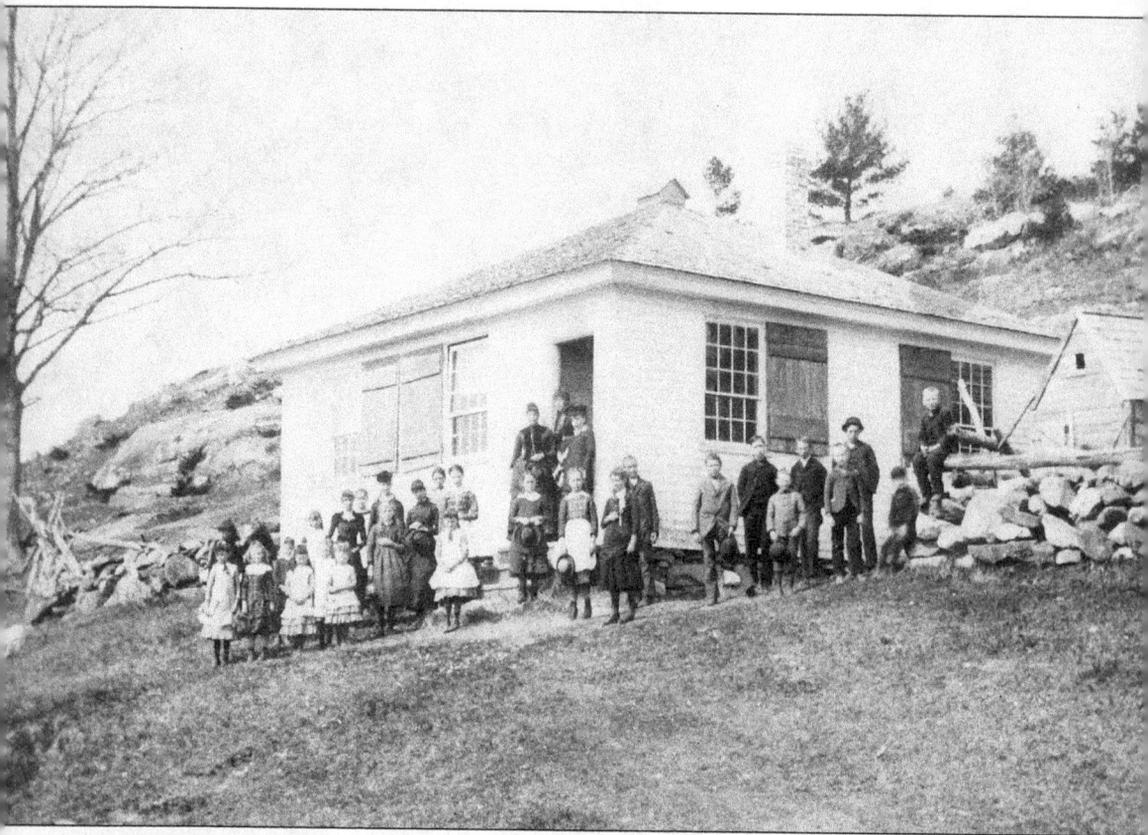

Pupils at the Sheepscot District 3 one-room school in 1885.

Six

The Workplace

The famous Yankee work ethic has always been deeply felt by those who work in the boat yards, on the farms, or in the mills and shops of the Wiscasset region. These folks, who are your friends and neighbors, take pride in what they do and enjoy not only serving the public in their place of business, but they also often take time to do volunteer work in the community. The firefighters serving us may be the local shipbuilders, druggists, lawyers, and plumbers, joining together to give back more than they take. This spirit of love for one's neighbor through service is a gift that has made our towns so special.

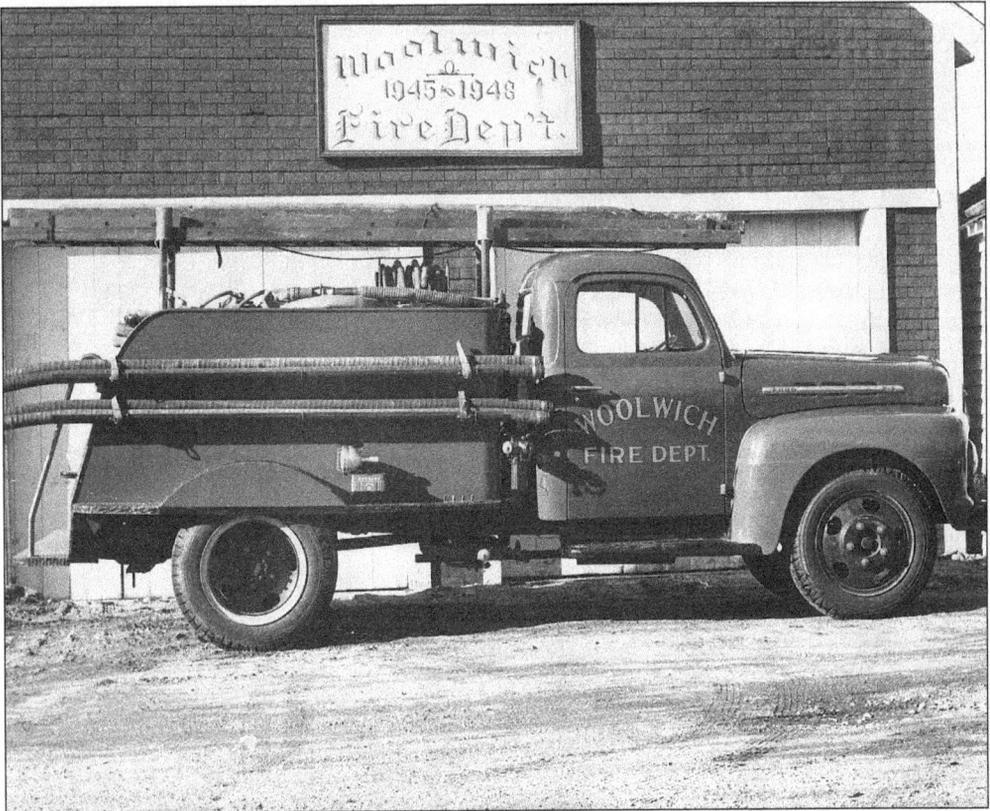

The town's first fire truck. Woolwich purchased its first complete fire truck in 1946.

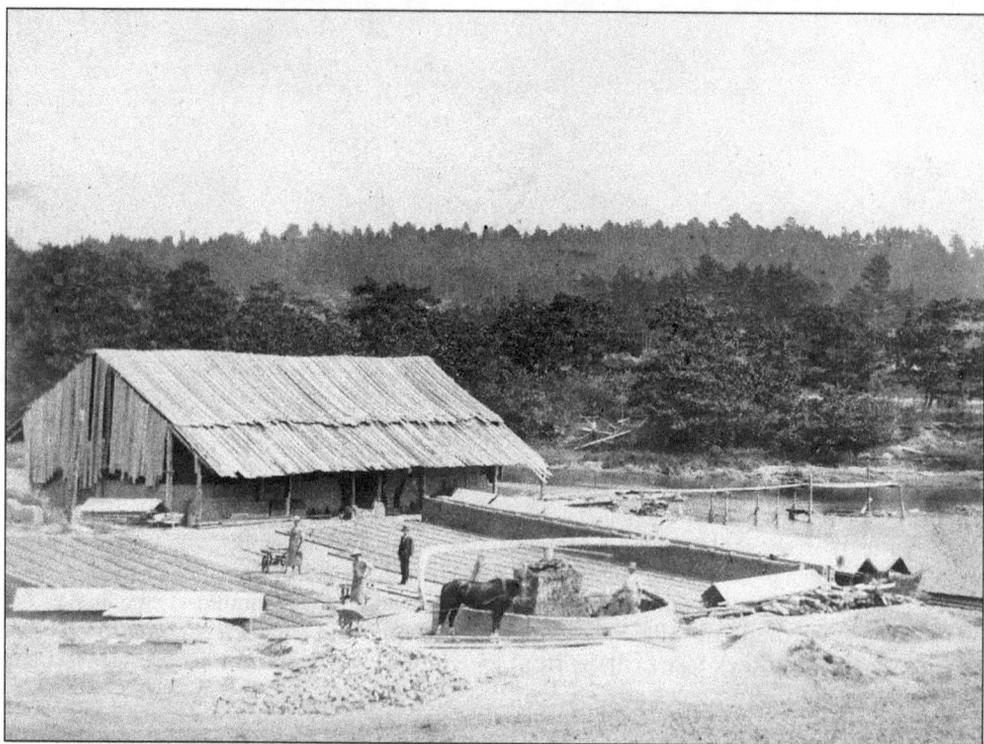

The Harnden Brickyard in Woolwich, 1890s.

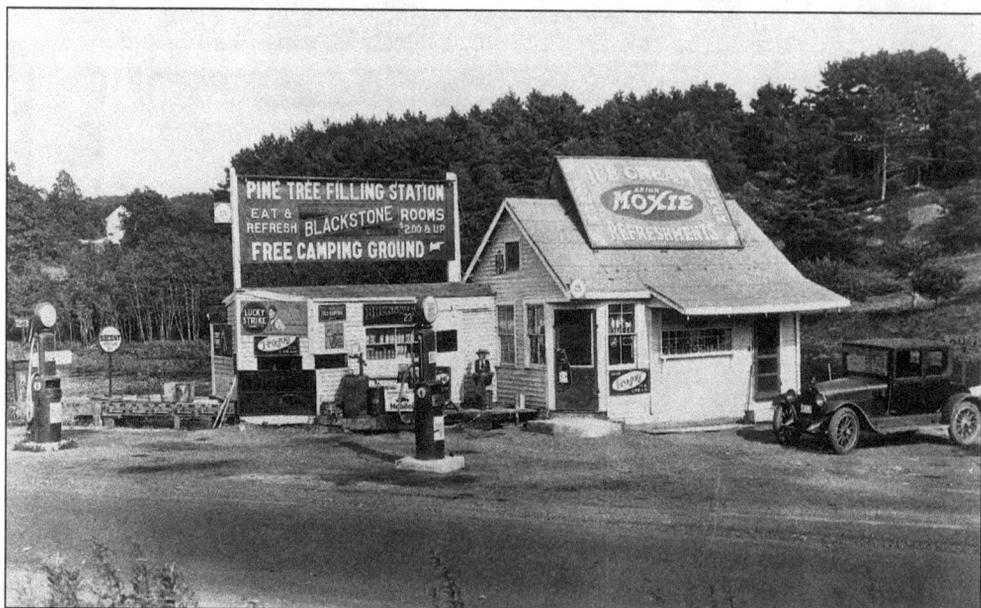

The Pine Tree Filling Station at Ryan's Corner in the Nequasset area on old Route 1 (now George Wright Road), c. 1920. This was a favorite stop for folks from away who were making their annual summer pilgrimage to "Vacationland."

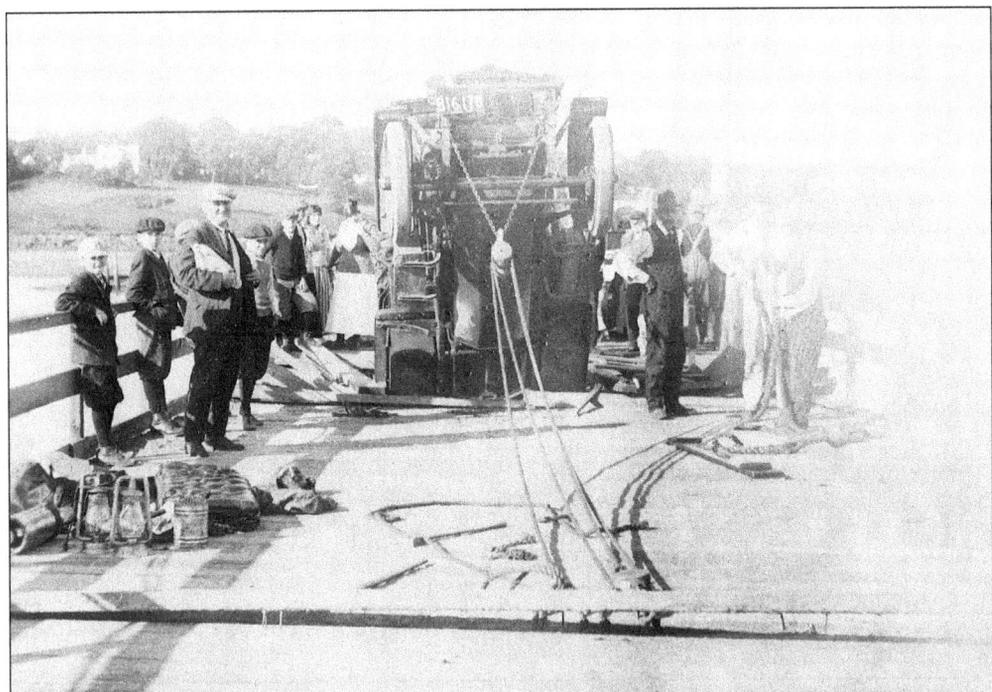
A construction crew working on Wiscasset's Birch Point Bridge in 1873.

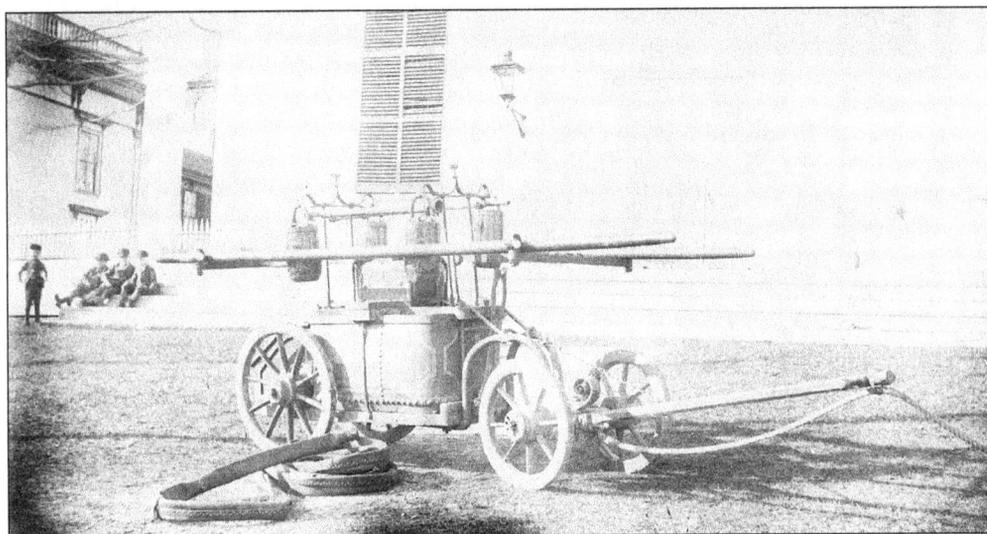
The Wiscasset Fire Society's old Settler fire tub, *c.* 1880.

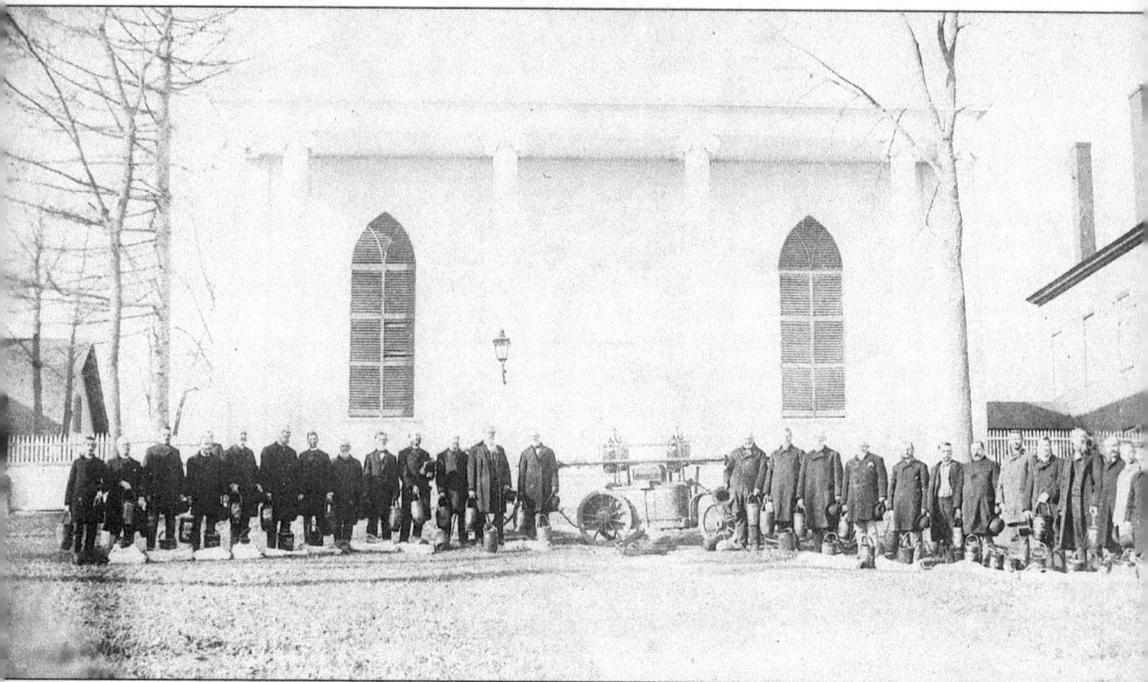

Members of the Wiscasset Fire Society, November 12, 1886. From left to right are: Joseph P. Tucker, David G. McRitchie, William G. Hubbard, Frank E. Johnson, F.P. Erskine, William H. Small, Frederick W. Sewall, James W. Savage, James M. Knight, George B. Sawyer, Joseph Tucker, Richard H. Tucker, Isaac Coffin, Silas L. Young, Henry Ingalls, William P. Lennox, Alfred Lennox, Richard H.T. Taylor, Isaac T. Hobson, Richard T. Rundlett, William D. Patterson, Charles Weeks, Seth Patterson, Jesse White, Charles E. Knight, Alfred H. Lennox, and Clarence A. Peaslee.

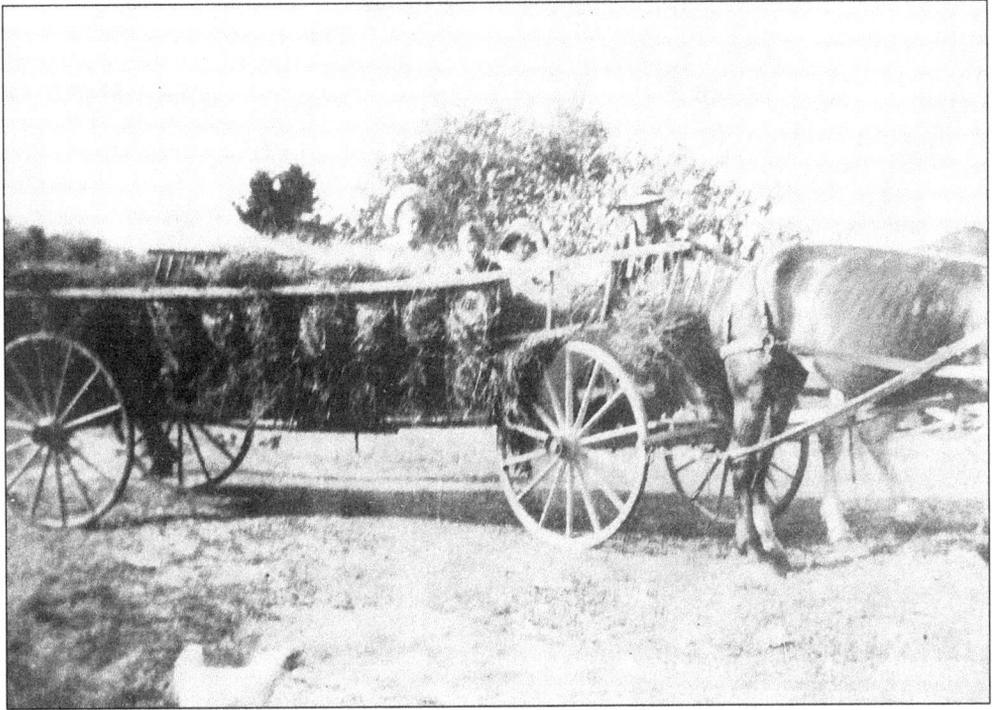

Asa Plumstead getting in the hay on his Wiscasset farm, c. 1890. This farmland is now part of Maine Yankee's property.

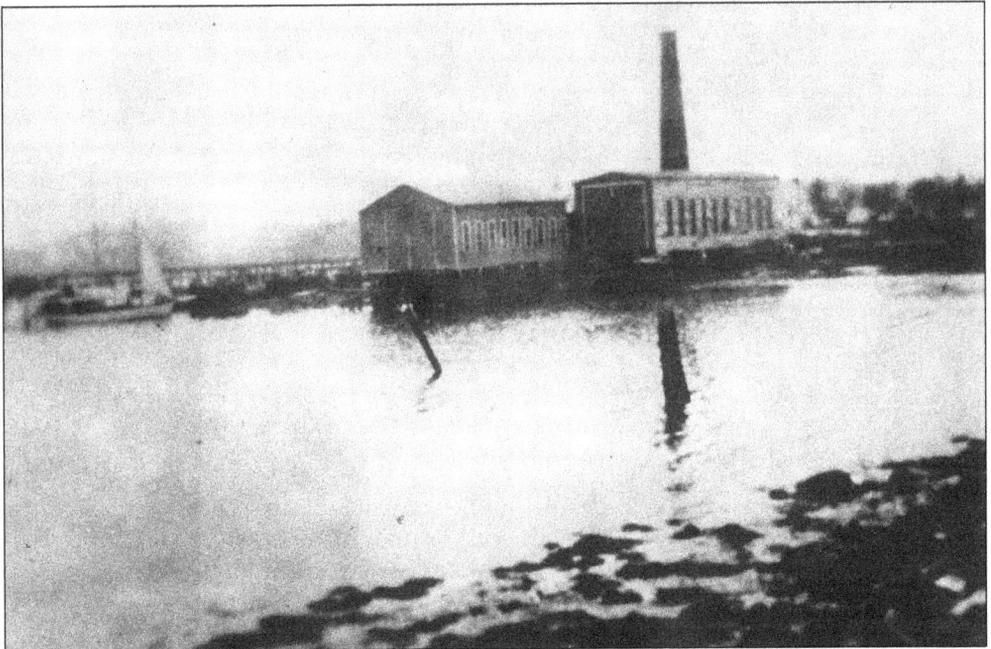

F.F. Pendleton's Boat Yard on Hobson's Island, Wiscasset, c. 1910.

George Plumstead working on his farm, c. 1920.

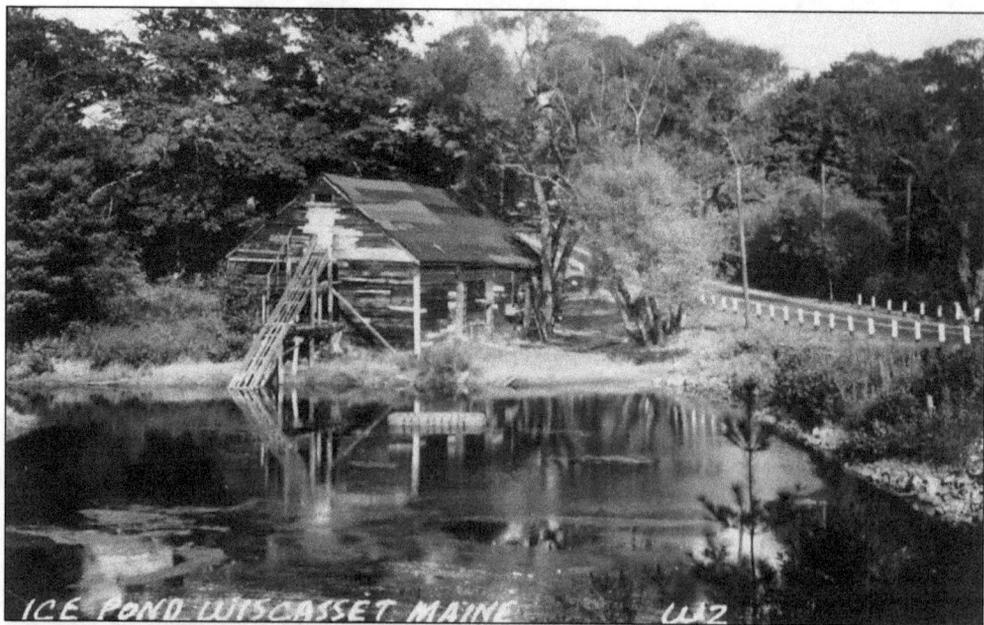

ICE POND WISCASSET MAINE W2

Ice "harvesting" on the river. Ice was big business for the region until the 1940s, when refrigeration technology rendered it obsolete.

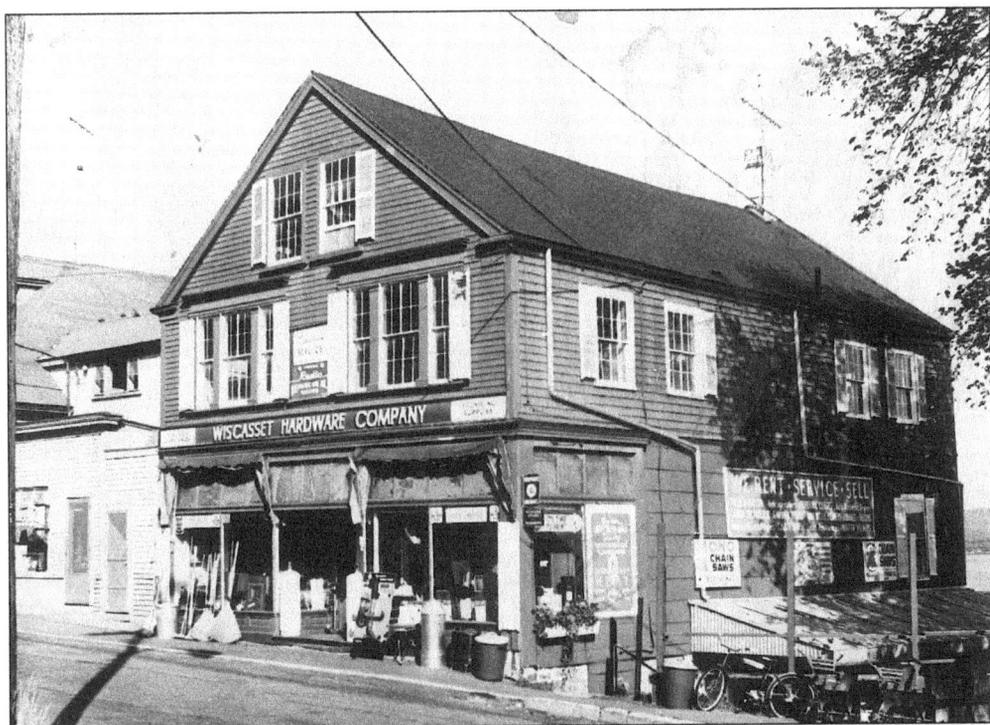

The Wiscasset Hardware Store on Water Street, *c.* 1950. This store maintains the hardware business tradition of the Haggett Brothers of an earlier day.

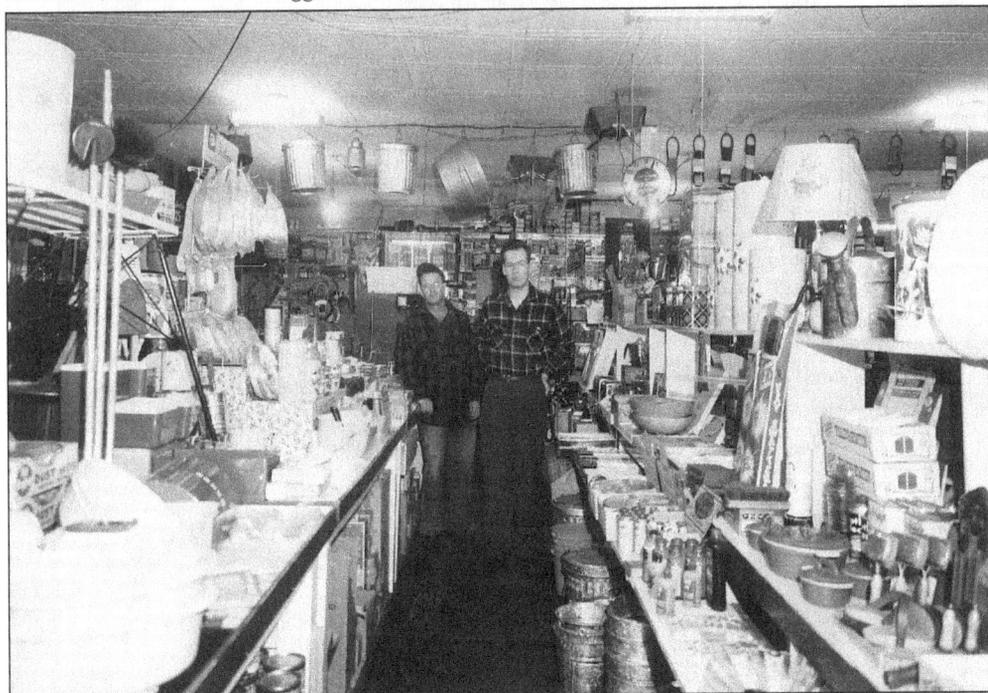

Louis Tabordis (left) and Bancroft Stetson (right) at the Wiscasset Hardware store during the 1950s.

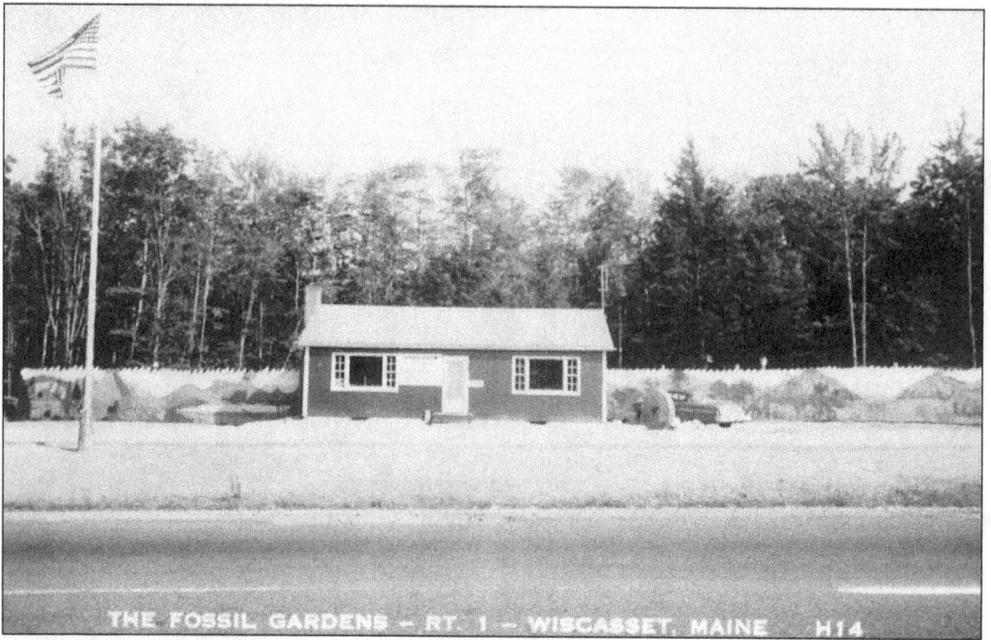

The Fossil Gardens, Route 1, Wiscasset, in the1950s.

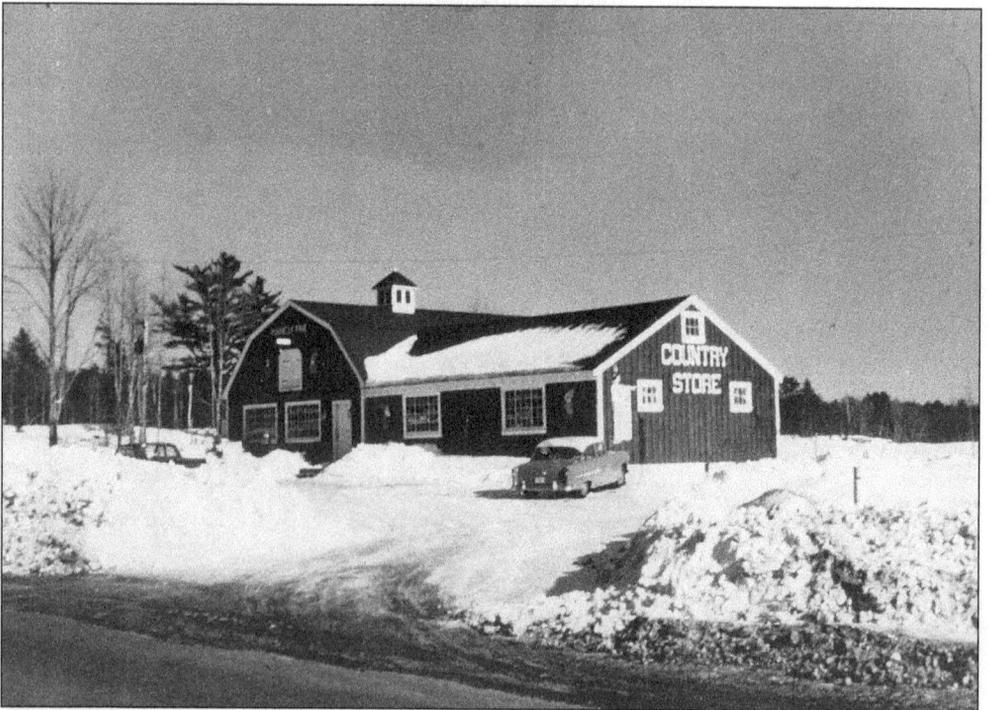

The Old Country Store, Route 1, Wiscasset. In 1961, Bob Nicoll revived the tradition of the Old Country Store at Mainely Pine.

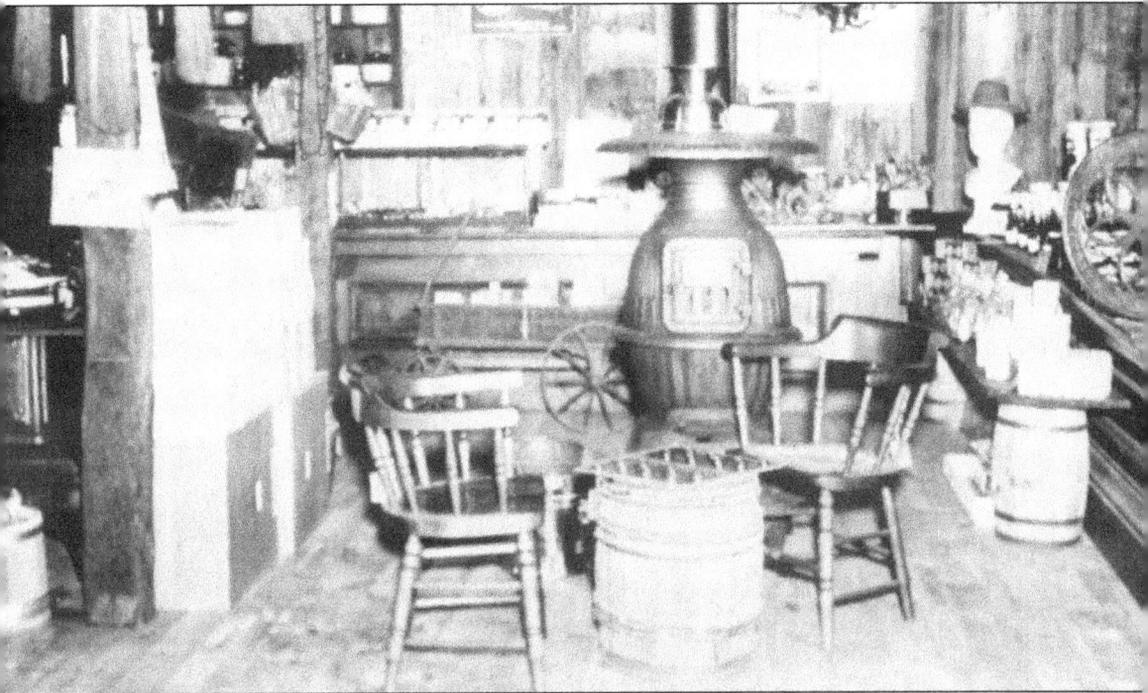

The Country Store, a favorite Wiscasset landmark since 1961. Bob Nicoll's restored Old County Store featured cracker and pickle barrels, old showcases filled with penny candy, Maine maple syrup, honey, jams, and much more. Locals and folks from away loved the nostalgic warmth that Bob had created and it quickly became a Wiscasset landmark. Bob's son Peter carries on the family tradition at the Maine Country Store on Route 1.

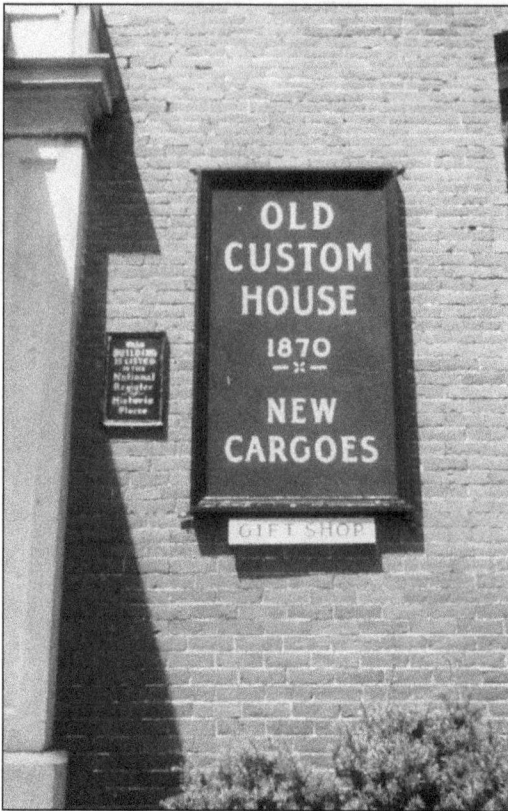

New Cargoes Gift Shop, in the old Custom House and Post Office Building. In 1970, Charlotte and Crosby Hodgman opened New Cargoes as a gift shop and gallery in Wiscasset's Old Custom House. The shop is now operated by Wendy Sparrell as Area's Jewelry and Gifts. The building has become known as "The Old Custom House," although in actuality, the building served the dual purposes of being the post office on the first floor and custom house on the second floor.

Captain James Heal Tarbox working with his team of oxen on the old James Loring Tarbox homestead, October 12, 1914.

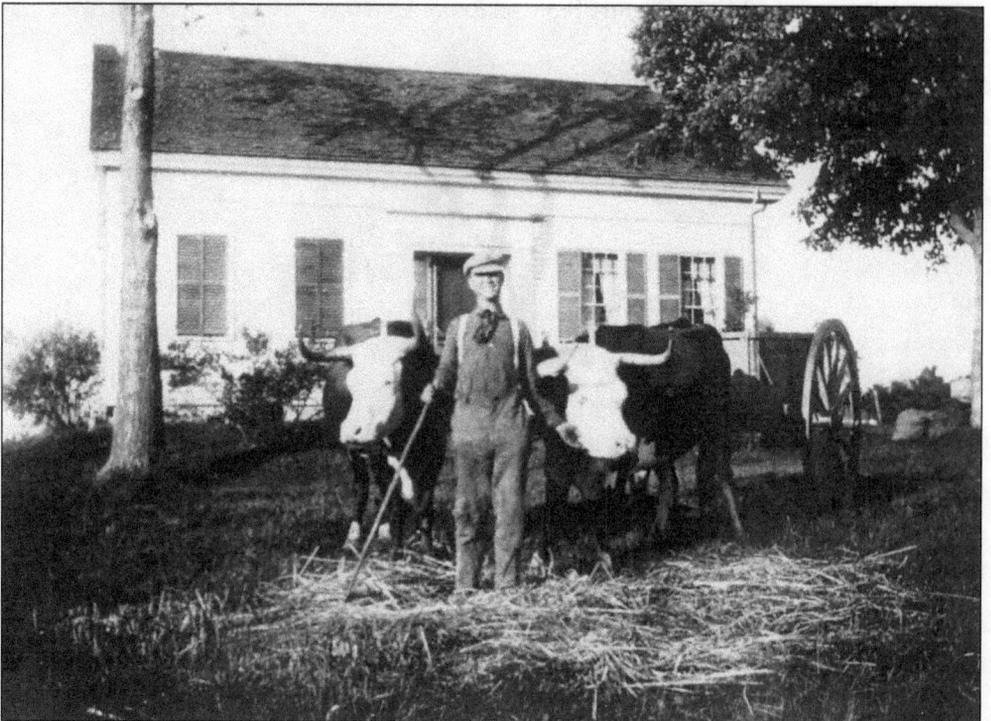

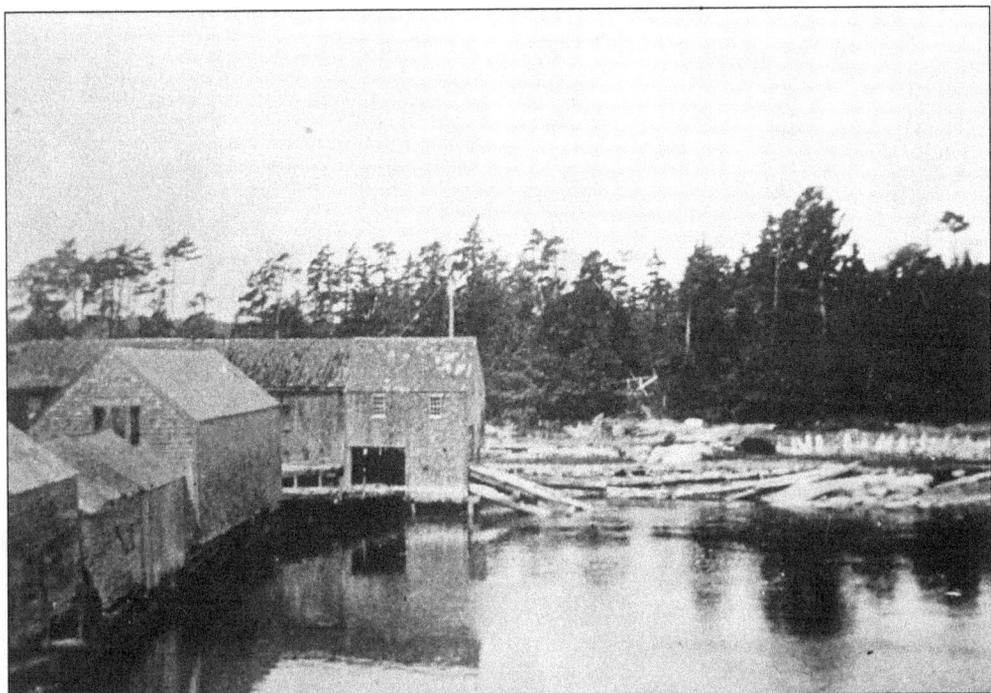

The lower Heal Mill, on the west shore of Westport Island. This was an active operation milling lumber during the busy building period of the 1890s. Captain James Heal managed the mill at that time.

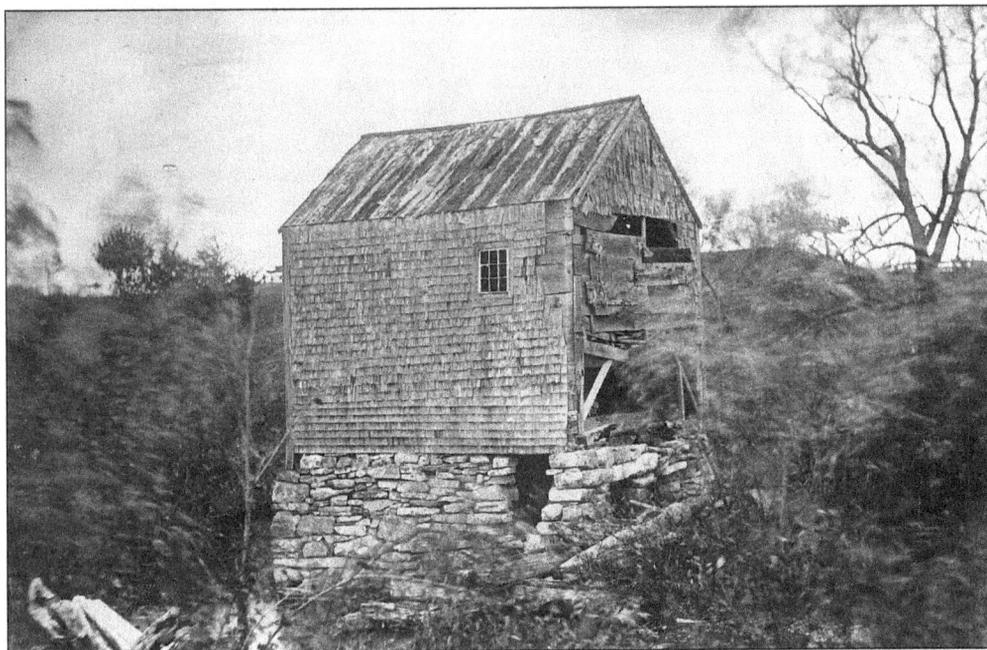

The old gristmill in Dresden Mills. Built by Dr. Gardiner in 1753, it is shown here during the 1880s.

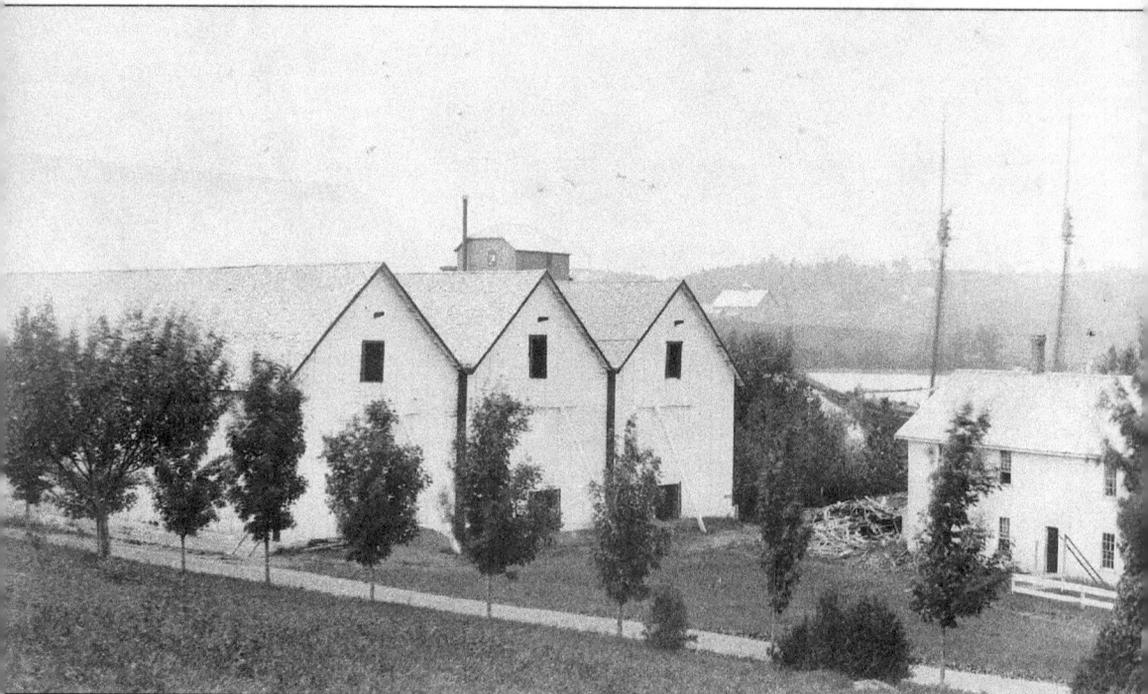

The Dresden Ice House on the Kennebec River. This facility was an active operation and employed a number of workers in the flourishing ice trade from the 1880s until it was made obsolete by refrigeration technology.

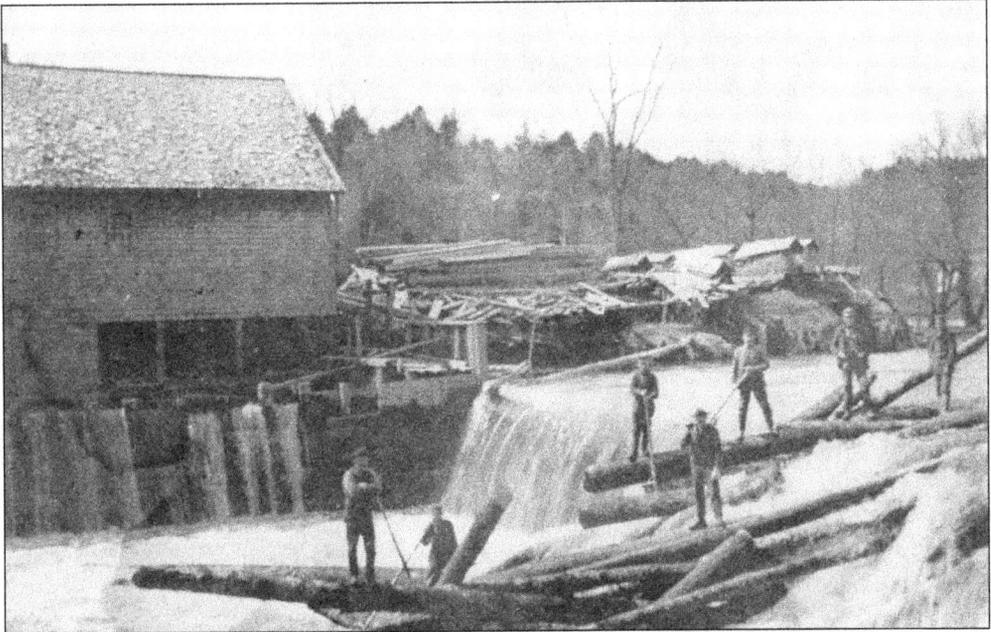

Running logs for milling at the Head Tide mill, *c.* 1900.

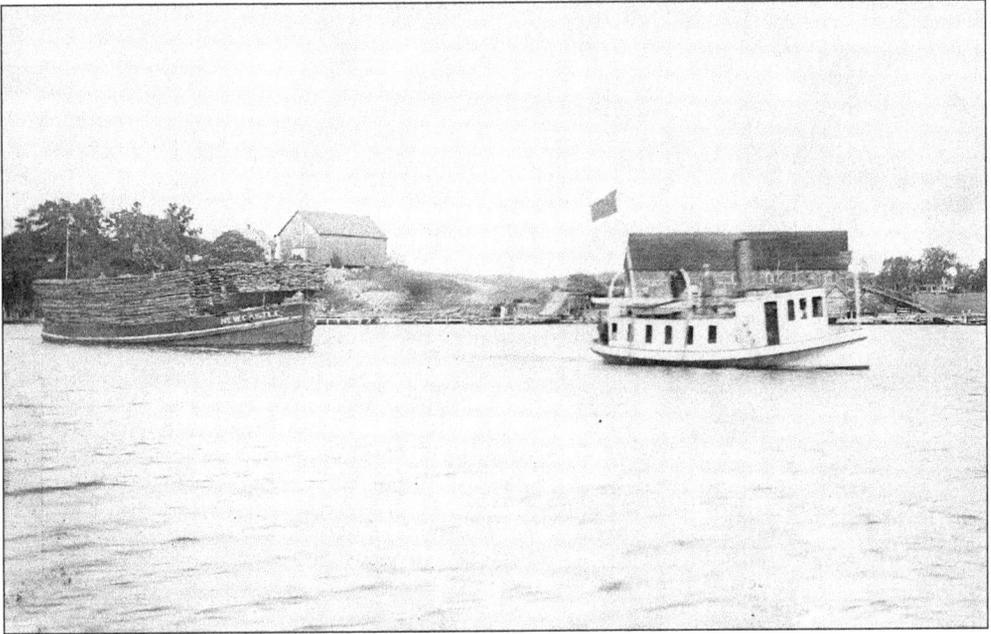

A tugboat heading south downriver and pulling a barge with a load of lumber. This photograph was taken near Reversing Falls, *c.* 1900.

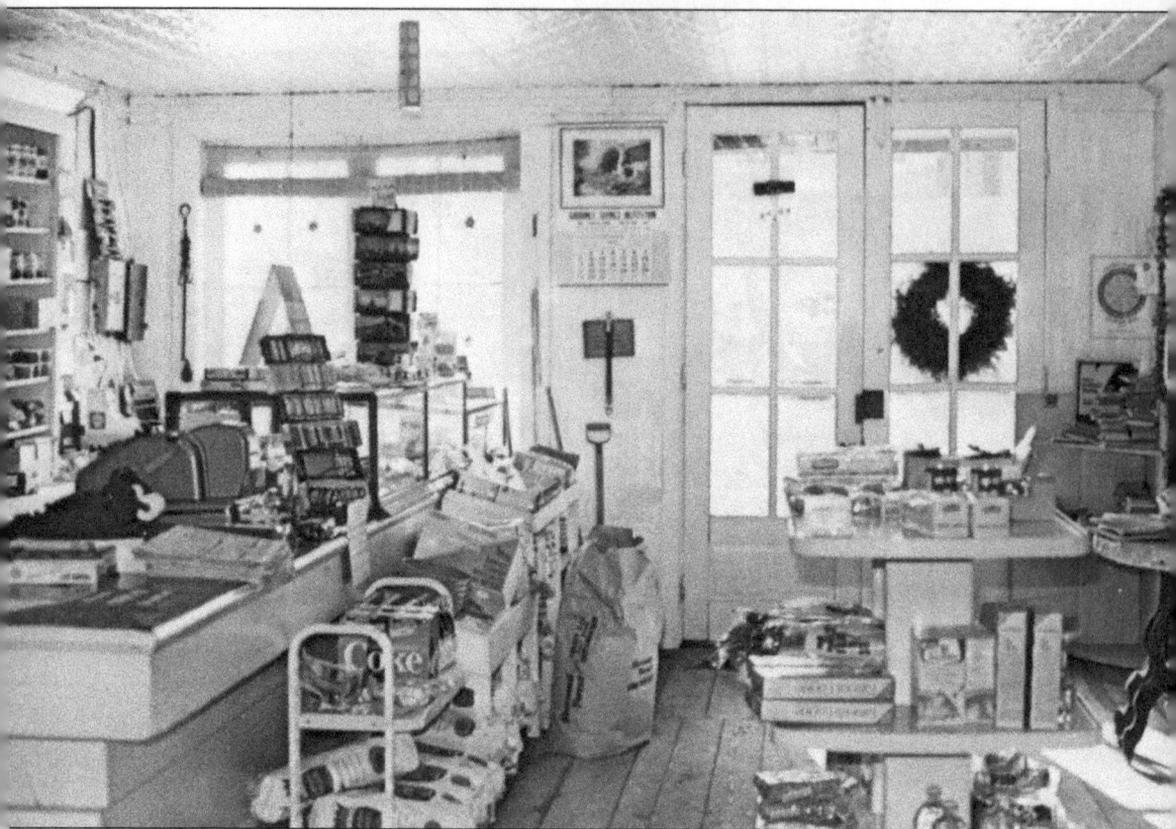

The Country Store in Puddle Dock, Alna. As can be seen here, the store offered a wide variety of useful gift items for the 1969 holiday season.

Seven

Hostelries

The early settlers of the region used the local hostelries as the social and political centers in each community. In fact, the inn of those bygone days was second in importance only to the meetinghouse. Prior to the building of a meetinghouse, all town meetings were held at the local inn. Hostelries have played a key role in our communities since the mid-1750s. A century later, the Wiscasset region was discovered as a vacation destination and the inns were used by folks from away on a much greater scale. Popular inns of the region have continually played a strong role in our commercial and social development.

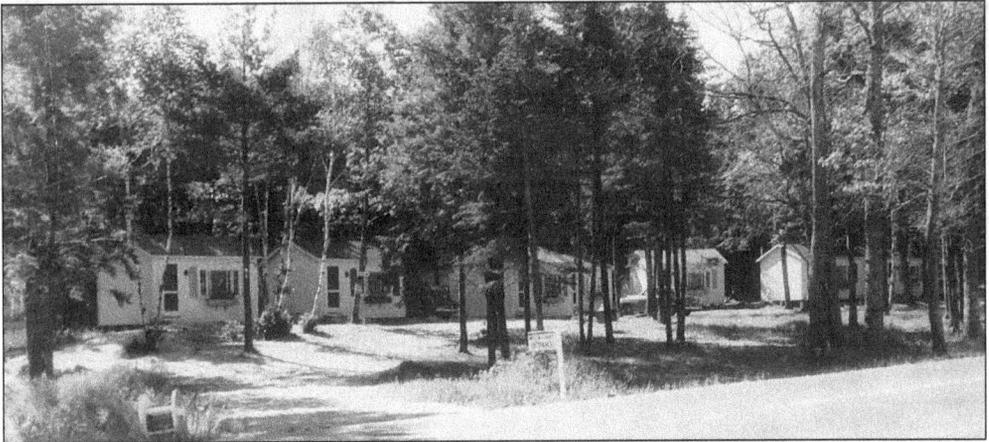

The Steak House Inn and Motor Court on Route 1, Wiscasset. This inn, with a tranquil Maine pine ambiance that brought guests back year after year, was a favorite mid-coast destination for many folks from away during the 1930s and '40s. It is now known as the Wiscasset Motor Lodge.

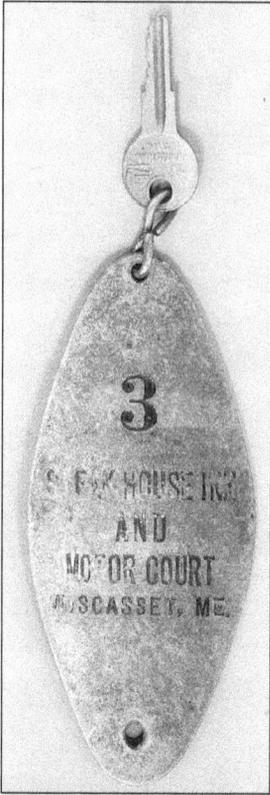

A key to a cabin at the Wiscasset Steak House Inn and Motor Court, c. 1930s.

A view looking down Route 1, late 1940s. Rounding the corner on Route 1, heading toward the Village of Wiscasset, one can see the Ledges Inn (right) and the Common (left) with the Congregational church and Lincoln County Court House in the background.

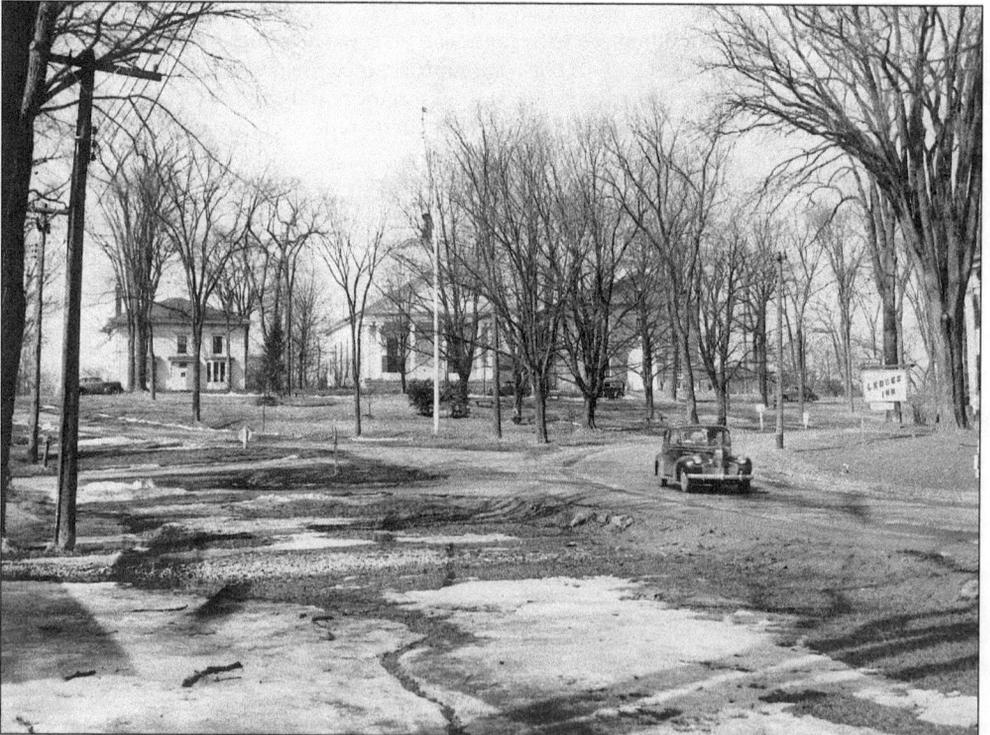

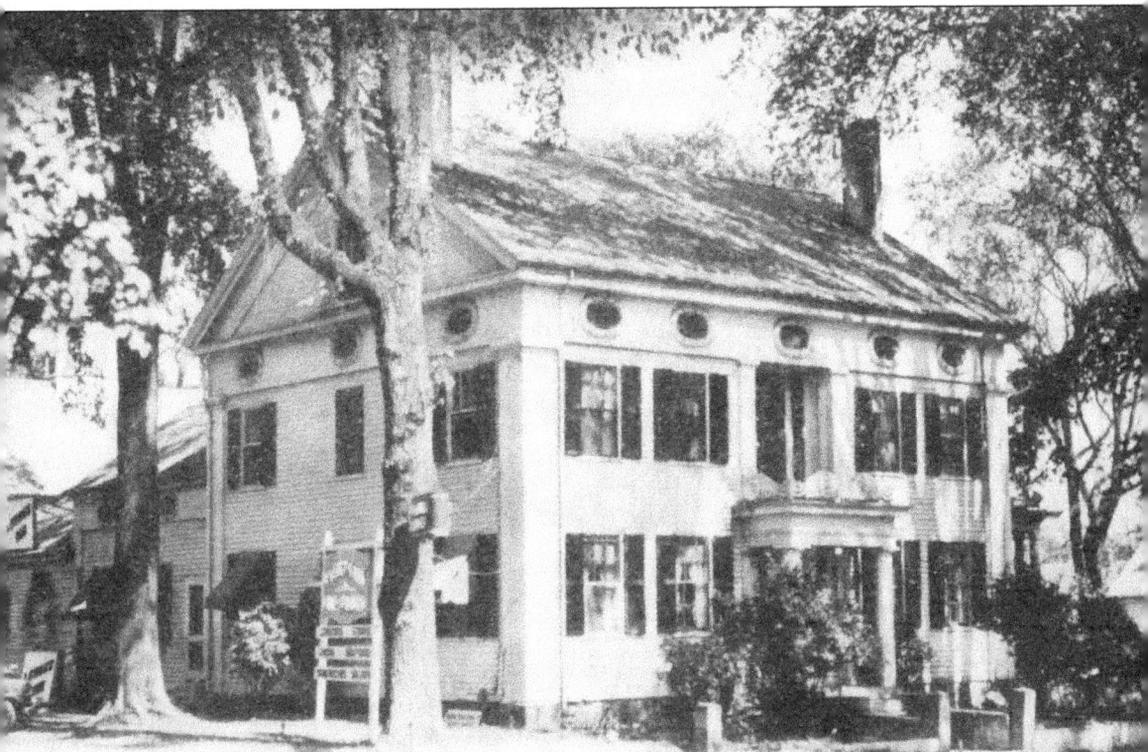

LEDGES INN, WISCASSET, MAINE

The Ledges Inn. In the 1940s, this hostelry beckoned to many a weary traveler to stop and enjoy the ambiance of a fine New England inn. It was the historic home of Dr. Bernard A. Bailey, and was built on the site of General Abiel Wood's home in 1845. In 1888, Captain Samuel Boyd Doane purchased the property. It remained in his ownership until his untimely death while trying to quell a mutinous sailor's attack; Captain Doane was stabbed to death in this skirmish, and in a burst of maniacal frenzy, a sailor also bit off the sea captain's nose. His widow lost their home to the bank shortly after his death. Today, the hostelry maintains its gracious tradition and warmth as The Bailey Inn and Restaurant.

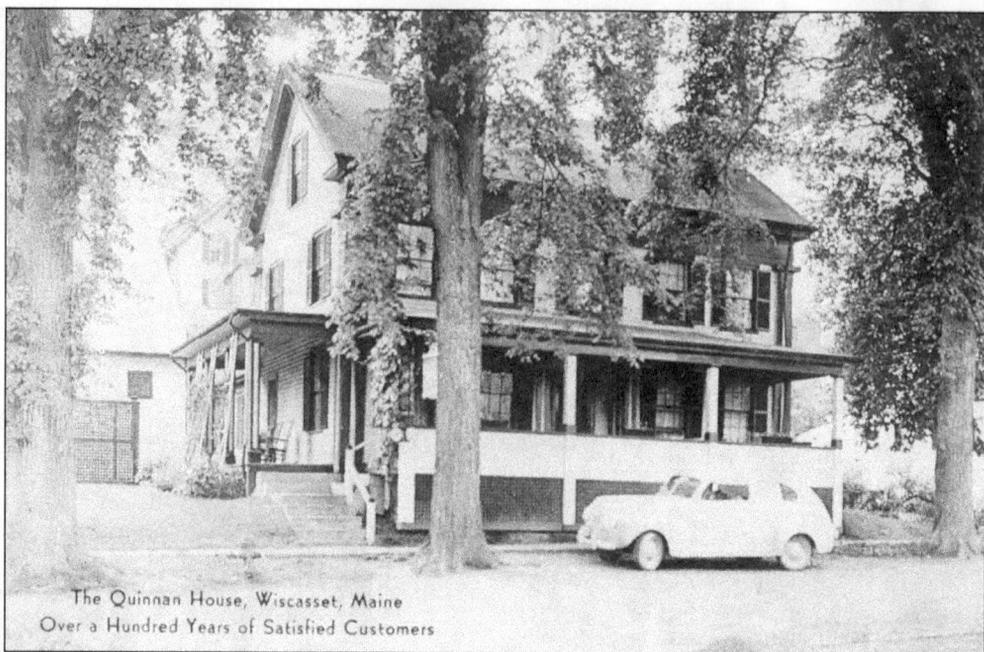

The Quinnan House, Wiscasset, Maine
Over a Hundred Years of Satisfied Customers

The Quinnan House on Middle Street, 1940s. This Wiscasset inn was a home away from home for guests to the region for over a century.

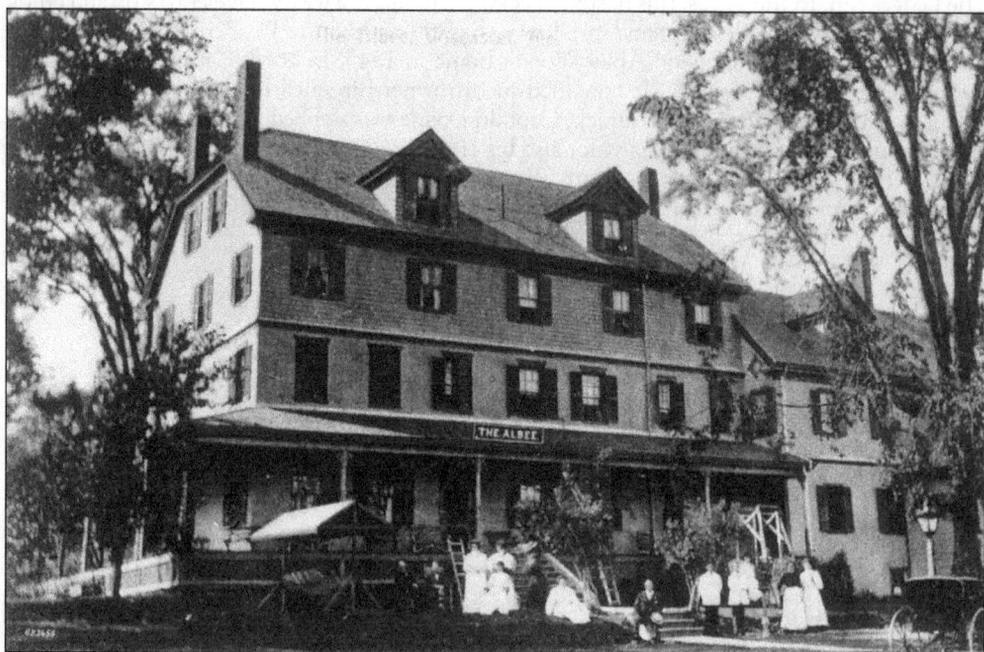

The Albee, c. 1900. The Stacy House, the Albee, and the Wiscasset Inn are names that this landmark hostelry on Federal Street has borne through the years.

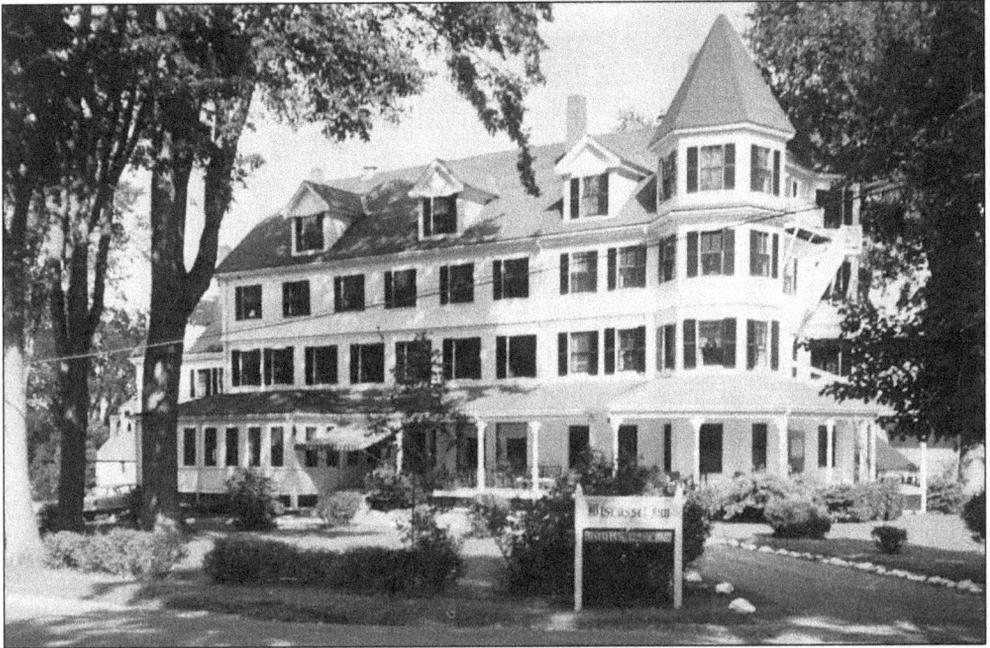

The Wiscasset Inn after a major face lift.

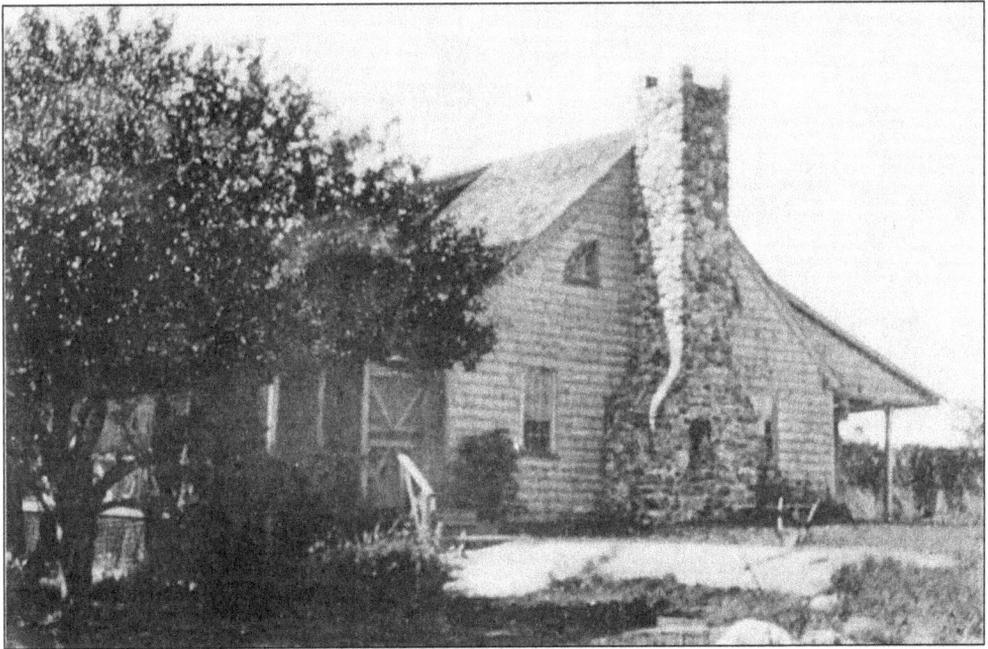

The Enchanted Barn Tea Room, c. 1950. This unique setting was a quiet oasis for both travelers and locals.

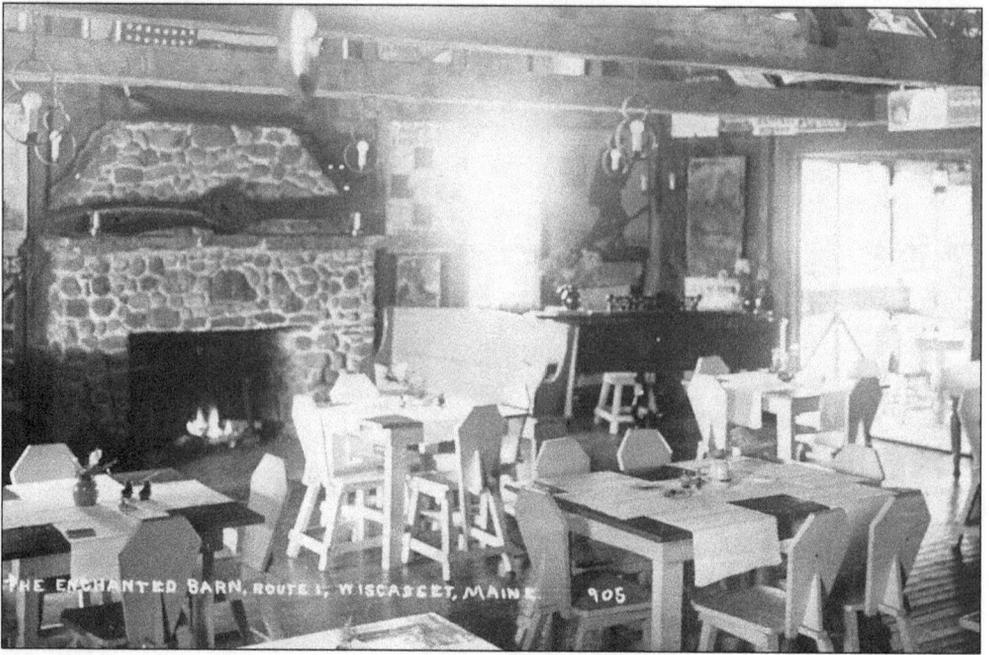

The Enchanted Barn Tea Room. Folks enjoyed tarrying awhile with tea and good company in this tranquil setting.

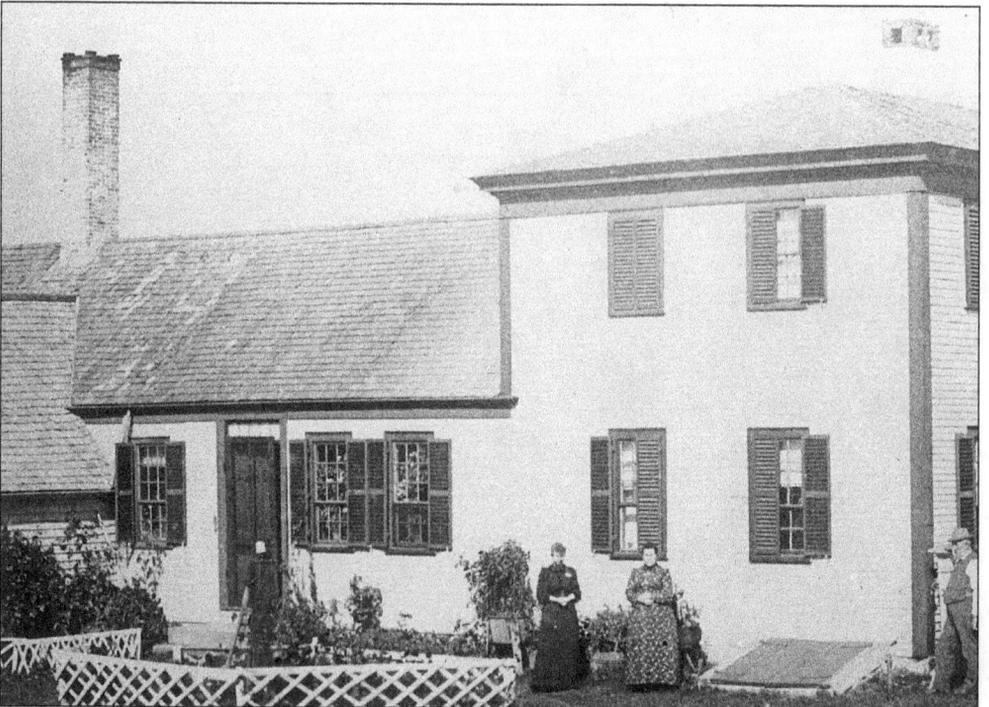

The Squire Tarbox House, Westport Island, 1890s. Shown are, from left to right: Bette Welch, Blanche Hilton, and Steve Webber. Since 1970, this historic home has been operated as a fine inn.

Eight

Tides of Fortune

When peace came at the close of the King Philip's Wars and resettlement of the region took place, the ingredients for a golden age were at hand. Wiscasset Harbor was one of the finest deepwater-protected ports on the east coast, the region was well-timbered, and new settlers were up to the challenge of developing their resources. Ships, brigs, and schooners were required for an active trade business with Europe and the burgeoning colonies of the West Indies. Many large cargo-carrying vessels were built in the region during the late 1790s and early 1800s. After the Civil War, new technology ended the need for the luxuriant type of ships that local yards were used to building and the region fell on hard times. A few small yards survived by staying focused on the building of small custom boats. It was 1910 before a shipyard emerged that captured the minds and hearts of famed naval architects and wealthy yachtsmen. In 1910 the Pendleton brothers, Fred and Emery, leased a section of Hobson's Island from Erastus Foote, the island's owner, to establish the F.F. Pendleton Shipyard. The two brothers were experienced shipwrights, and the next twenty-nine years saw this small yard, which never employed many more than twenty men, build some of the most elegant yachts built in America.

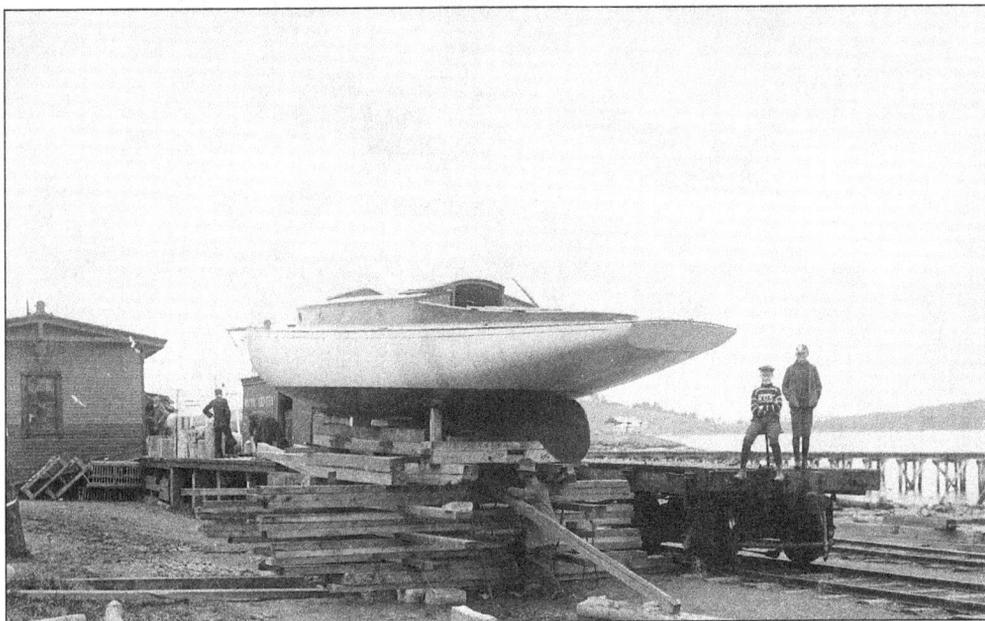

Work at the F.F. Pendleton yard, 1920s.

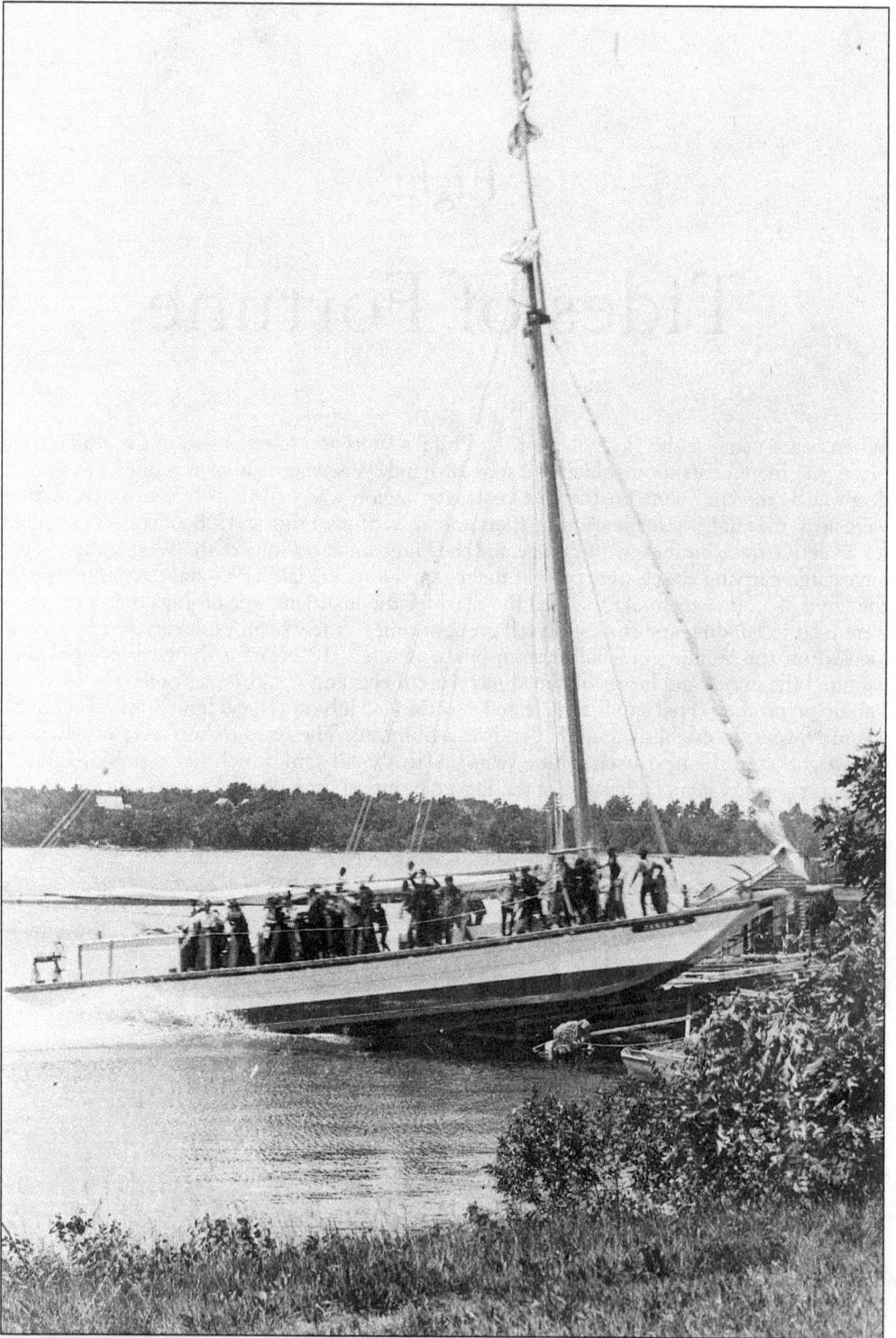

The *James M11*. Owned by James Tiller, the *James M11* was launched at Woolwich on June 8, 1895.

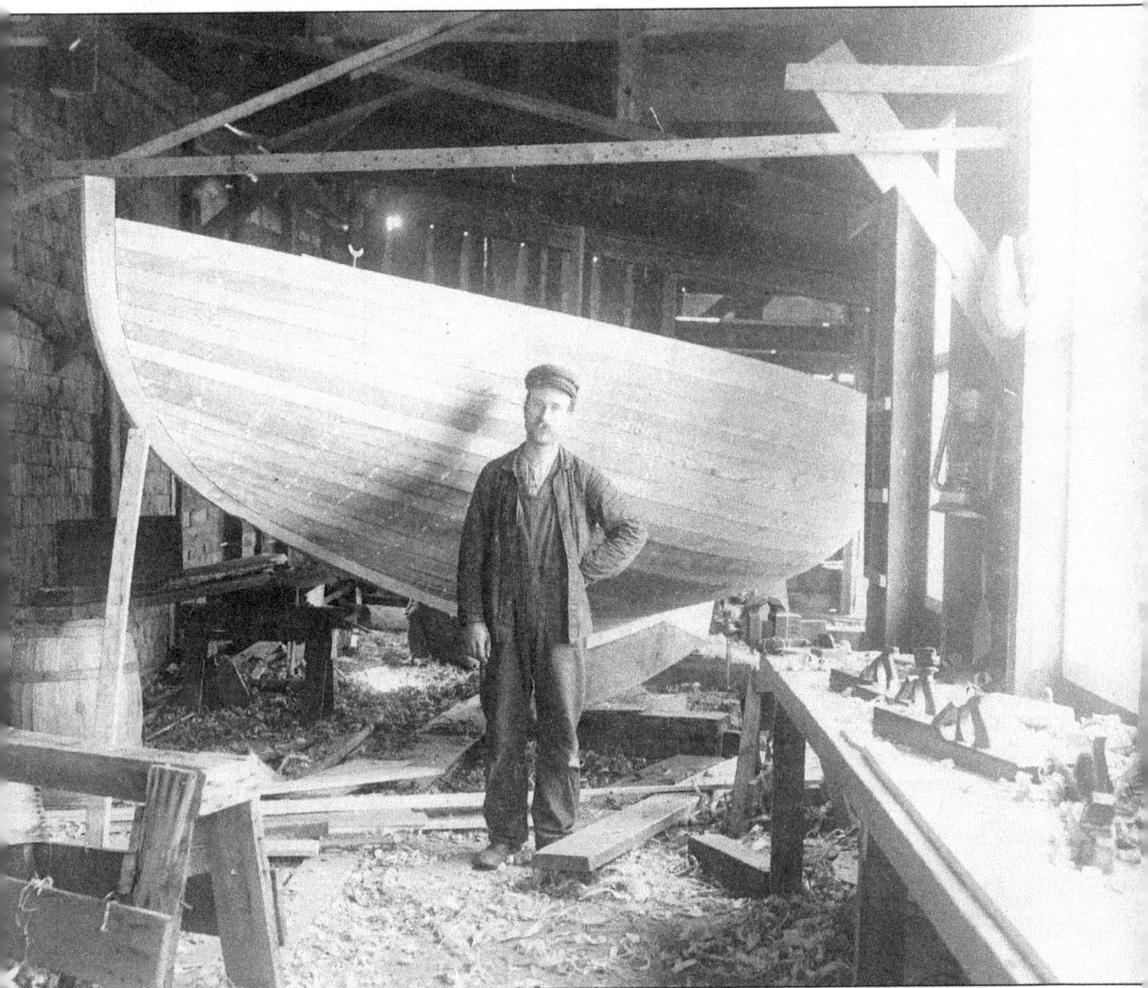

The F.F. Pendleton yard. This shipbuilding yard was one of the most commercially active operations on the Wiscasset waterfront. It was nationally known for building high-quality schooners.

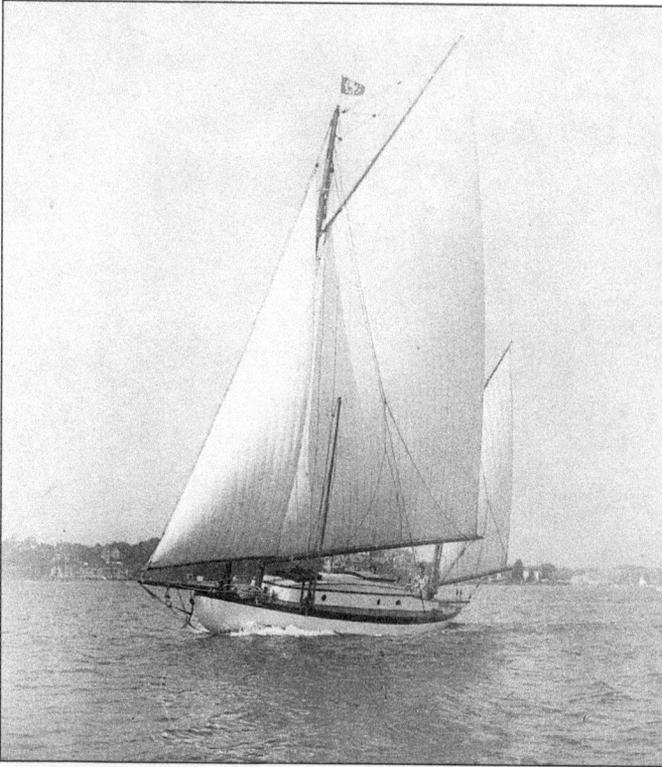

The *Athro F* under sail. This vessel was built at the F.F. Pendleton yard in the 1920s.

The *Windfall*, originally named the *Flying Cloud*. This vessel was launched from F.F. Pendleton's in 1922. The 64-foot schooner made a return trip to Wiscasset under Captain Cummings. The yacht's owner was USAF Colonel Hinkley, of New Orleans, LA.

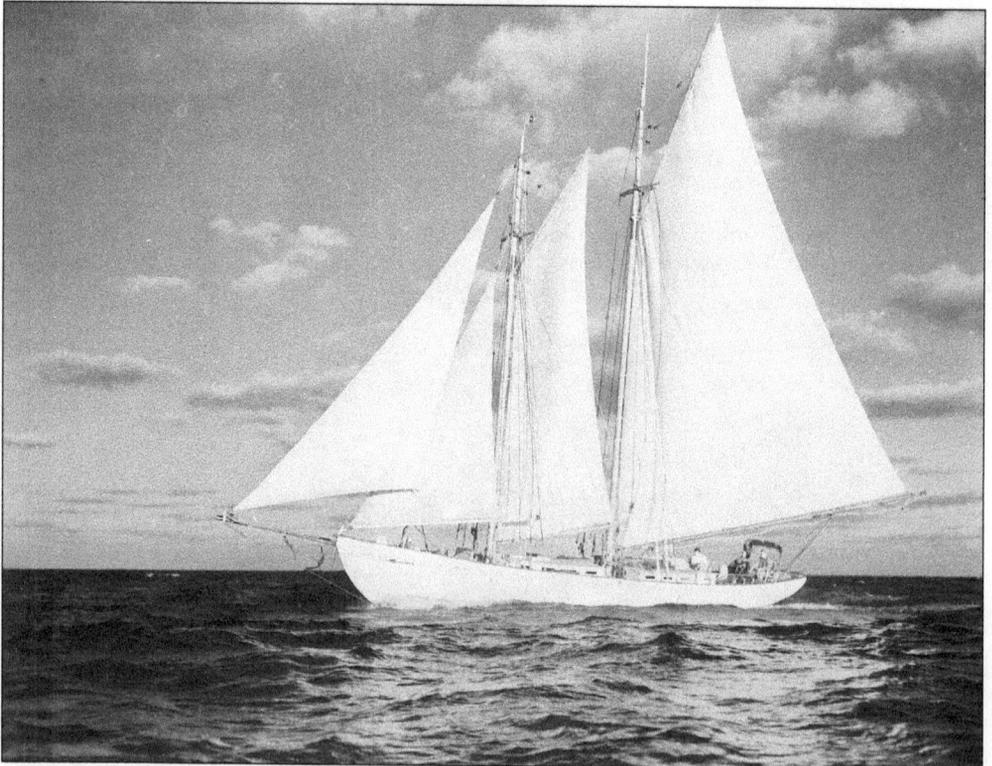

Work in the interior joiner shop of F.F. Pendleton's in 1934.

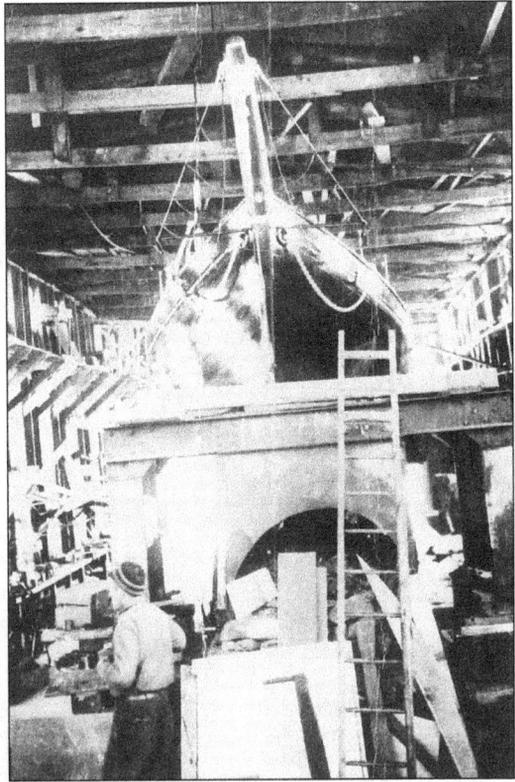

The *Coaster III*. This ship was built by the F.F. Pendleton yard for a Mr. Royce of California during the 1920s.

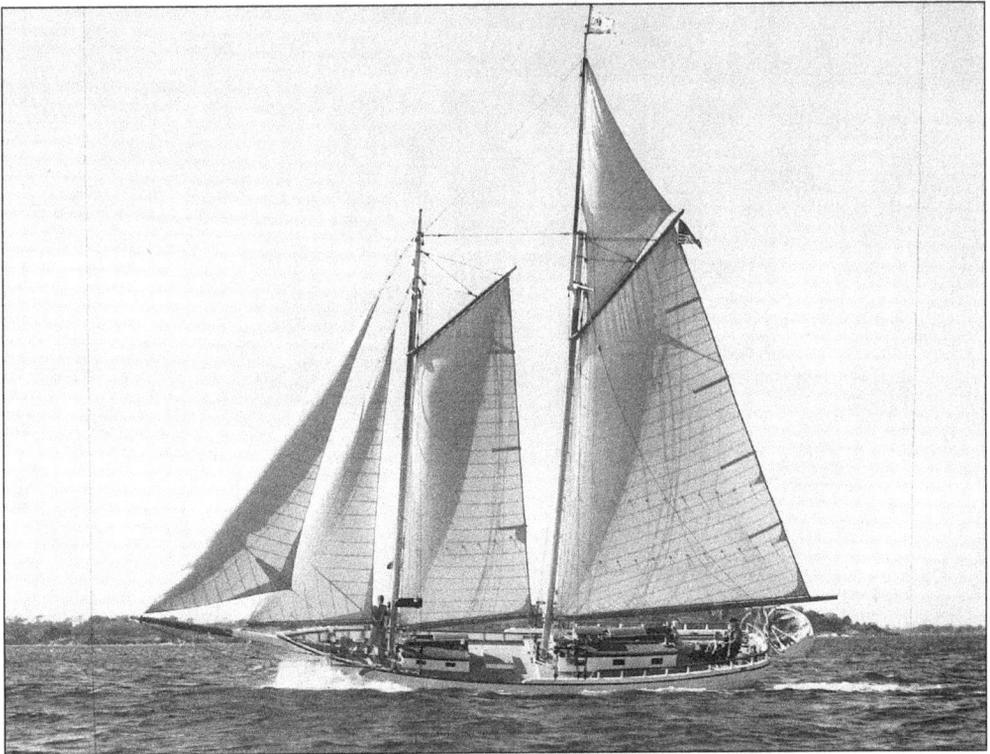

The contract between General George Patton and the F.F. Pendleton yard of Wiscasset. The contract provided that F.F. Pendleton's would build him a 63-foot 5-inch auxiliary schooner.

The *When and If.* General George S. Patton's schooner was launched from the Pendleton yard in the fall of 1938. The general planned to sail his schooner around the world someday. Casting a weary eye toward Europe— and upon his own uncertain destiny as a career U.S. Army officer—helped to provide the name for his yacht.

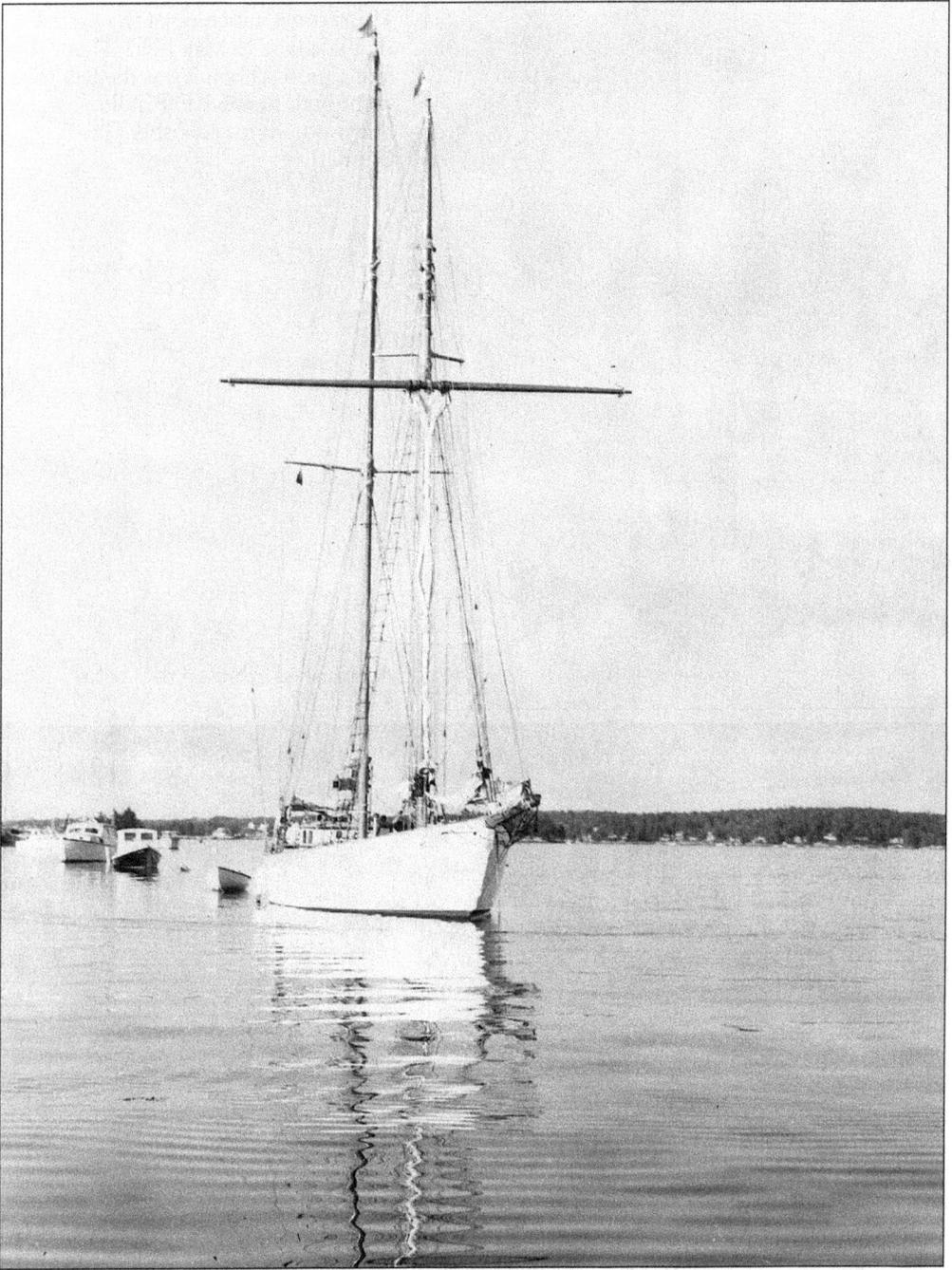

The *When and If* on a mooring in Boothbay Harbor during the 1960s. The yacht was then owned by General Patton's brother-in-law, Mr. Ayers of Massachusetts.

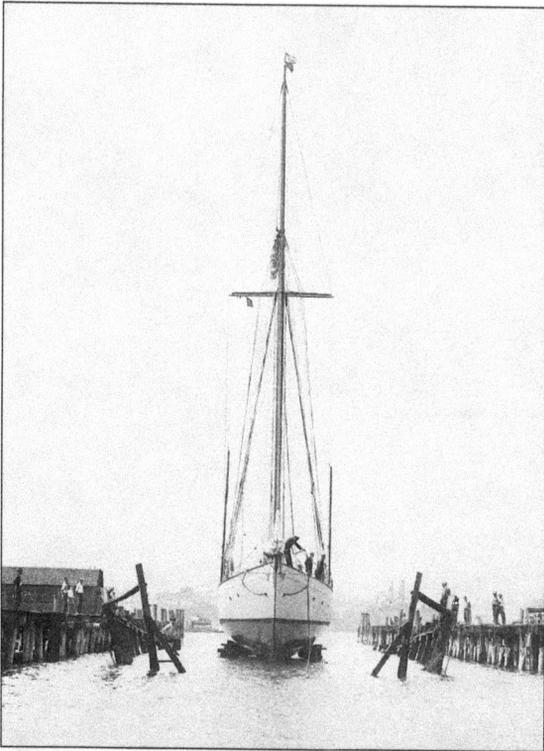

The second launching of the *Kestrell II* at Portland in May 1930. This 931-foot topsail schooner was the largest yacht built by the F.F. Pendleton yard. She was built for publisher Guy P. Gannett.

A furnished cabin on the yacht *Kestrell II*.

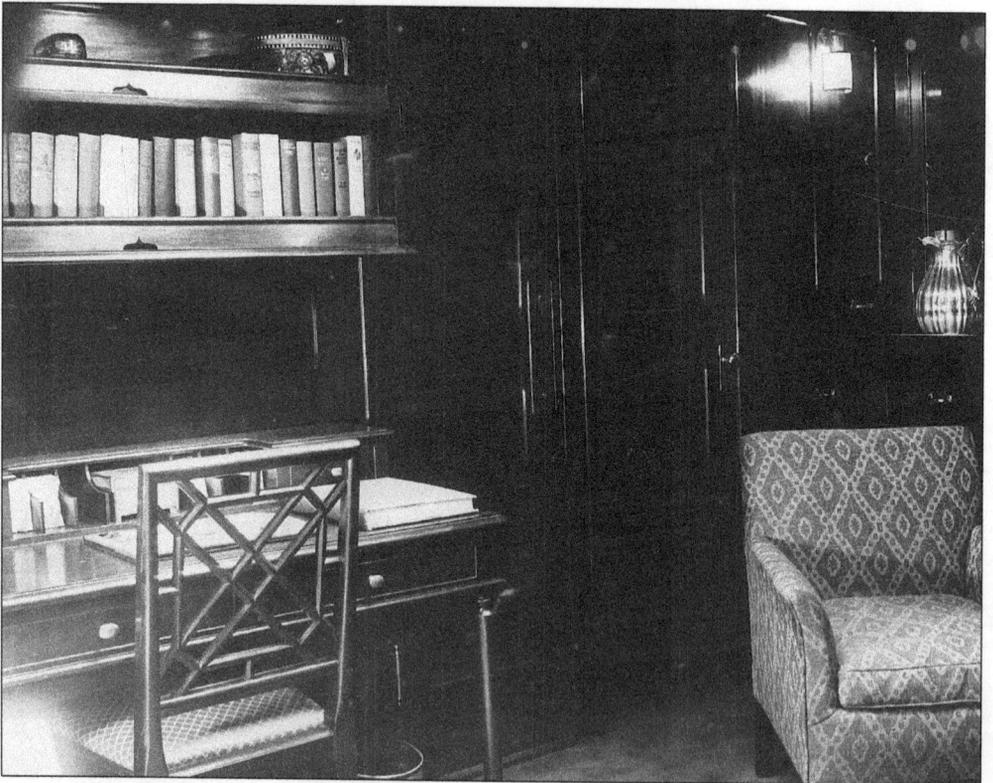

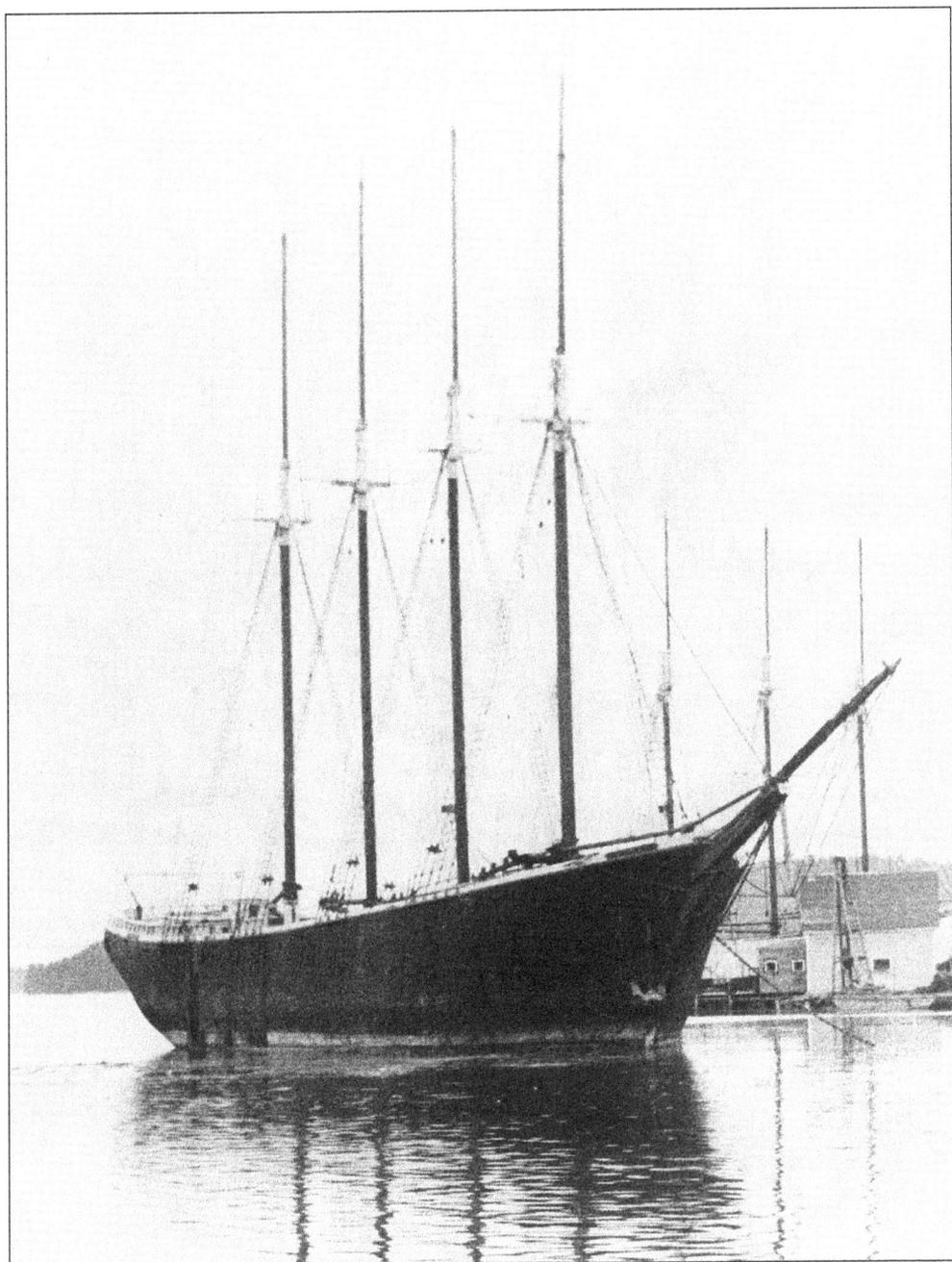

The *Hesper* as she was being brought in from her Wiscasset Harbor mooring for beaching in the late 1930s. The masts seen in the background belong to the docked *Luther Little*.

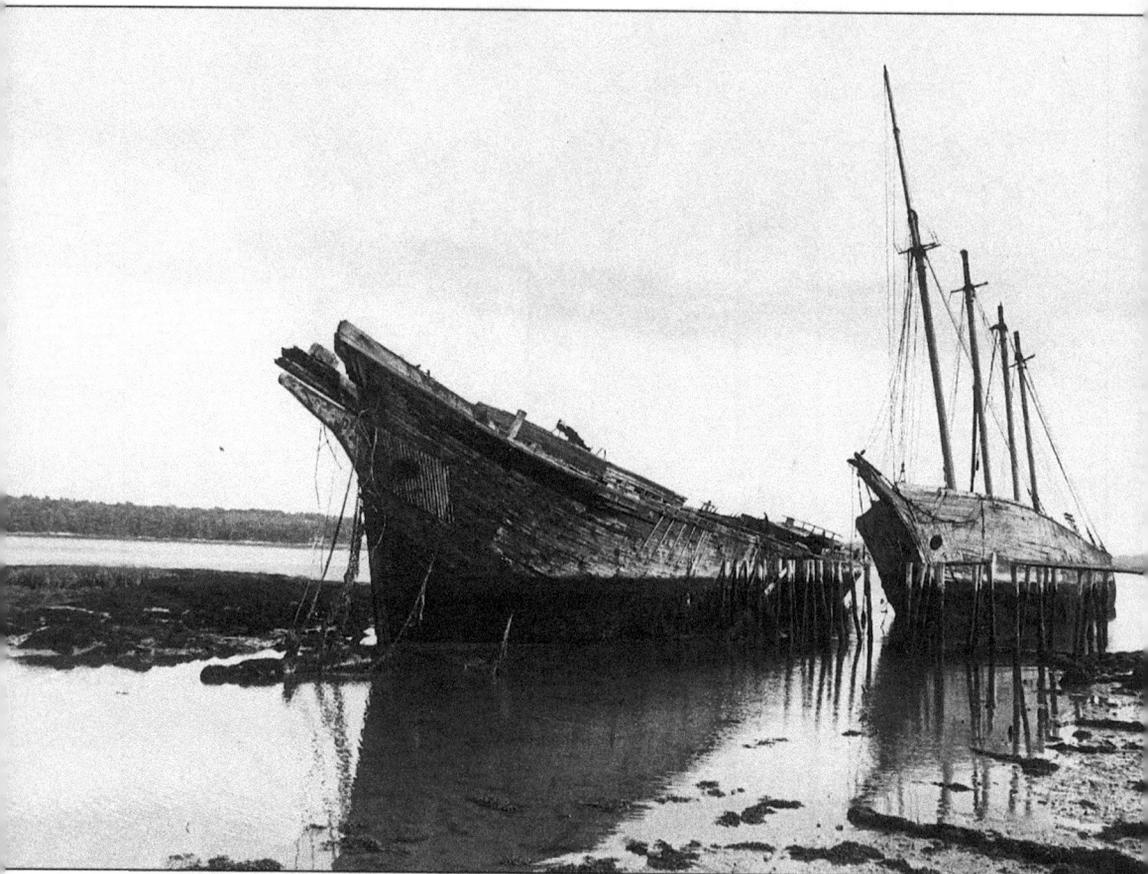

The *Hesper* and *Luther Little*. For more than six decades they have evoked the presence of a faded maritime history. Here, on the mud flats of the Sheepscot River in the village of Wiscasset, lie the hulks of the *Hesper* and *Luther Little*. They are the last surviving remains from a fleet of four-masted schooners which no longer ply the seven seas.

Nine

The Fun Times

These were simpler times—when a Fourth of July parade, a ball game, a boat ride, sleighing in the snow, or a walk through the woods would rekindle our spirits and bring out the kid in each of us. Back then, "burnout" referred to not stacking the stove with sufficient wood. These were surely the best of times.

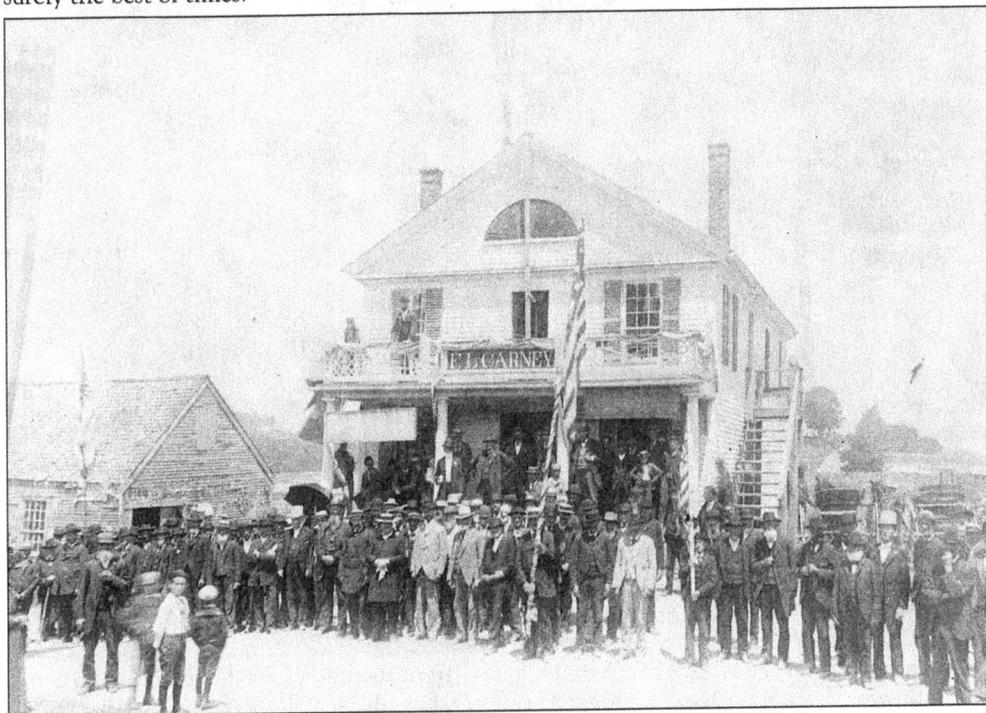

Celebrating the removal of the toll on the Sheepscot Bridge on July 22, 1894.

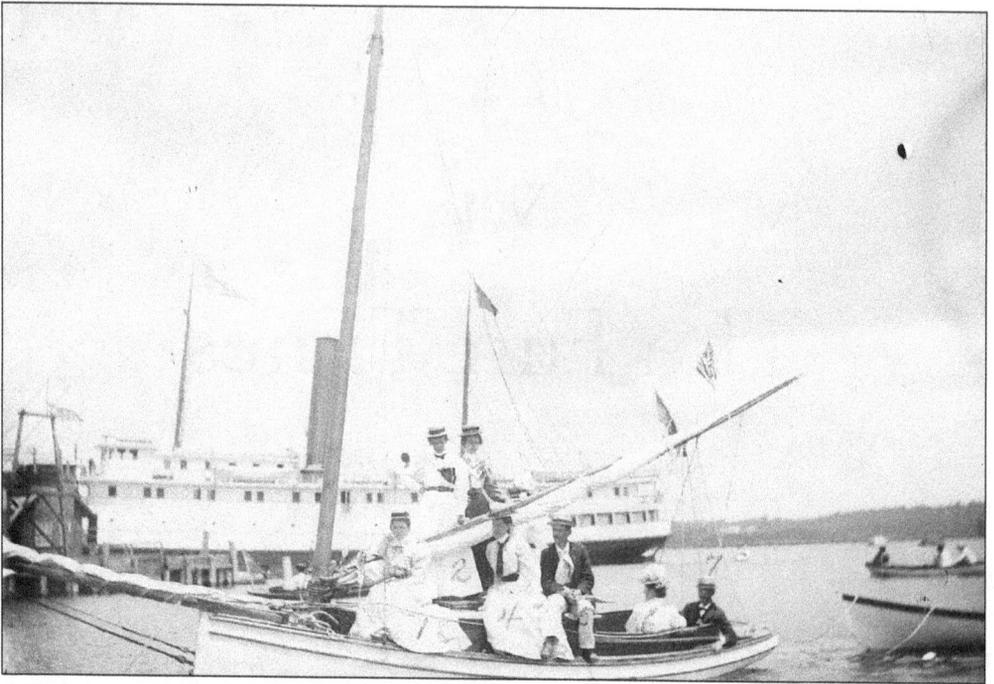

A yachting party during the summer of 1900, near Whaleship Wharf, Wiscasset Harbor. The party included: Mrs. Sol Holbrook, Helen McLaughlin, Mamie Taylor Hubbard, Nina Rundlett, Fred Lennox, Elizabeth Neal Tucker, and Joe Tucker.

A summer gathering, c. 1900. This group includes: (front row) Alice Taylor, Fred Lennox, and Anna Brown; (back row) Nina Rundlett Lennox, Elizabeth Neal Tucker, and Helen Lennox McLaughlin.

114

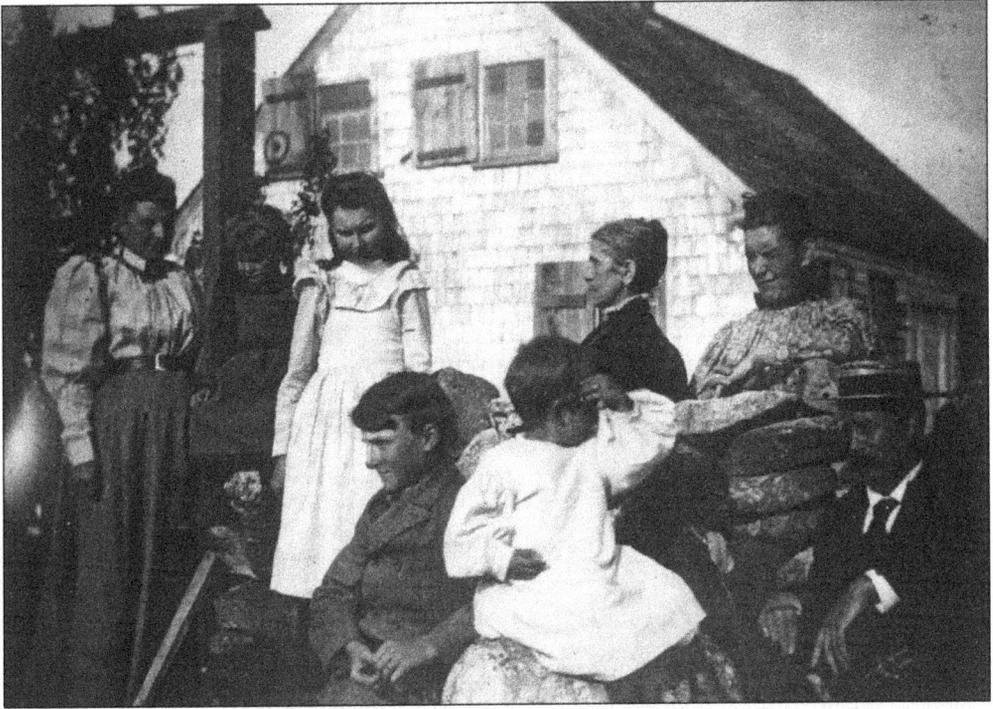

The Cornelius Tarbox family of Chicago during the summer of 1910 at a cottage on Beal Island.

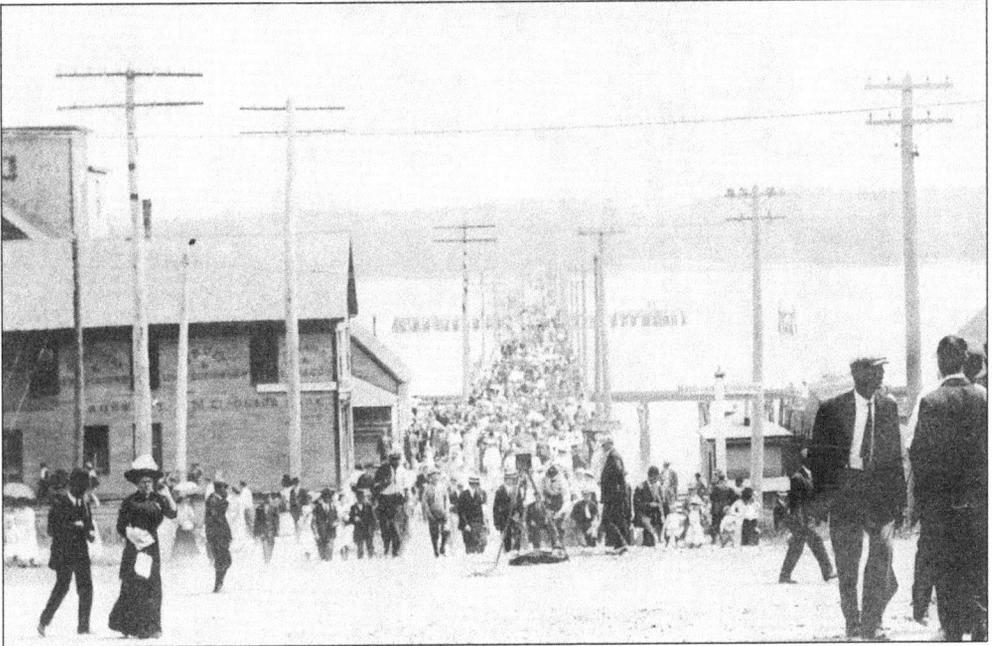

The 1912 Wiscasset Fourth of July celebration.

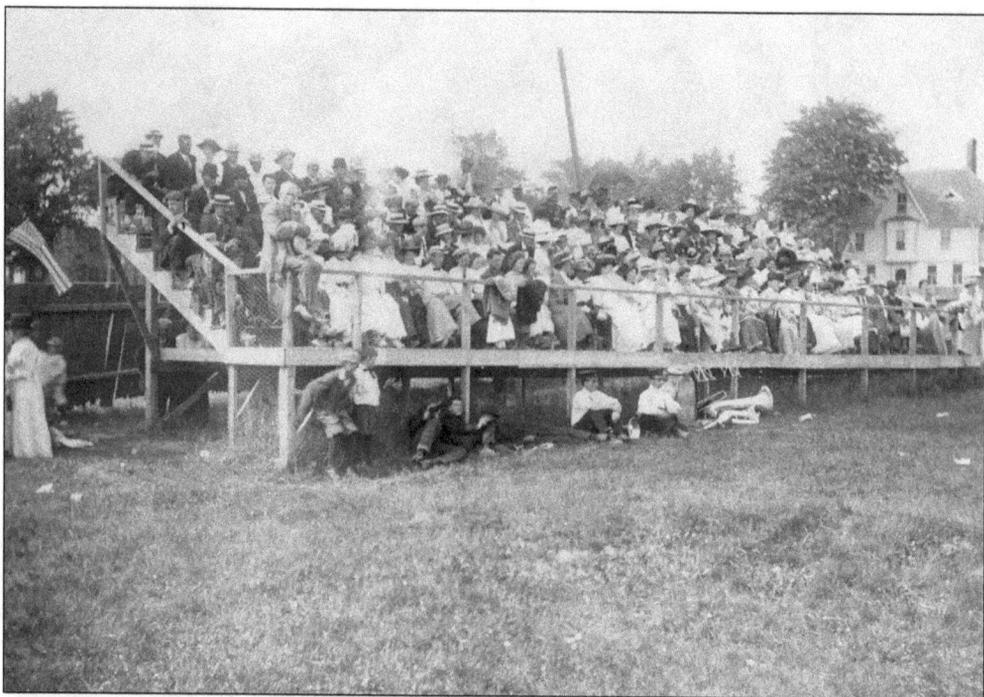

The Wiscasset Ball Grounds on the Fourth of July, 1912.

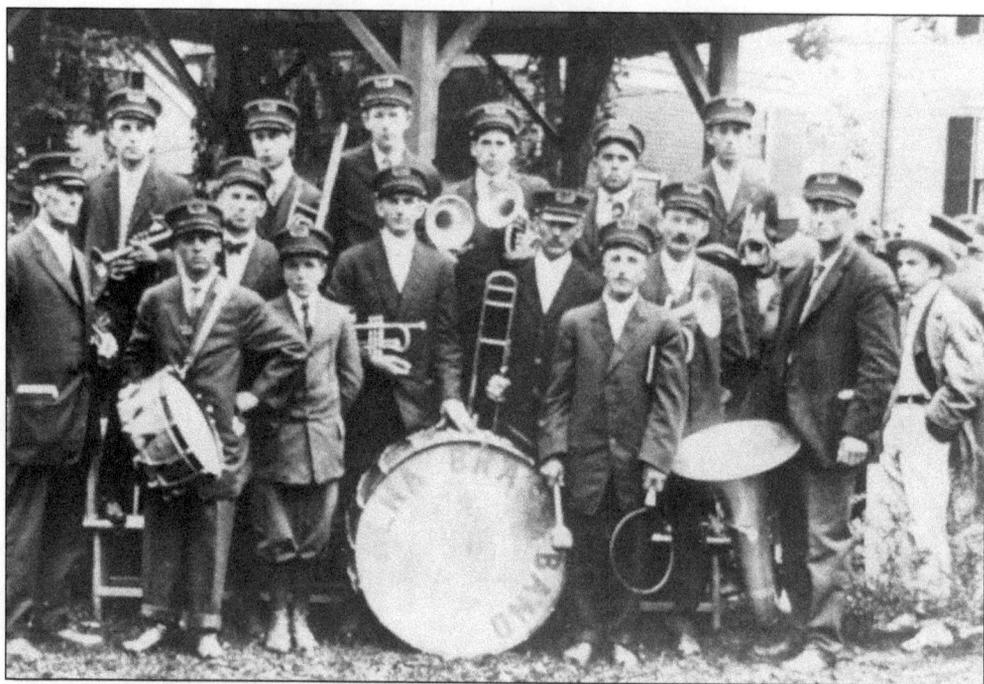

The Alna Band, c. 1913.

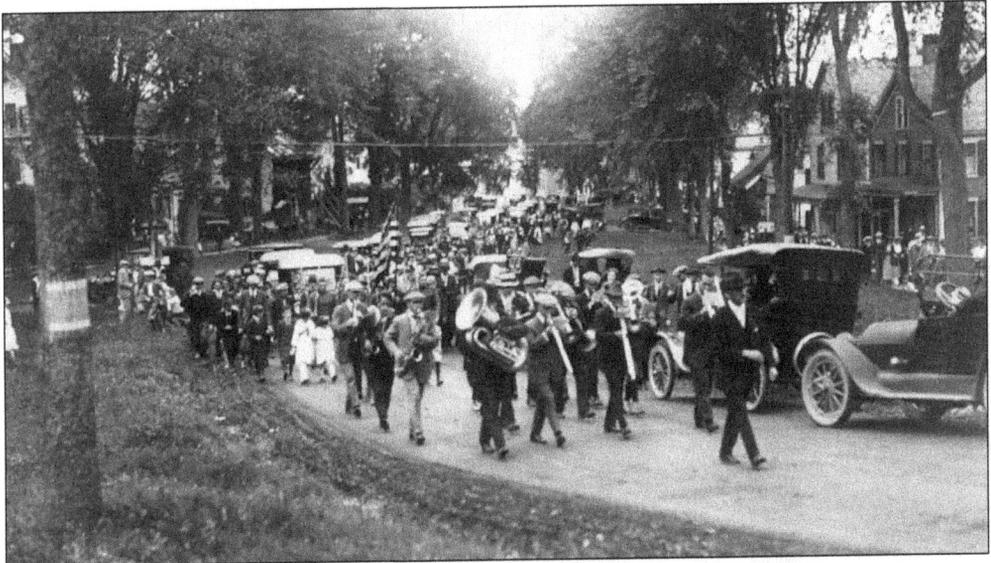

A World War I-era parade in Wiscasset, *c.* 1917.

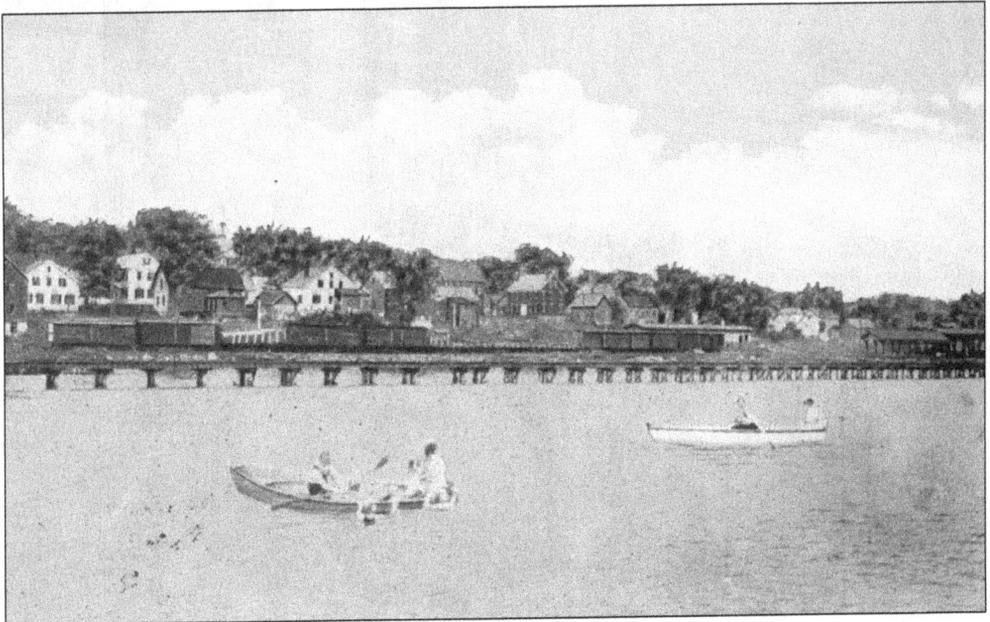

A summer day on the water in the in the 1920s.

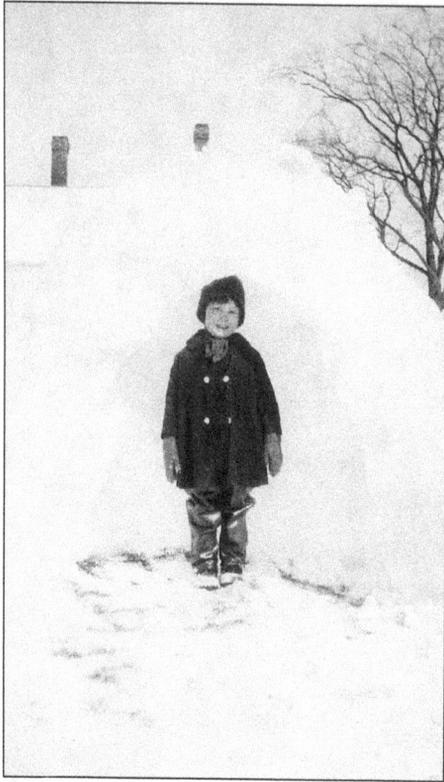

Bee Plumstead in an igloo during the winter of 1931.

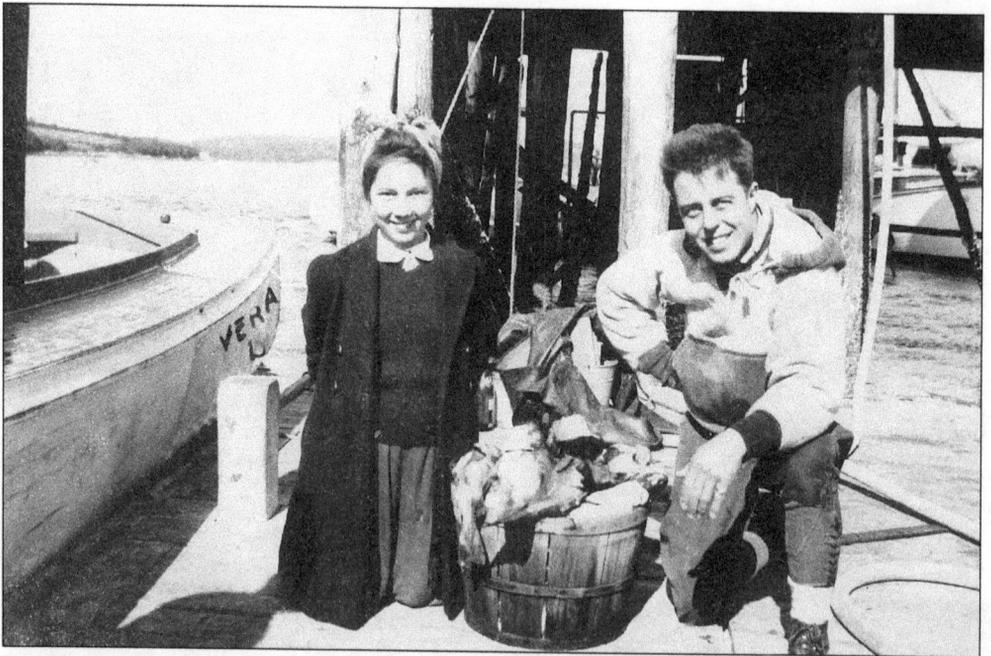

Bee Plumstead and Dick King with a nice catch of cod after a summer day's outing in 1940.

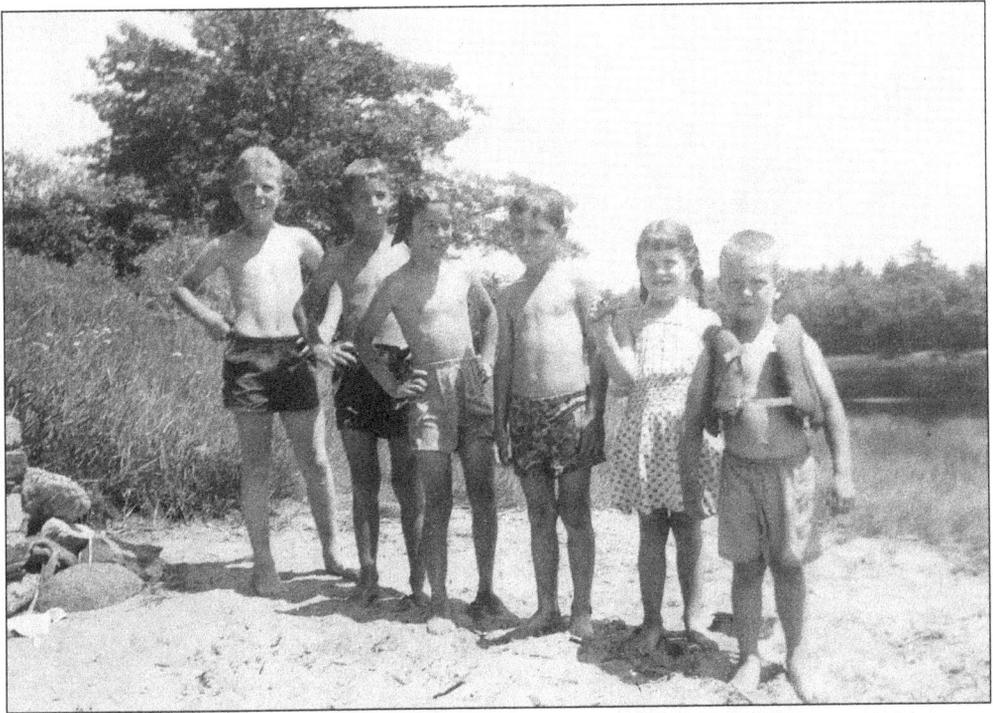

The summer of 1948 at Murphy's Corner, Woolwich. The Cook and Wiggins children are shown here on their annual vacation.

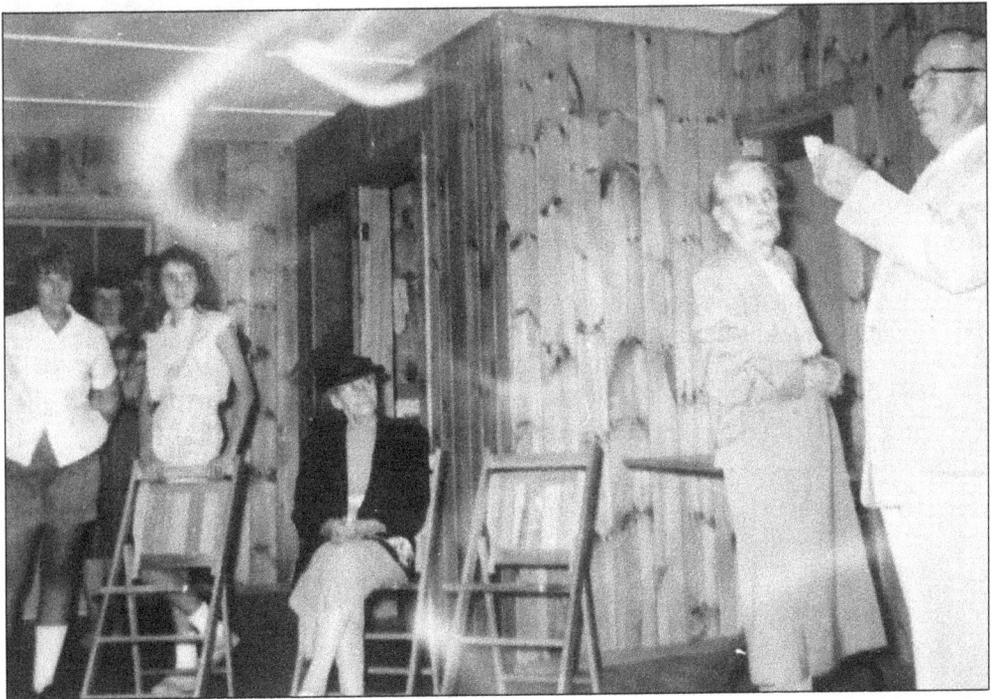

The Wiscasset Yacht Club, celebrating its 10th anniversary. Dr. Lawrence Averell, commander of the yacht club, is shown toasting Miss Jane Tucker and her friend, Miss O'Donnell (seated).

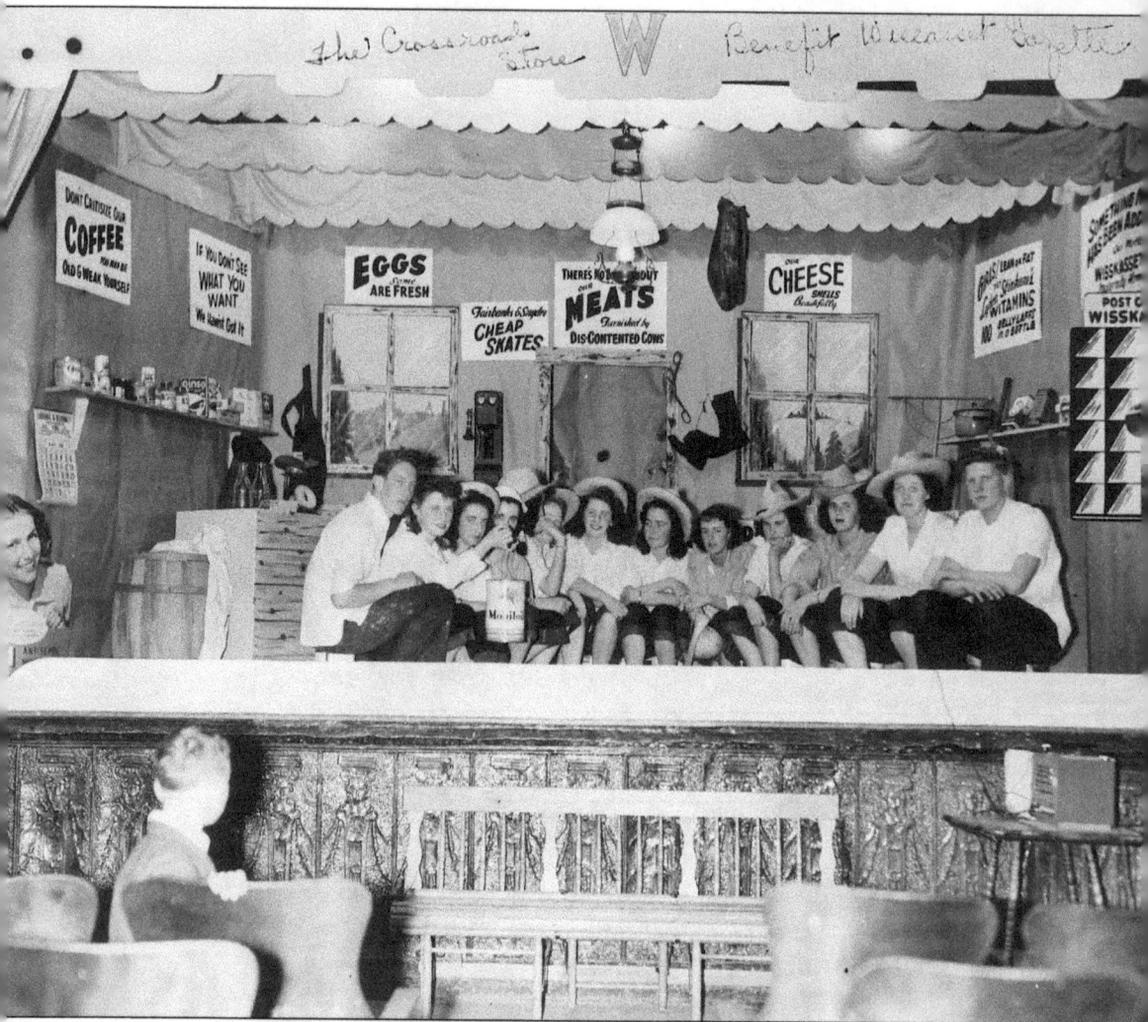

The cast of *The Crossroads Store* on May 26, 1944, at the Red Men's Hall, Wiscasset. From left to right are: (front row) Walter Dow Jr., Estu Libby, Valeria Bean, Gloria Pinkham, Barbara Merry, Betsey, Marlyn Petrie, Carolyn Rines, Carlene Shea, Elaine M., Clara Dow, Dorothy Thompson, Clifton Hutchins, and Bernard Seaman; (back row) Chester Pendleton, Conrad Peters, Bunny Lewis Bailey, Bertha Day, Caroline Pendleton, Madelaine Colby, Ed Mason, Raymond Sherman, Mark Caton, Olive Dow, Frances, Ralph Brewer, Harvey Pease, Walter Dow Sr., Winona Leavitt, Louise Mason, May Sherman, and Bernard Bailey.

Ten

Transition Through Time

The winds of change were essentially in the doldrums when it came to technical innovations during the Colonial period and the early days of the republic. Beginning in the early nineteenth century, a soft breeze started picking up. Soon this wind was blowing technological changes into every town and village; new modes of transportation, communication media, and much more arrived to change the way we live and work. The Wiscasset region has been a part of this great transition.

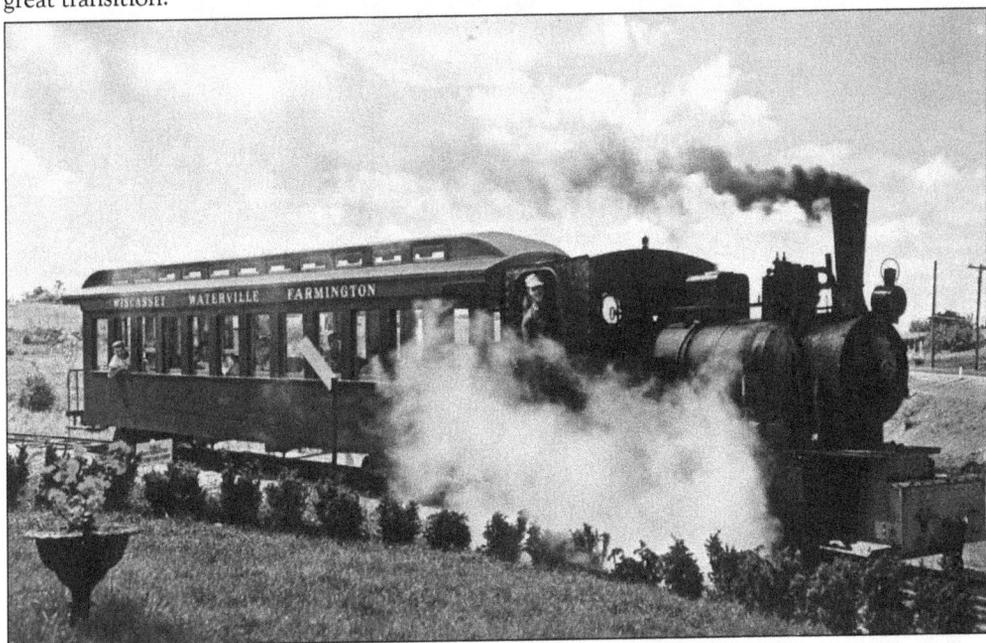

The Wiscasset, Waterville & Farmington narrow-gauge railroad. This line connected interior Maine with the coast and provided a fast means of transport for people and such goods as milk, lumber, coal, and fish.

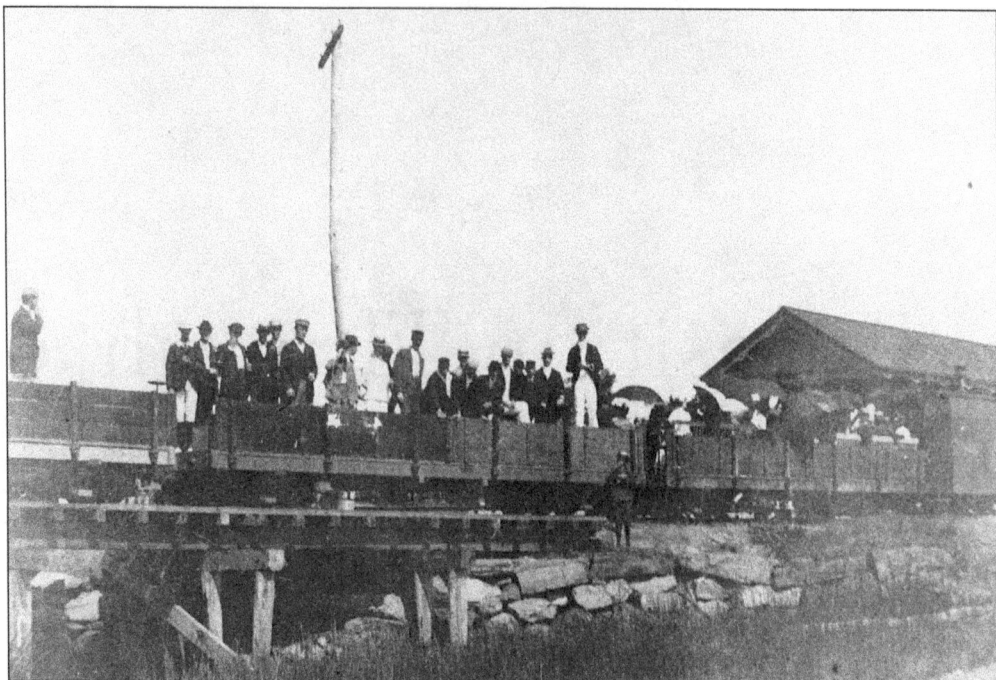

A Wiscasset, Waterville & Farmington excursion train, Wiscasset Station, with a large group of tourists during the summer of 1903.

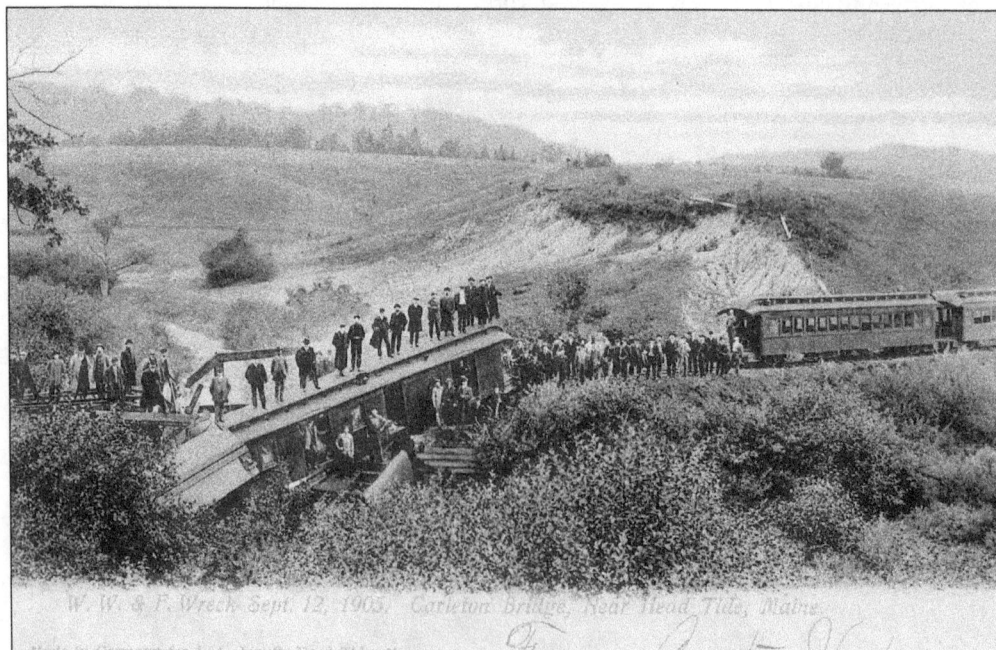

The Carlton Bridge train wreck, September 12, 1905. This wreck of a Wiscasset, Waterville & Farmington excursion train occurred near Carlton Bridge, Head Tide. The train was carrying a large Masonic group from the Gardiner area who were going to Wiscasset to connect with a boat for Boothbay Harbor.

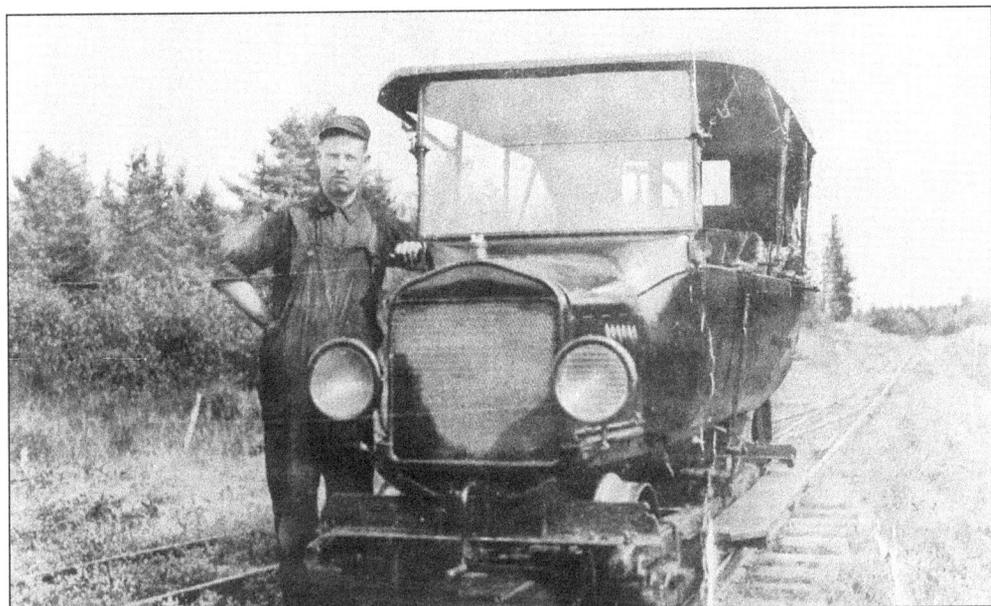

Manley Glidden with Dr. Sewall's inspection car on a stretch of track in Alna, *c. 1920.*

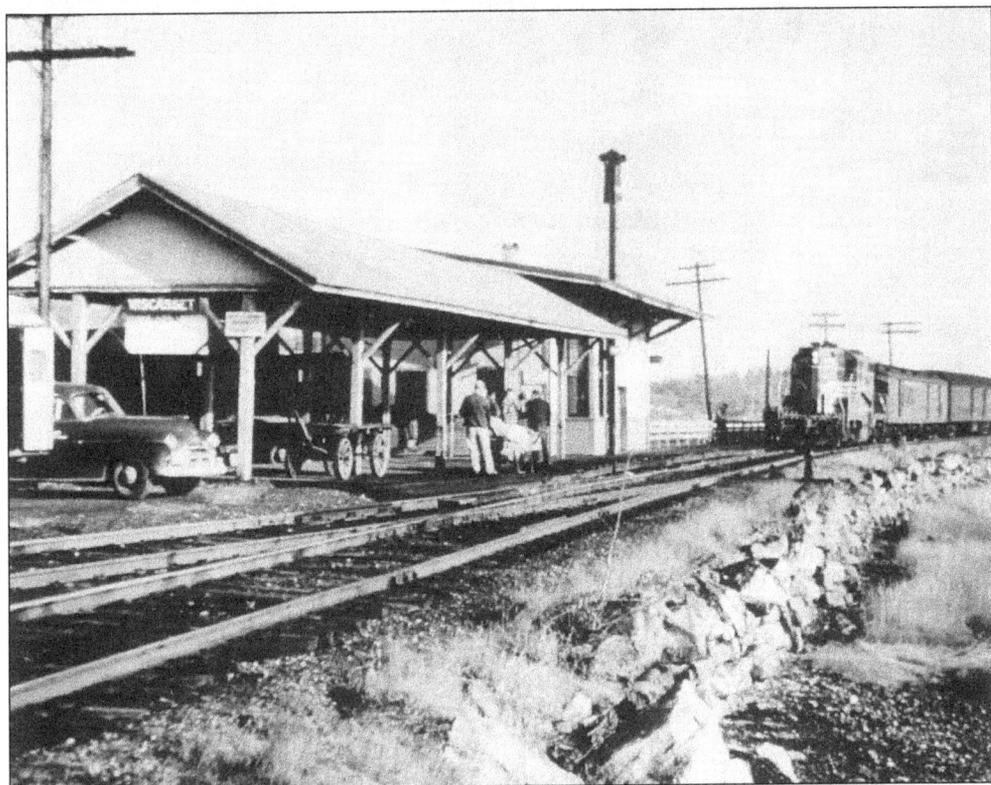

The end of an era. The whistle blew for the last time as the final run pulled into Wiscasset Station in 1954.

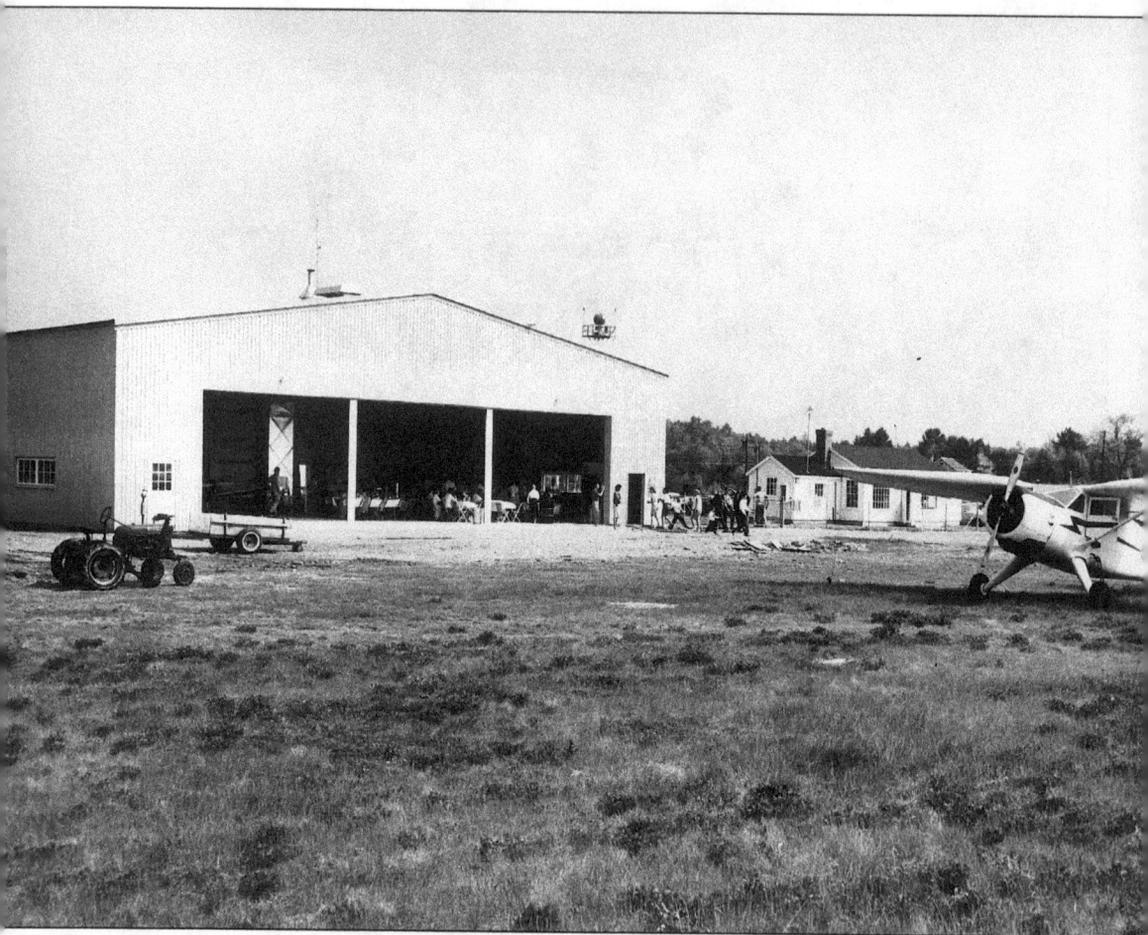

The opening of the Wiscasset Airport in 1960. This event began a new era of transportation for the area.

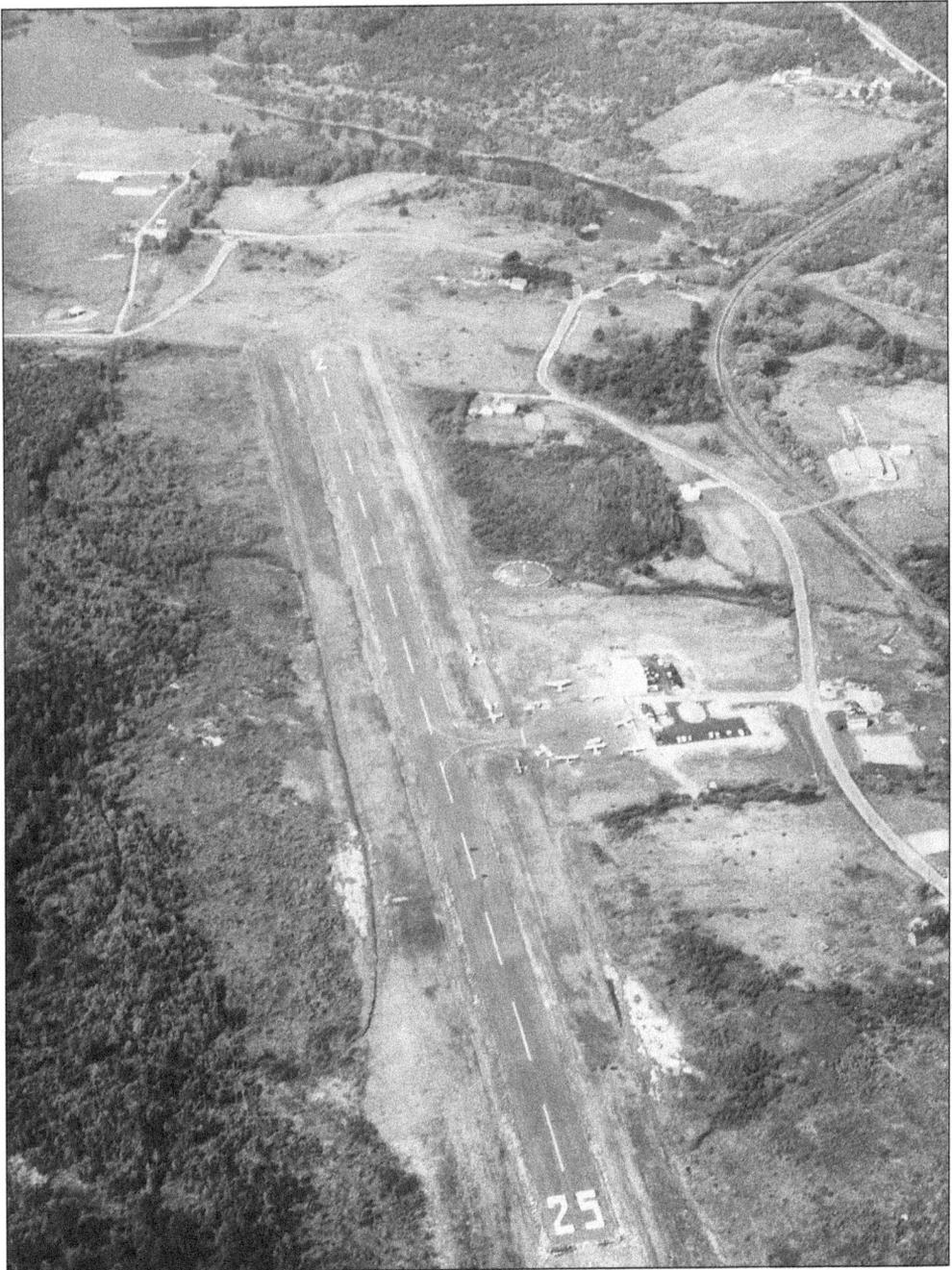

An aerial view of the new airport, c. 1960.

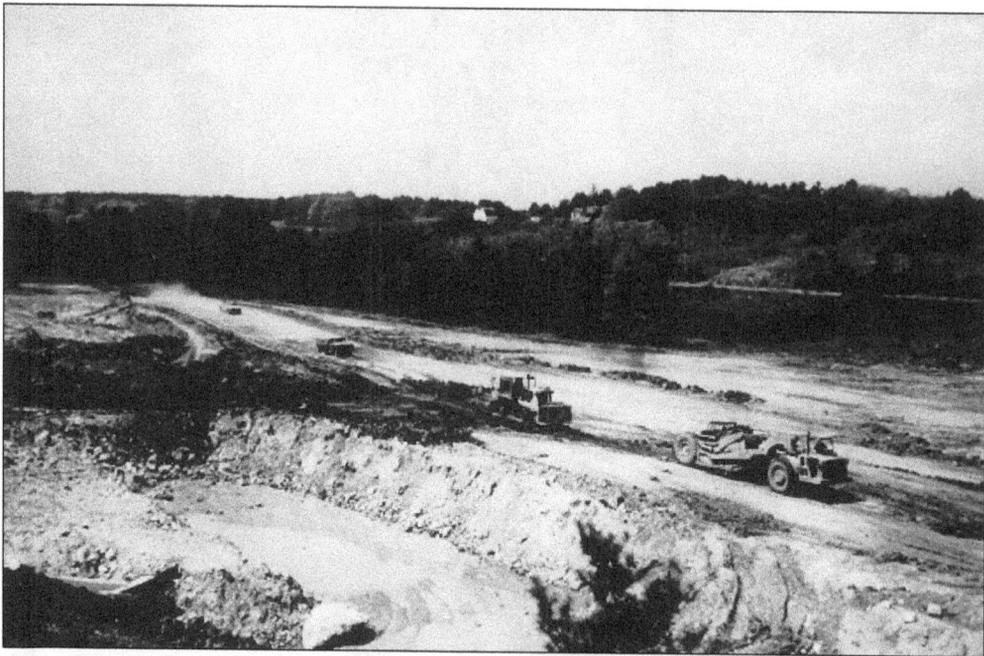

The start of the construction of Maine Yankee in 1968. It took four years for the project to be completed and the reactor to go online.

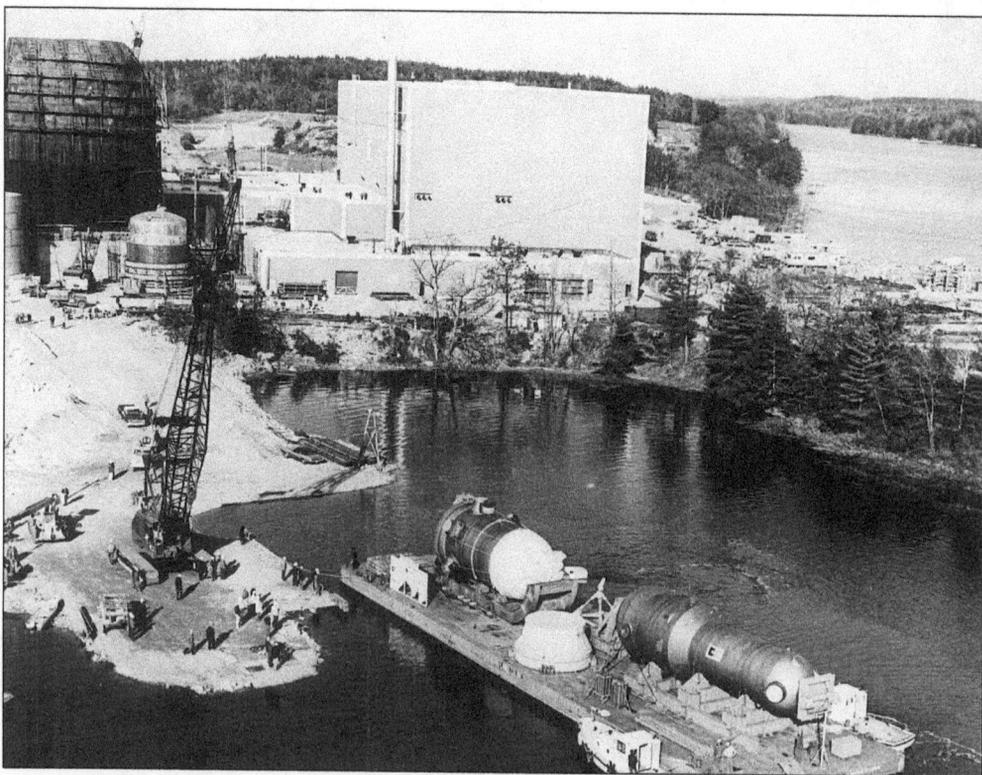

A barge carrying the reactor vessel and a steam generator for installation, c. 1969.

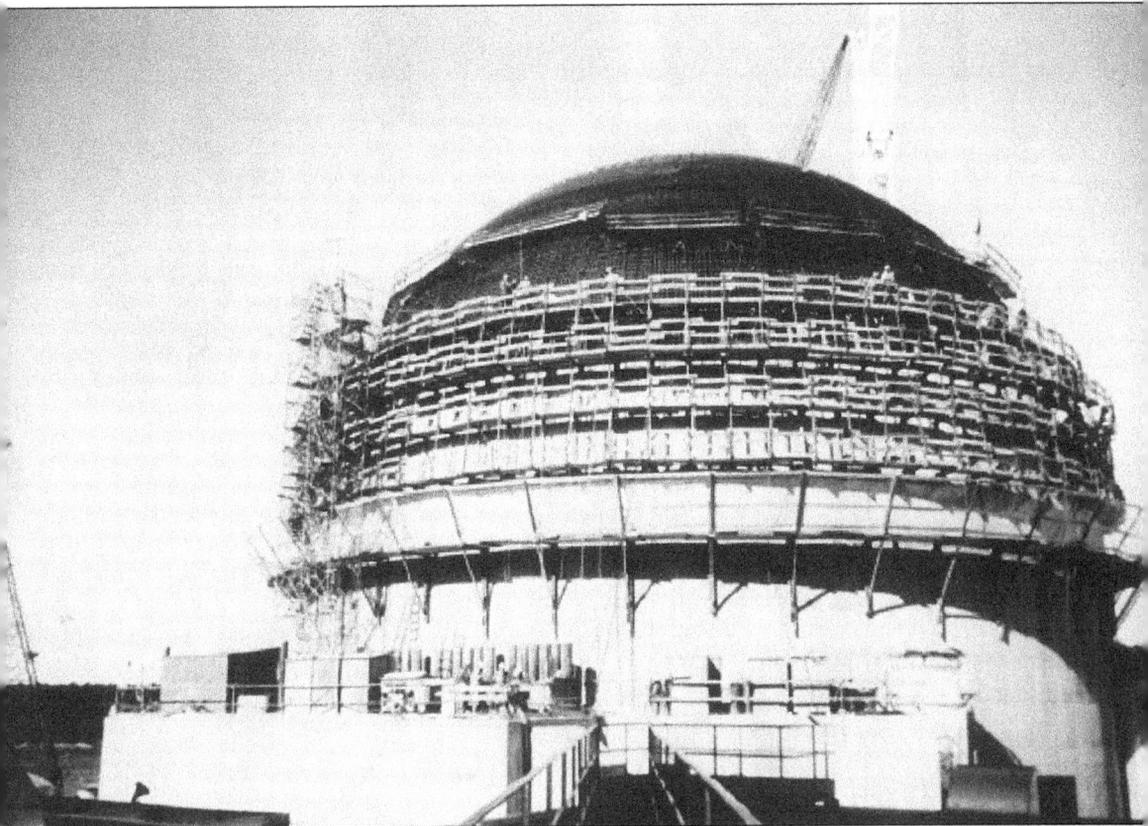

The Maine Yankee containment dome facility, under construction by Graver Tank Corporation. The finished building is 150 feet high with an inside diameter of 135 feet. The containment walls are lined with carbon steel 3/8 inch thick on the sides and 1/2 inch thick on top. The dome portion of the facility is 2 feet 6 inches in thickness and is fabricated with steel-reinforced concrete.

Acknowledgments

I would like to thank the following for their kind assistance: James Bergmann, Arnold Cowley, Robert DeWick, Anne Dolan, Roy Farmer, George Flanders, Bill and Nancy Gillies, Janeth Haslam, Charlotte and Crosby Hodgman, Bee and Dick King, Danilo Konvalinka, David and Lois Kwantz, the Wiscasset Public Library, the Lincoln County Cultural and Historical Association, Richard McElman, Robert Nicoll, Carroll Pendleton, Jeffrey Pendleton, Susan Rizzo, David Soule Sr., David Stetson, Joe Sullivan, Ronald Tarbox, Jane Tucker, Ellen Turner, Jeannie Weeks, and Maine Yankee.

Bibliography

I felt that readers would appreciate a short list of excellent and highly readable histories of towns within the Wiscasset region. All of these books were helpful references for me in compiling material for my work and in educating me on the rich heritage of each community.

Allen, Charles Edwin. *History of Dresden, Maine*, 1931. (Formerly a part of the old town of Pownalborough from its earliest settlement to the year 1900.)

Chase, Fannie S. *Wiscasset in Pownalborough*, 1941.

Maher, Frances Soule and Burnette Bailey Wallace. *History of Woolwich, Maine: a Town Remembered*, Woolwich Historical Society, 1994.

Swanton, John and Louise. *Westport Island once Jeremysquam*, Westport Community Association, 1993.

www.ingramcontent.com/pod-product-compliance
Lightning Source LLC
Chambersburg PA
CBHW080848100426
42812CB00007B/1957